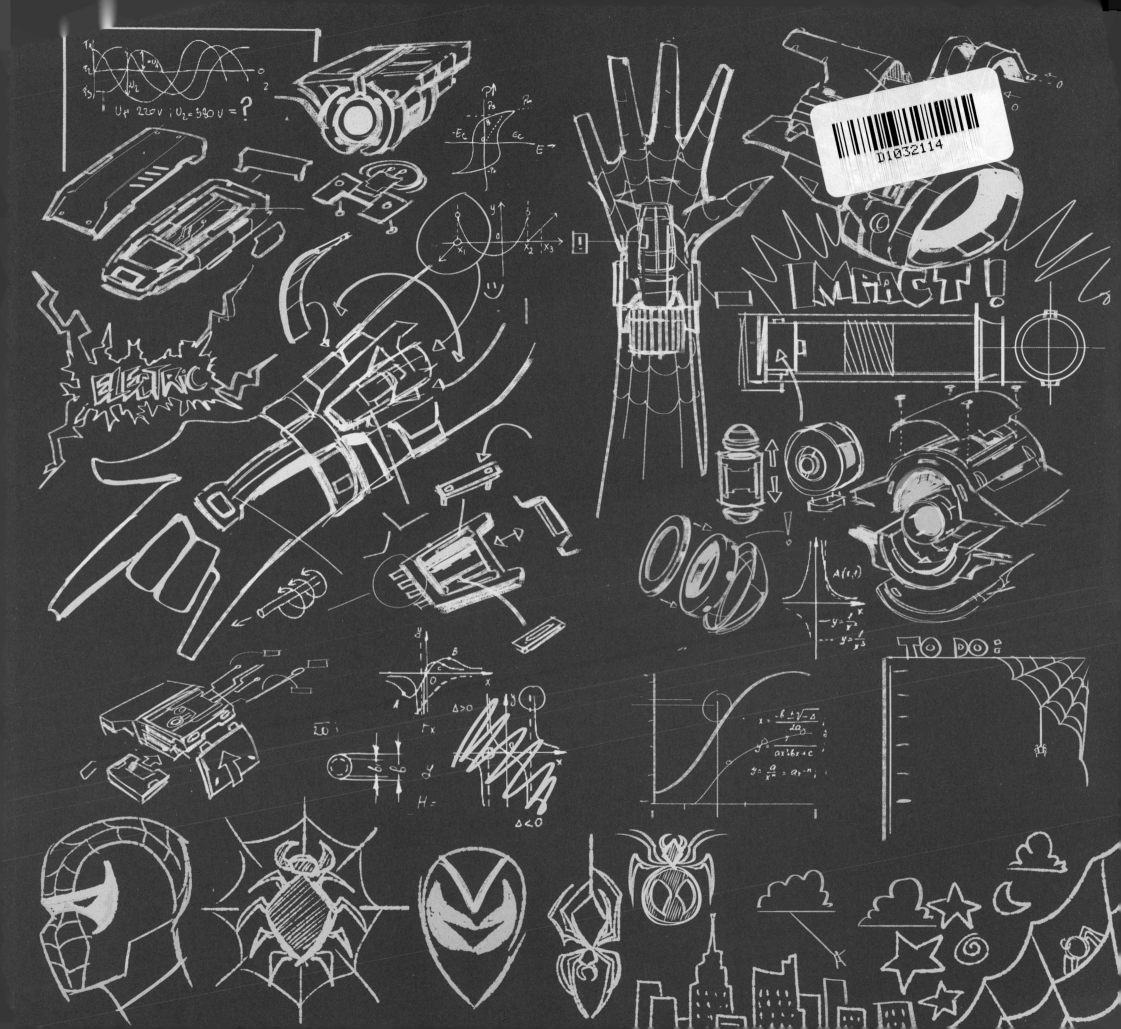

D1032114

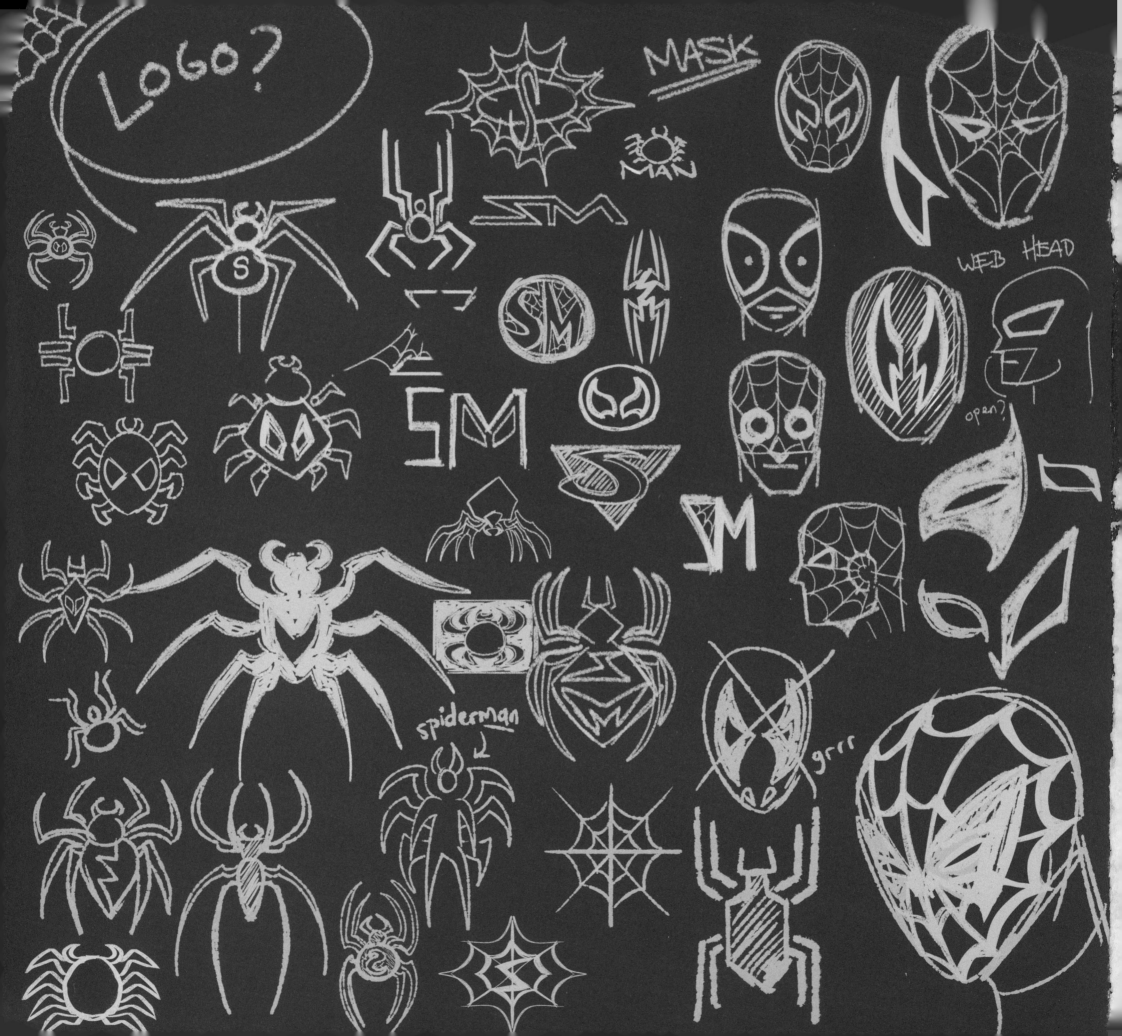

MARVEL

SPIDER-MAN

THE ART OF THE GAME

MARVEL'S SPIDER-MAN: THE ART OF THE GAME

Spider-Man created by Stan Lee and Steve Ditko

Forewords by Bryan Intihar and Bill Rosemann

MARVEL GAMES
Isabel Hsu, Assistant Creative Manager
Mike Jones, Executive Producer & VP
Becka McIntosh, Senior Operations Manager
Haluk Mentes, Executive Director, Business Development & Product Strategy
Eric Monacelli, Lead Senior Producer & Project Lead
Jay Ong, Senior Vice President
Bill Rosemann, Executive Creative Director
Chuck Roquemore, Operations Manager
Tim Tsang, Art Director

MARVEL PUBLISHING
Jeff Youngquist, VP Production & Special Projects
Caitlin O'Connell, Assistant Editor, Special Projects
Jeff Reingold, Manager, Licensed Publishing
David Gabriel, SVP Print, Sales & Marketing
C.B. Cebulski, Editor in Chief
Joe Quesada, Chief Creative Officer
Dan Buckley, President, Marvel Entertainment

ISBN: 9781785657962
Limited Edition ISBN: 9781785657979

Published by Titan Books
A division of Titan Publishing Group Ltd.
144 Southwark St.
London
SE1 0UP

First edition: 2018
10 9 8 7 6 5 4 3 2 1

© 2018 MARVEL
© 2018 Sony Interactive Entertainment LLC
Developed by Insomniac Games, Inc.

To receive advance information, news, competitions, and exclusive offers online,
please sign up for the Titan newsletter on our website: www.titanbooks.com

Did you enjoy this book? We love to hear from our readers.
Please e-mail us at: readerfeedback@titanemail.com
or write to Reader Feedback at the above address.

No part of this publication may be reproduced, stored in a retrieval system, or transmitted,
in any form or by any means without the prior written permission of the publisher, nor be
otherwise circulated in any form of binding or cover other than that in which it is published
and without a similar condition being imposed on the subsequent purchaser.

A CIP catalogue record for this title is available from the British Library.

Printed and bound in China.

About the Author
Paul Davies worked in journalism for twenty-five years.
He is now a freelance writer and creative consultant.

MARVEL
SPIDER-MAN

THE ART OF THE GAME

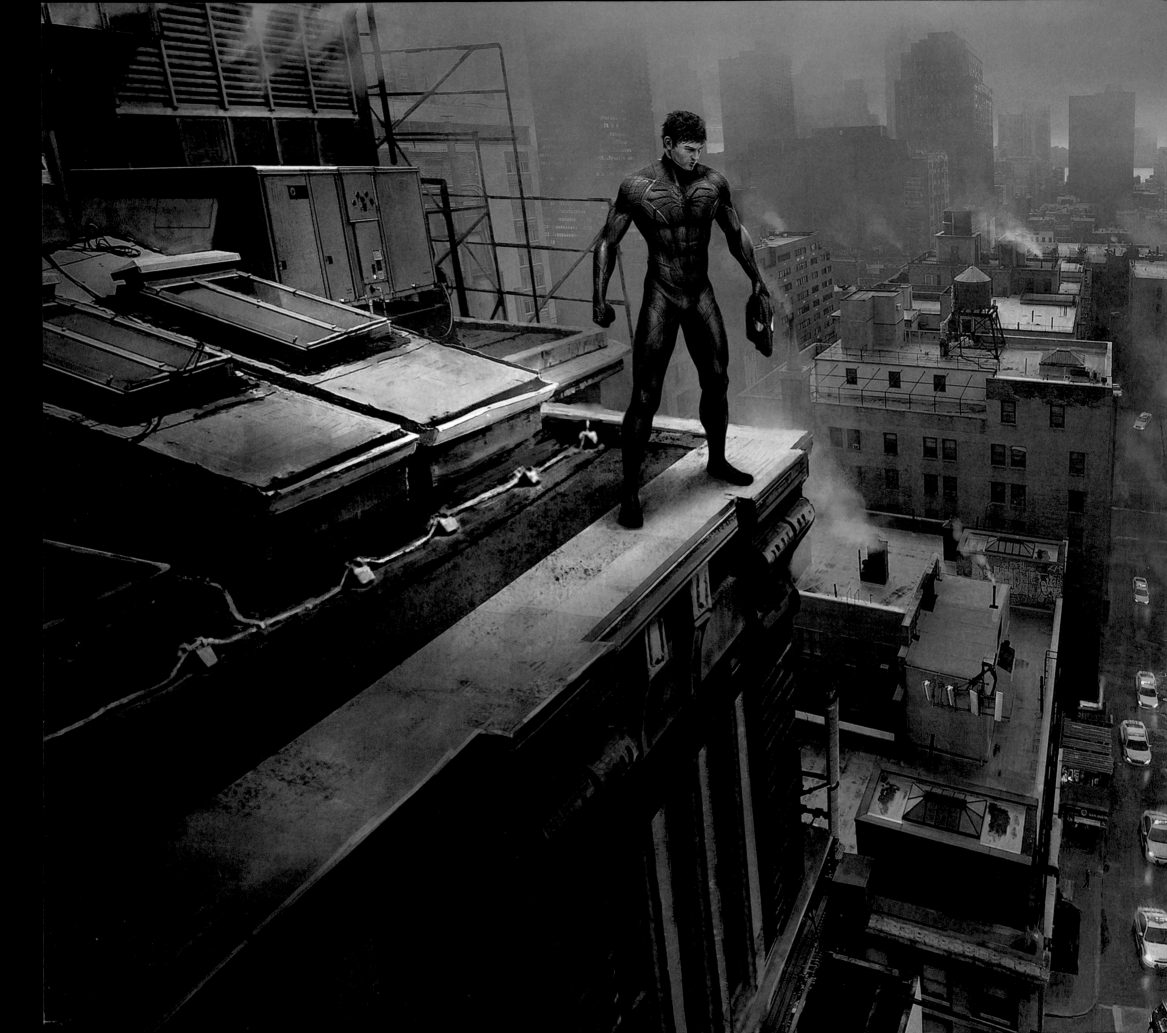

CONTENTS

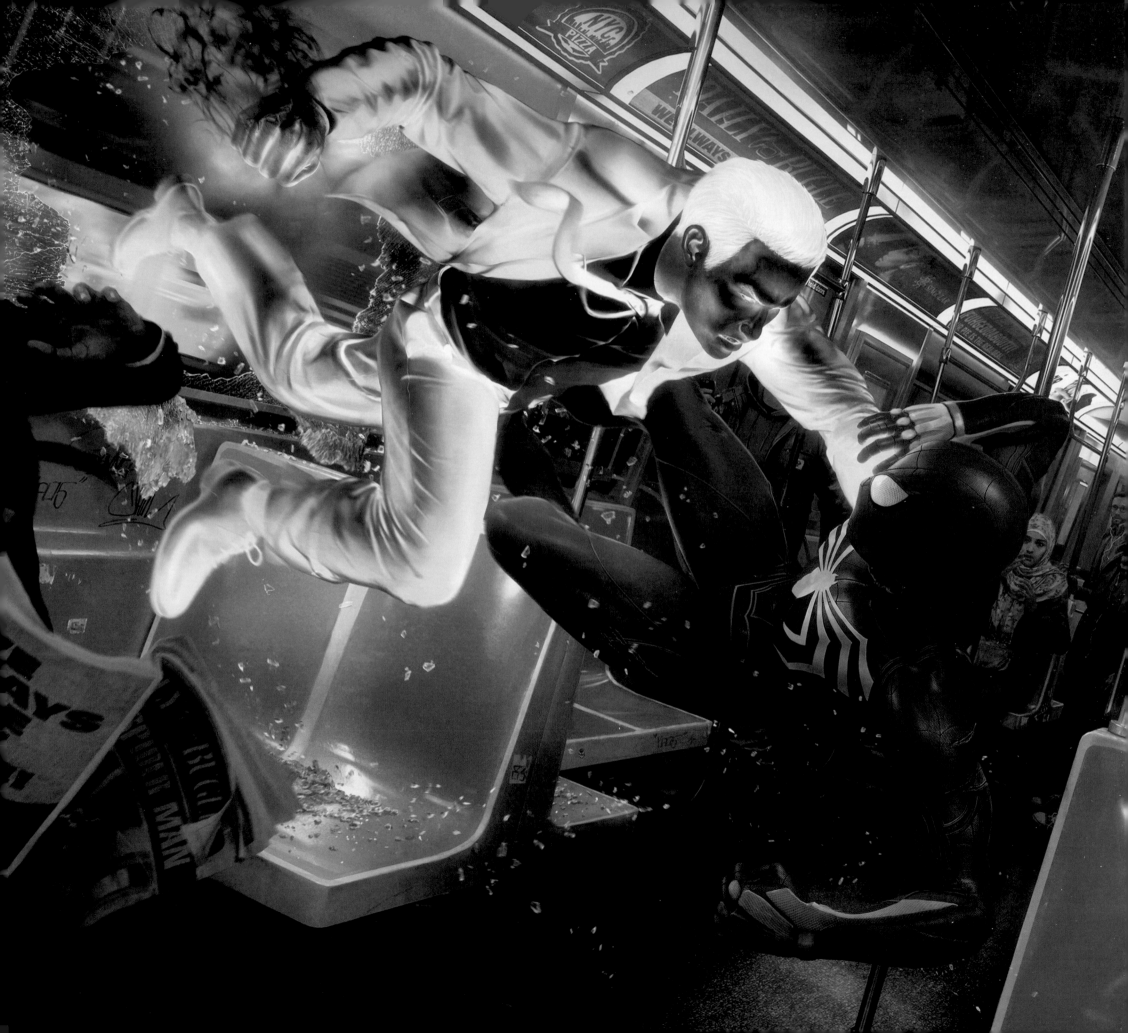

THE KID WHO LOVES SPIDER-MAN

LET ME TELL YOU ABOUT THIS KID I KNOW.

He was seven when he first saw the red and blue web-slinger swing across his TV screen in reruns of the classic 1960s cartoon, and it was love at first sight. A year later he walked into his school's book fair, bought a paperback-sized reprint of Stan Lee and Steve Ditko's *Amazing Spider-Man #7–#13* and was bitten by the storytelling bug, just as Peter Parker was bitten by that famous irradiated spider. He never stopped enjoying Spider-Man stories—whether in comic books, novels, TV shows, movies or video games—for the next forty years.

During those years he cherished his Spider-Man birthday cakes, Halloween costumes, Mego dolls, action figures and Underoos. He wrote Spider-Man stories for school assignments and for fun. He asked his mom to make him wheat cakes, and when he was prescribed glasses he was proud because Peter Parker once wore them.

You see, it was in Peter that the kid saw himself (or who he strived to be): a bookish nerd who wasn't perfect, who often failed, but who always tried to do the right thing. Peter may have been outnumbered by his enemies, hated by his boss and the press, and who literally had the weight of the world on his shoulders via a pile of rubble, but he never gave up. Peter may have let the burglar who eventually killed his Uncle Ben run by him, but that didn't mean that every day he couldn't pull on that mask and seek redemption. The kid came of age along with Peter, and when faced with difficult moral decisions would ask himself: "What would Peter Parker do?"

During his second summer home from college, the apartment building in which the kid and his mother lived caught fire. He ran in and out of their ground-floor unit, carrying out anything he could find. On his last trip in, with the lights to the building cut off, he felt his way back to his bedroom and carried out a long box of comics...because most of them starred Spider-Man.

Galvanized by that moment to pursue a career telling super hero stories, the kid actually pulled it off and landed an entry-level position at Marvel. Through the company's bankruptcy and eventual ascendance, the kid did whatever he could to champion the brand and—whether he was writing and editing comic books or helping to make video games—he happily worked at Marvel for over twenty years. When the kid had a kid of his own, he named him—what else?—Peter.

You've no doubt guessed by now that the kid is me. But he's also everyone at Marvel, Insomniac and PlayStation who grew up with the wall-crawler and is now lucky enough to work on *Marvel's Spider-Man*. More importantly, he's you. You are why we pursued our dreams to create games, and why we poured every ounce of our creative energy into making this particular game amazing. We thank you for coming along with us on this journey, and we hope you enjoy all of the spectacular art and world building spotlighted in the following pages.

We all have a Spider-Man story, and hopefully we'll run into each other at a convention or on social media and you can tell me yours. Until then, may your web shooters always be full of fluid, may your spider-sense always warn you of danger, and may you never stop asking yourself: "What would Peter Parker do?"

Your Mann At Marvel,
Bill Rosemann
Exec. Creative Director, Marvel Games

P.S. The title for my intro is inspired by "The Kid Who Collects Spider-Man" by Roger Stern and Ron Frenz, a short story that first saw print in *Amazing Spider-Man #248*. If you have the chance, please track it down and give it a read—it's widely considered to be one of the greatest Spider-Man stories of all time. Better yet, share it with a young reader. You just may create another kid who loves Spider-Man.

GREAT POWER, BUT AN EVEN GREATER RESPONSIBILITY

"SO, WHAT DO YOU THINK ABOUT WORKING ON A GAME WITH SONY AND MARVEL?"

I vividly remember hearing that question. It was a late afternoon a few years back during the Fall and I had just swung by the office of Ted Price, Insomniac Games' founder and CEO. I was updating him on the progress of a game our studio was wrapping up. After we'd finished he quickly changed the subject—and my life. Without hesitation, I practically shouted, "Yes! And I'd love to lead the project."

As any super hero fan can probably imagine, being able to bring the friendly neighborhood Spider-Man to the PlayStation®4 system has been a dream come true, and that feeling resonates across our studio. Not only do so many of us connect with the character's charm, vulnerability and humor on a personal level, but he also fits the personality of Insomniac perfectly. We were meant to make this game.

Spider-Man is such an iconic character and he's beloved by so many people, which is why we have always felt an unbelievable responsibility to deliver a gaming experience that not just met but exceeded expectations. Early on, the stunning artwork by the talented artists that you'll see throughout this book helped provide us with the inspiration needed to deliver an unforgettable Spider-Man experience. I sit right next to our Art Director Jacinda Chew and, any time a new piece of concept art would come in, I would leap out of my chair to check it out. Seeing the artwork gave me feelings of wonder and excitement, which mirrors how I felt as a kid whenever I looked through the pages of a Spider-Man comic.

Personally, being the Creative Director on *Marvel's Spider-Man* has been the greatest moment of my professional career. But as you'll see throughout this book and when you play the game, everything we do is a team effort. And I couldn't have done my job without the unwavering support and passion of so many people at Sony Interactive Entertainment, Marvel Games and, of course, my Insomniac family.

Thank you for joining us on this all-new Spider-Man adventure, and I hope you have as much fun playing it as we did making it.

Bryan Intihar
Creative Director at Insomniac Games

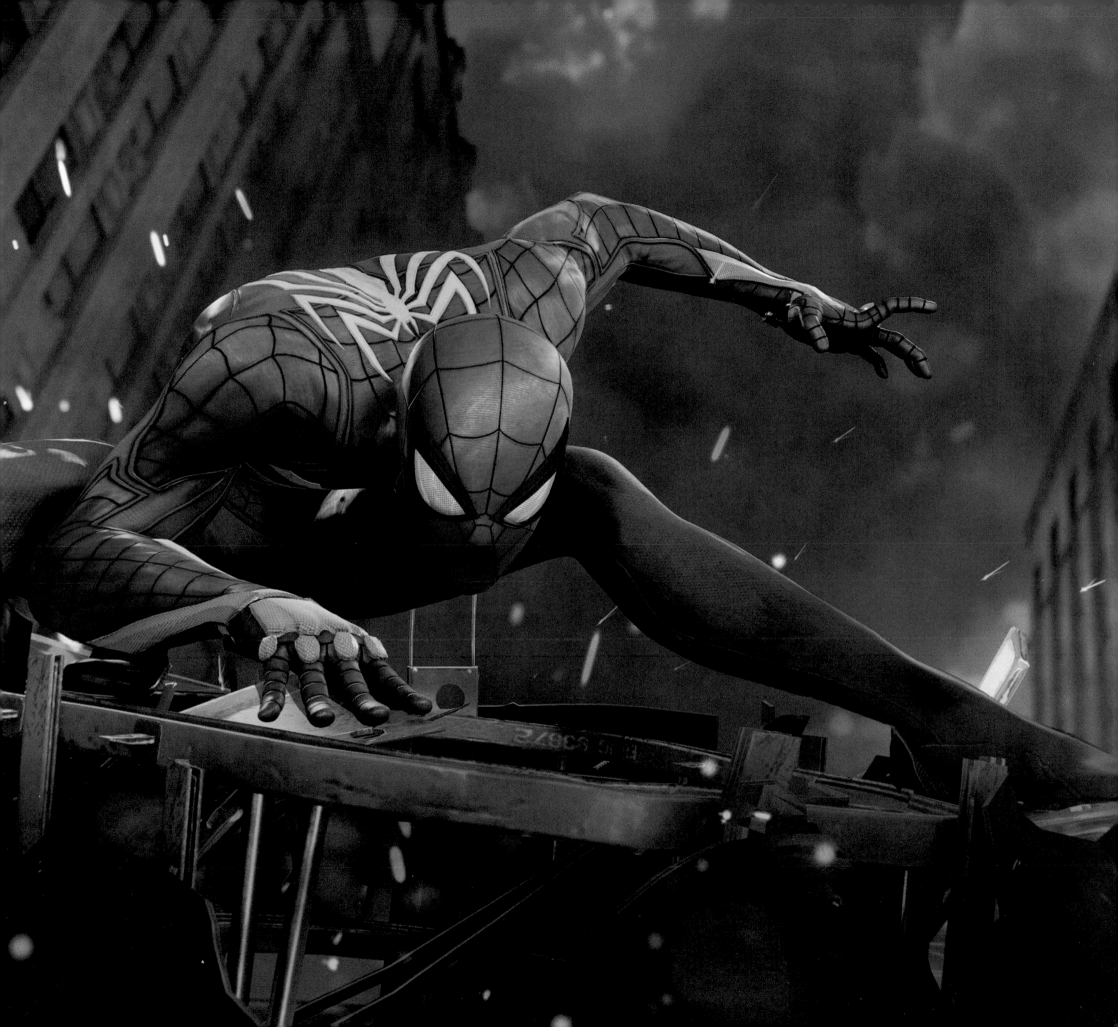

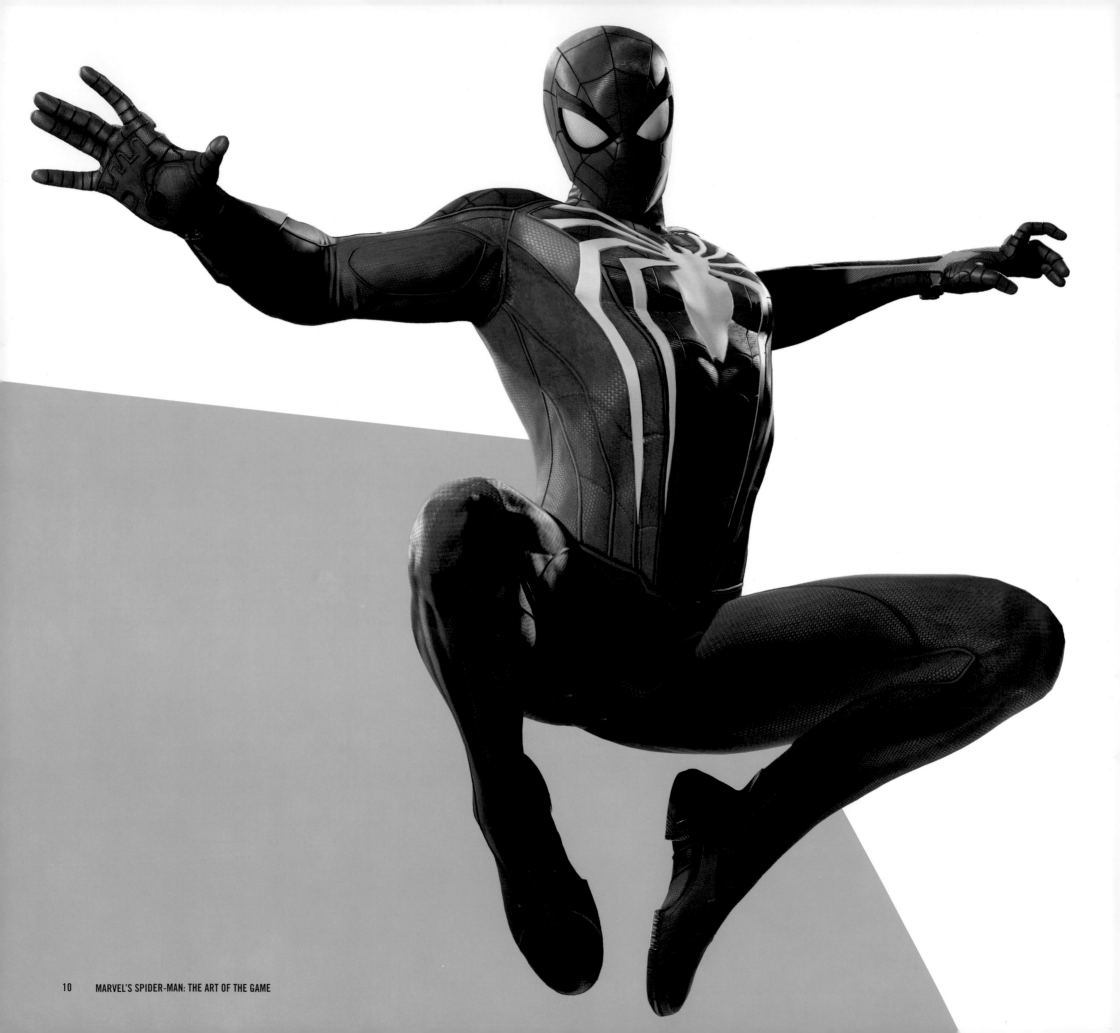

"With Insomniac we found the perfect partner. We knew they had a shared admiration of and ability to deliver humor, character, a strong narrative, and most importantly fun."

Bill Rosemann

STILL TODAY THERE ARE PEOPLE who believe that video games are more shackled by creative limitations than other mediums. *Marvel's Spider-Man* elegantly states otherwise, passionately crafted for PlayStation 4 as a meaningful, impactful and important work of art.

It is the result of a collaboration between Marvel, whose writer Stan Lee and artist Steve Ditko co-created Spider-Man in 1962, and Insomniac, the studio whose video games have been inspiring players since 1996. Together, Marvel and Insomniac set about forging an experience during which our thoughts should not remain idle, our minds would be engaged, and our souls could be stirred through becoming this wonderful super hero, knowing that, 'In this world, with great power there must also come—great responsibility.'

While it is true that the making of *Marvel's Spider-Man* required digital techniques using Photoshop, ZBrush and 3DCoat, *Marvel's Spider-Man: The Art of the Game* is not a study about that. Titan Books spoke to the people involved in the game's creation to learn their thoughts and inspirations, and to better understand the purpose of it all. *Marvel's Spider-Man: The Art of the Game* comes from them.

"I know that this journey that we are on wouldn't be possible without the people I work with," Bryan Intihar, the Creative Director at Insomniac told us. "The team here are not just people I work with; I consider them family. I think of Insomniac as my second home. People I get to work with, I think of them as legends. We have our awesome moments, and we have our moments when we have passionate discussions—and that's what makes for a great video game."

Jacinda Chew is the Studio Art Director of Insomniac. She oversees art and animation, which includes character and environment modeling, FX, lighting, UI, and concept art. "I work closely with the Creative Director and Game Director to realize the vision of each project," explains Chew. "We sit next to each other to keep communication tight, normally developing all three arms of each project concurrently, and bouncing ideas off each other while we do. There is a lot of respect between us, so we don't hesitate to offer feedback and suggestions on all parts of the game, regardless of our specialty."

"Whenever Marvel selects and works with any creator to tell any story—whether that's via a comic book, TV show, movie or video game—it starts with a combination of skills and passion," states Executive Creative Director at Marvel Games, Bill Rosemann. "Do they have the abilities needed to best bring a particular character to life? Do they have the burning desire needed to deliver their unique vision to the world?

"With Insomniac, who possessed both crucial elements, we found the perfect partner. As fans of *Sunset Overdrive* and the *Ratchet & Clank* series, we knew they had a shared admiration for and ability to deliver humor, character, a strong narrative, and most importantly, fun! What we learned after meeting with them was that their team, like us, grew up loving Spider-Man and had dreamed of making a spectacular game that fully delivered on the amazing fantasy of web-slinging, wall-crawling and battling Spidey's infamous rogue's gallery."

Rosemann outlines his role on *Marvel's Spider-Man* as being, "To provide whatever support my friends at Insomniac and PlayStation need to fully embrace and deliver their vision of the world-famous web-slinger in his most amazing game yet.

"That support can take form through brainstorming (story, characters, gameplay, marketing, etc.), reviewing content, providing daily feedback, and giving whatever clarification, opinions and guidance I can based on my experience as a comic book writer and editor, and my overall knowledge of the brand gained during my twenty-year career at Marvel. I'm here to collaborate, be a soundboard and, most importantly, help the team create the Spider-Man game they—and the fans—always dreamed of."

Working with Marvel has been one of the best experiences of my entire life. It has been awesome. At the end of the day we are all Marvel fans who love games. We all talked about making the best Spider-Man experience possible."

- Bryan Intihar

Art Director at Marvel Games, Tim Tsang, is primarily responsible for working closely with the art directors and leads at Insomniac to collaborate and provide art and brand feedback on art, animation and VFX. "The goal was to produce a fresh new take on the Spider-Man universe, with characters, locations and stories that you have not seen or experienced before," Tsang outlines, "but at the same time ensuring that the iconic heroes and villains remained authentically Marvel."

"Like most people, I was ecstatic to find out that Insomniac was on board to make the next Spider-Man game," Tsang enthuses. "Combining the fun, charm and attitude of Insomniac, with Marvel storytelling and the Spider-Man universe, the possibilities were…limitless. Personally, I was most excited with the prospect of seeing Insomniac's frenetic animation flair and style and seeing that come through in a modern Spider-Man game."

You might imagine that all staff involved, being so experienced, would be immune to the thrill of it all. This was not the case. Performance nerves were real, fueling a desire to live and breathe the subject at the deepest level.

"I was a bit scared at first," Jacinda Chew says. "Spider-Man is such a beloved character and I felt a lot of responsibility! I got a subscription to Marvel Unlimited and started reading Spider-Man comics to flesh out my knowledge of his universe. The *Ultimate Spider-Man* comics by Brian Michael Bendis became my favorite."

For Bill Rosemann, working on *Marvel's Spider-Man* was an opportunity to finally deliver on a childhood fantasy, following the path set out by the greats. "We all grew up loving the fact that Stan Lee, Steve Ditko, Jack Kirby, John Romita Sr. and all the amazing Marvel founders were dedicated to 'putting the human in the superhuman'," says Rosemann. "You root for them while they wear their crazy costumes and battle fantastic threats because you first connected with and fell in love with them as people. Marvel characters are the greatest because they are not perfect. Like us, they have weaknesses and challenges that they must face and overcome (or at least grapple with).

"I discovered Spider-Man comic books through a third grade book fair…and I've never stopped believing. Spider-Man became my favorite hero not because he was perfect, but because he *wasn't*. He was never the biggest or strongest competitor in the fight, but that didn't mean he never stopped trying. Just because he got knocked down multiple times, that didn't mean he didn't stop getting up."

This awe-inspiring level of commitment has proven infectious for Insomniac, and the reason why *Marvel's Spider-Man* and this book contains that spine-tingling fulfillment we all seek.

When asked about working with Marvel, Bryan Intihar said: "This is not PR speak. Working with that team at Marvel has been one of the best experiences of my entire life. They are part of the development team, and it has been awesome. I'm texting and talking to those guys all the time. We're going out and getting drinks and dinner. At the end of the day, we are all Marvel fans who love games. We all talked about making the best Spider-Man experience possible. It wasn't, 'Put these characters in the game,' or, 'Make sure you hit this storyline.' It was, 'What is going to make for the best Spider-Man experience when you're playing a video game—at the highest quality possible?'

"They were open to new ideas, as long as it served the story and the gameplay, and made for a better experience. We've gone through nailing the voice of Peter and Spider-Man, making sure the likeability and the humor come across. Making sure we're putting the 'super' into super hero; that this feels like a super hero world, but also a believable world like we see in the movies, and in the comics.

"They've rolled with it, they've understood it. I would love to do more with them, because it's been a fun journey. One of their jobs is to protect the brand, which is great, but then they'd be open to something more risky, which has been… enlightening."

We hope that you enjoy exploring *Marvel's Spider-Man: The Art of the Game*.

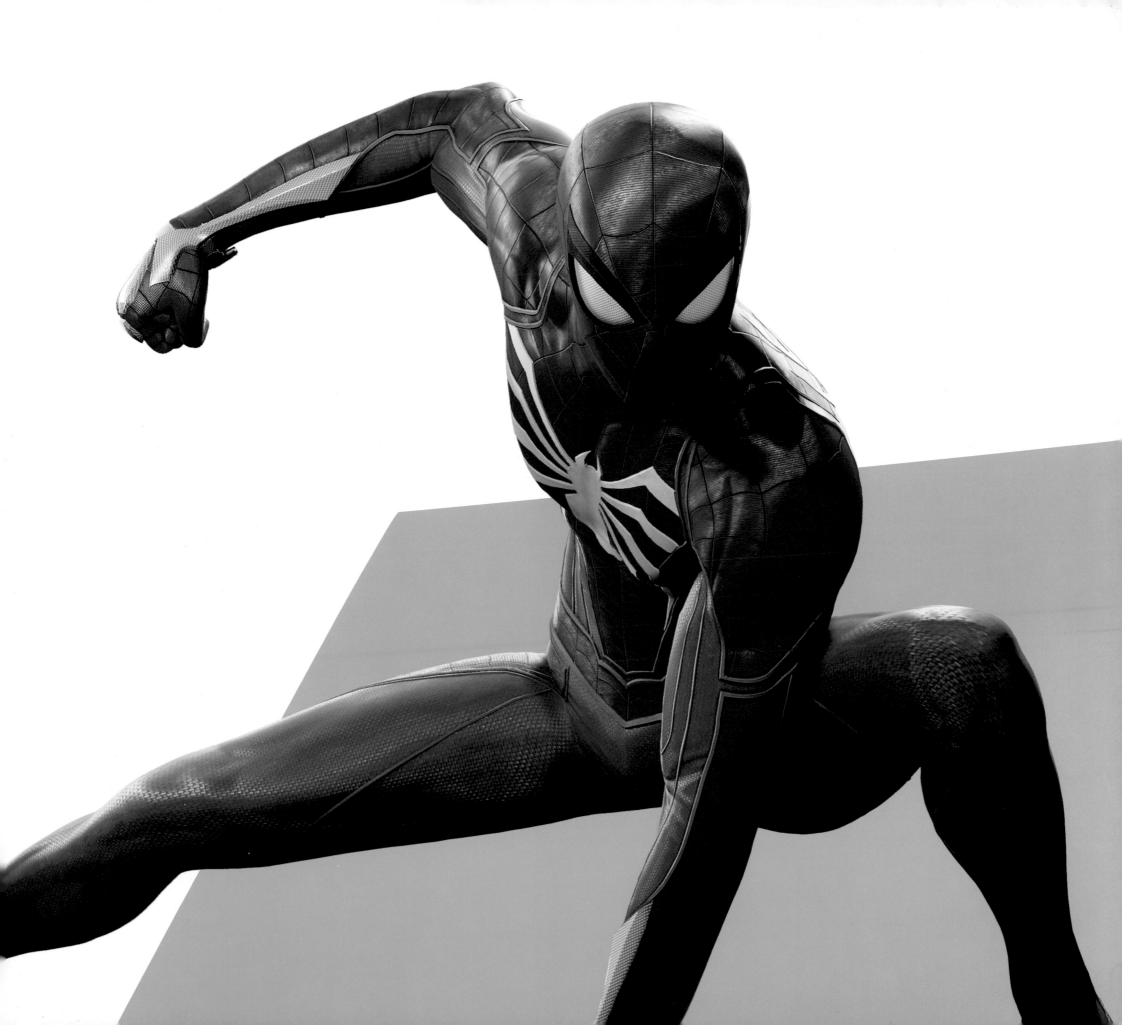

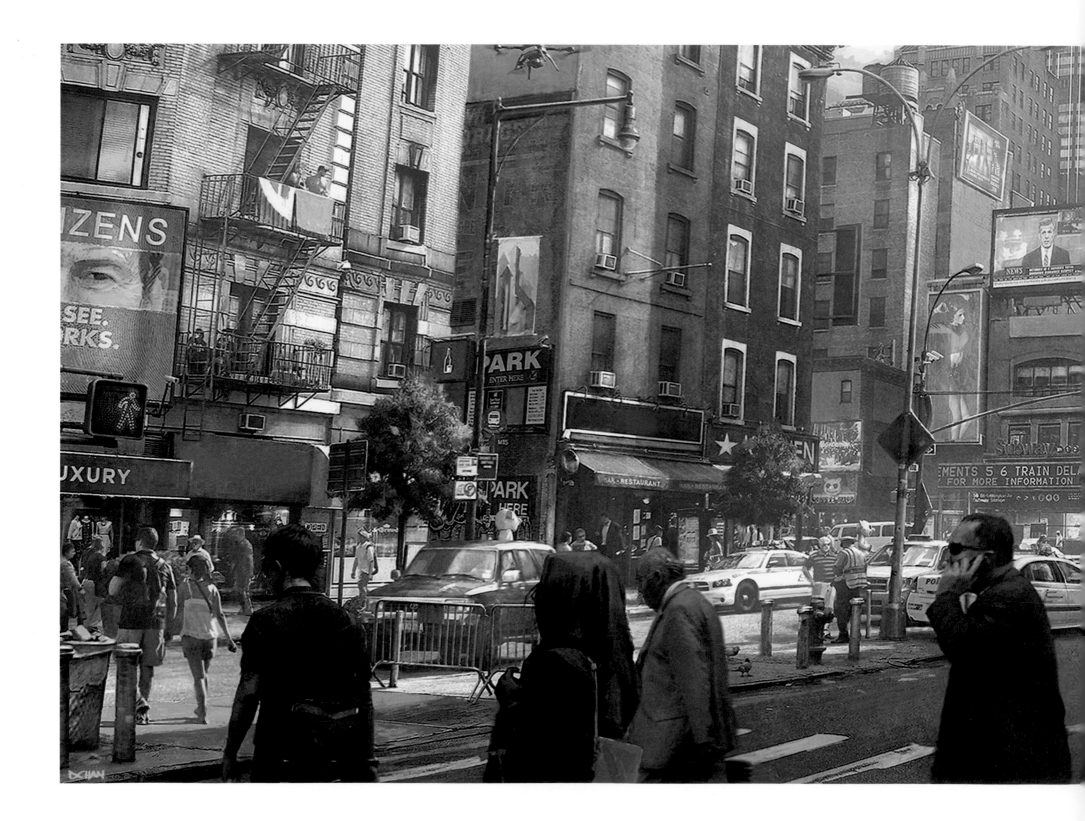

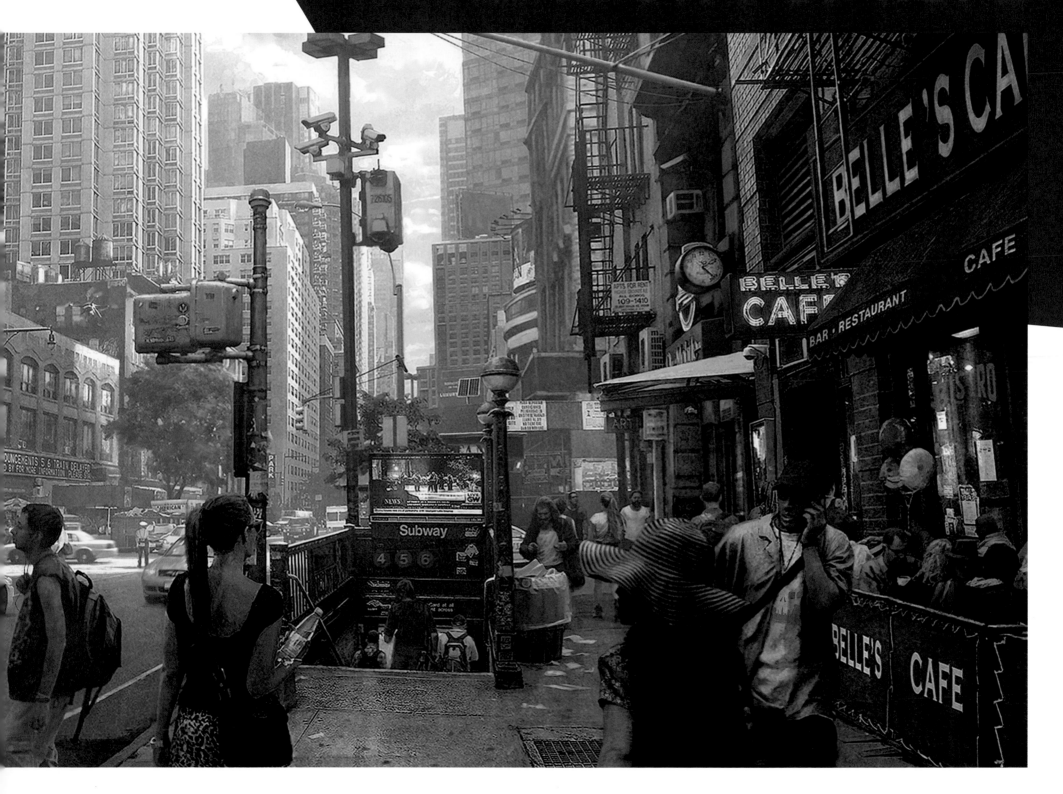

SPIDER-MAN

AN OLDER, MORE EXPERIENCED SPIDER-MAN.

Such a potent concept, never before realized in a video game, which Insomniac enthusiastically set out to explore. Working closely alongside the team at Marvel, Studio Art Director at Insomniac, Jacinda Chew, adapted her meticulous working practices to welcome one of the most iconic heroes in comic book history. "After discussing the early design with Marvel, I quickly realized that it's slightly different designing characters for a long-established franchise than for an original IP," says Chew. "We had to identify what classic details were necessary to remain true to the character, and then how to make it our own."

Speaking to this "extremely collaborative" relationship, Art Director Tim Tsang also states how those early stages were crucial from his position at Marvel Games. "There are probably only a few instances where we held our ground firmly," Tsang recalls. "The one that sticks out the most was the early design direction of the Spider-Man suit." The end result was worth it.

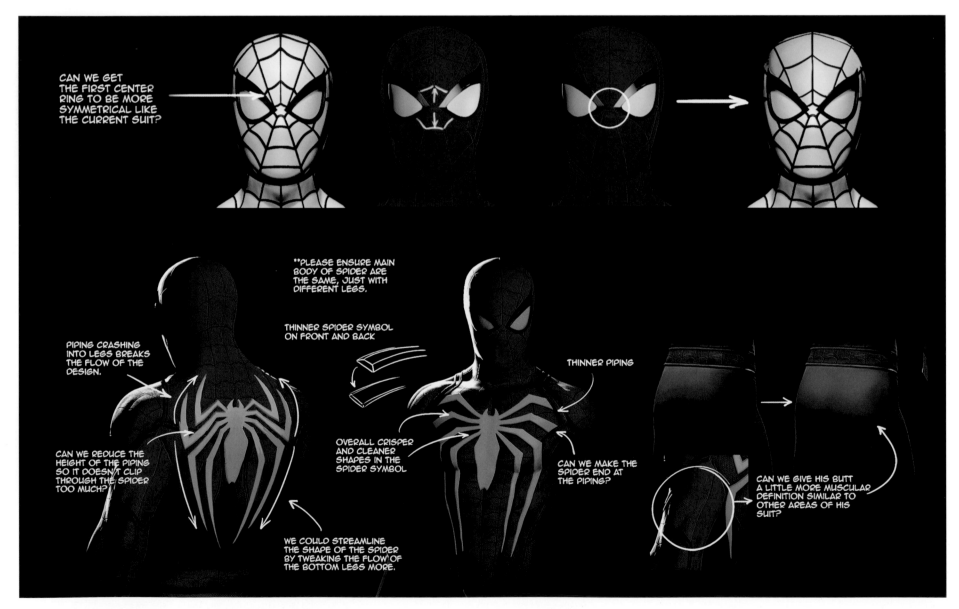

ABOVE: "The web always radiates from the center of the mask, and continues onto the red parts of the costume." Jacinda Chew / Design notations by Tim Tsang

"Our Spider-Man originally had the gangly frame of a young man. This briefly bounced to a football player's frame before we landed on more of a fighter's build. Riggers and character artists sculpted custom anatomy for any poses that didn't look good in the game."

Jacinda Chew

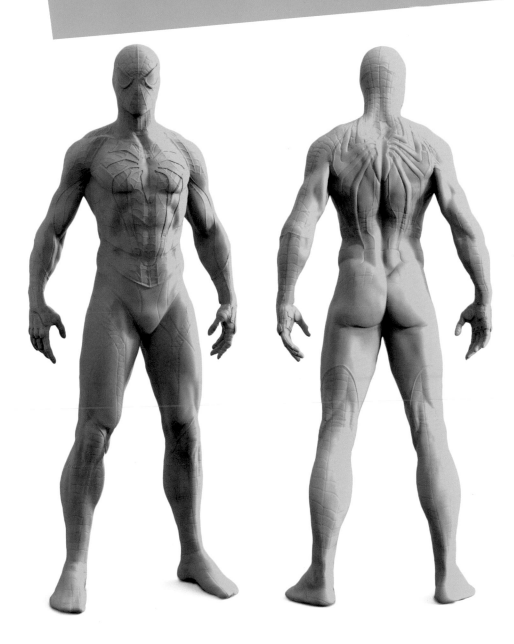

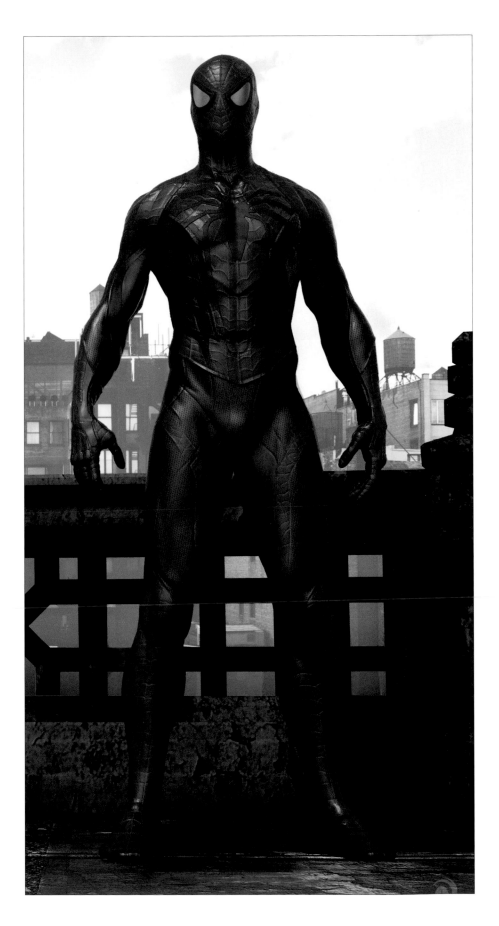

ABOVE: "This is an early concept sculpt of Spider-Man, which started it all. We ended up moving away from the heavy musculature of this version because he didn't feel sleek enough when he was swinging through the city." Jacinda Chew

EVERY NEW ITERATION OF SPIDER-MAN was scrutinized by the Insomniac art team to ensure the suit would dazzle from every angle. "Weeks would go by while we were playing the game with the newest suit before we would decide if we liked a change or not," says Chew. "I lost count of how many tweaks to color, anatomy, and design we did on the suit during that time, but we all ended up loving it in the end."

The white spider design was one concept that emerged from evaluation during gameplay. "The white spider design follows a lot of the paneling, so it feels modern, sleek and aerodynamic like the rest of the suit," explains Chew. "I thought about where one would really notice something iconic on Spider-Man, and concluded that since this is a third-person game you spend most of your time looking at Spider-Man from the back. Because of that, whatever iconic design element we used should be on his back. This is how the spider ended up being white." Another crucial, immovable factor was that the Spider-Man designed by Insomniac is twenty-three years old and visibly more capable than the high-school version seen in the comics.

"Think about an athlete," illustrates Intihar. "You see a change when they go from college football and basketball to the pros. Their bodies mature. Now they're training full-time, there's a level of mastery. Pete's been doing this since age fifteen. He's had eight years fighting villains. He's not a bumbling super hero anymore; he knows his powers, and now he's perfecting them. He had one coming-of-age story where he got bit by the spider and he got those powers. Our game is a second coming-of-age story—he's becoming a young adult."

"This isn't the rookie teenager of *Spider-Man: Homecoming*," informs Executive Creative Director at Marvel Games, Bill Rosemann. "While he still has worries and carries the weight of the world on his shoulders, he has the capabilities and confidence that comes from experience. This isn't Spider-Man's first rodeo, but if he doesn't dig deep and fight as never before, it just might be his last!

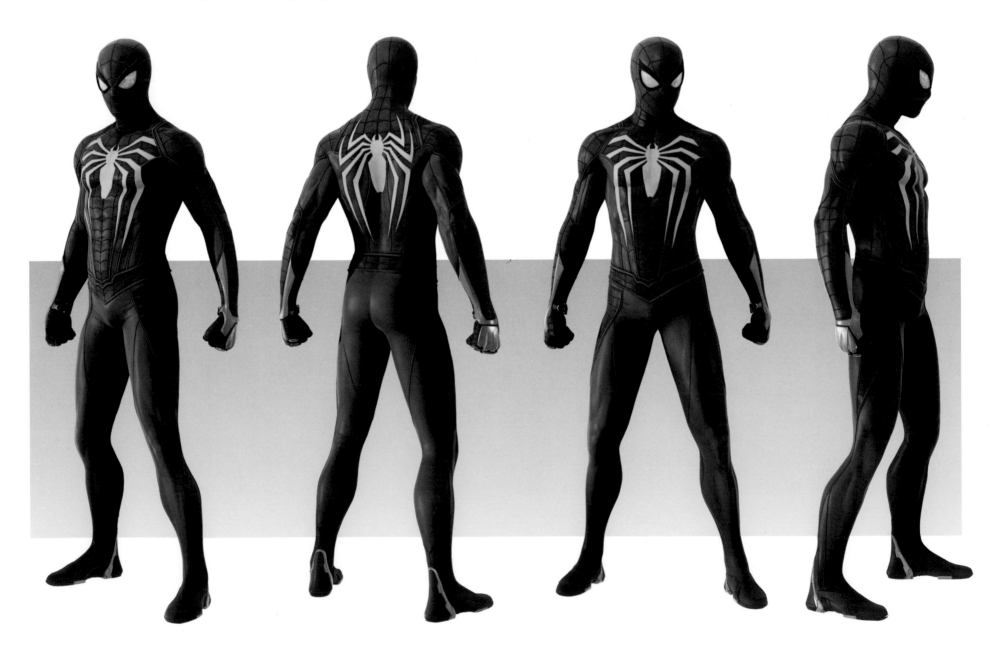

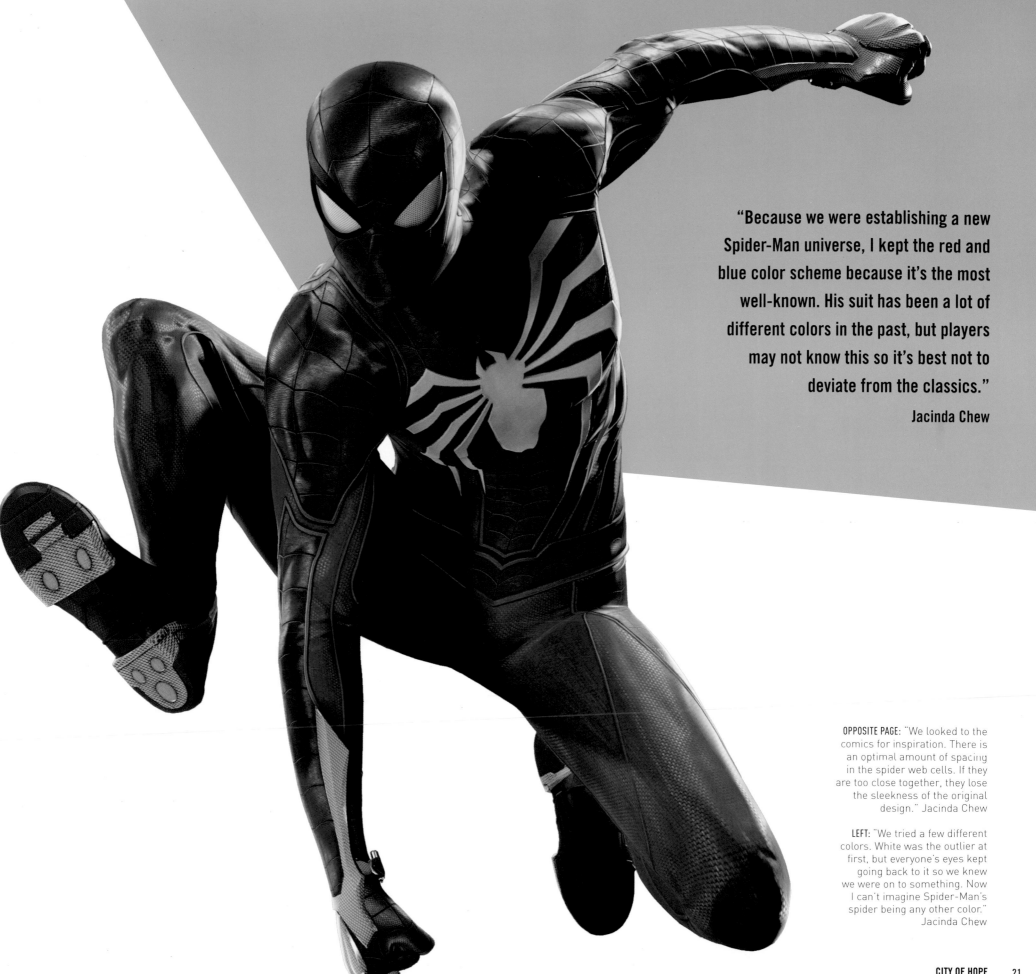

"Because we were establishing a new Spider-Man universe, I kept the red and blue color scheme because it's the most well-known. His suit has been a lot of different colors in the past, but players may not know this so it's best not to deviate from the classics."

Jacinda Chew

OPPOSITE PAGE: "We looked to the comics for inspiration. There is an optimal amount of spacing in the spider web cells. If they are too close together, they lose the sleekness of the original design." Jacinda Chew

LEFT: "We tried a few different colors. White was the outlier at first, but everyone's eyes kept going back to it so we knew we were on to something. Now I can't imagine Spider-Man's spider being any other color." Jacinda Chew

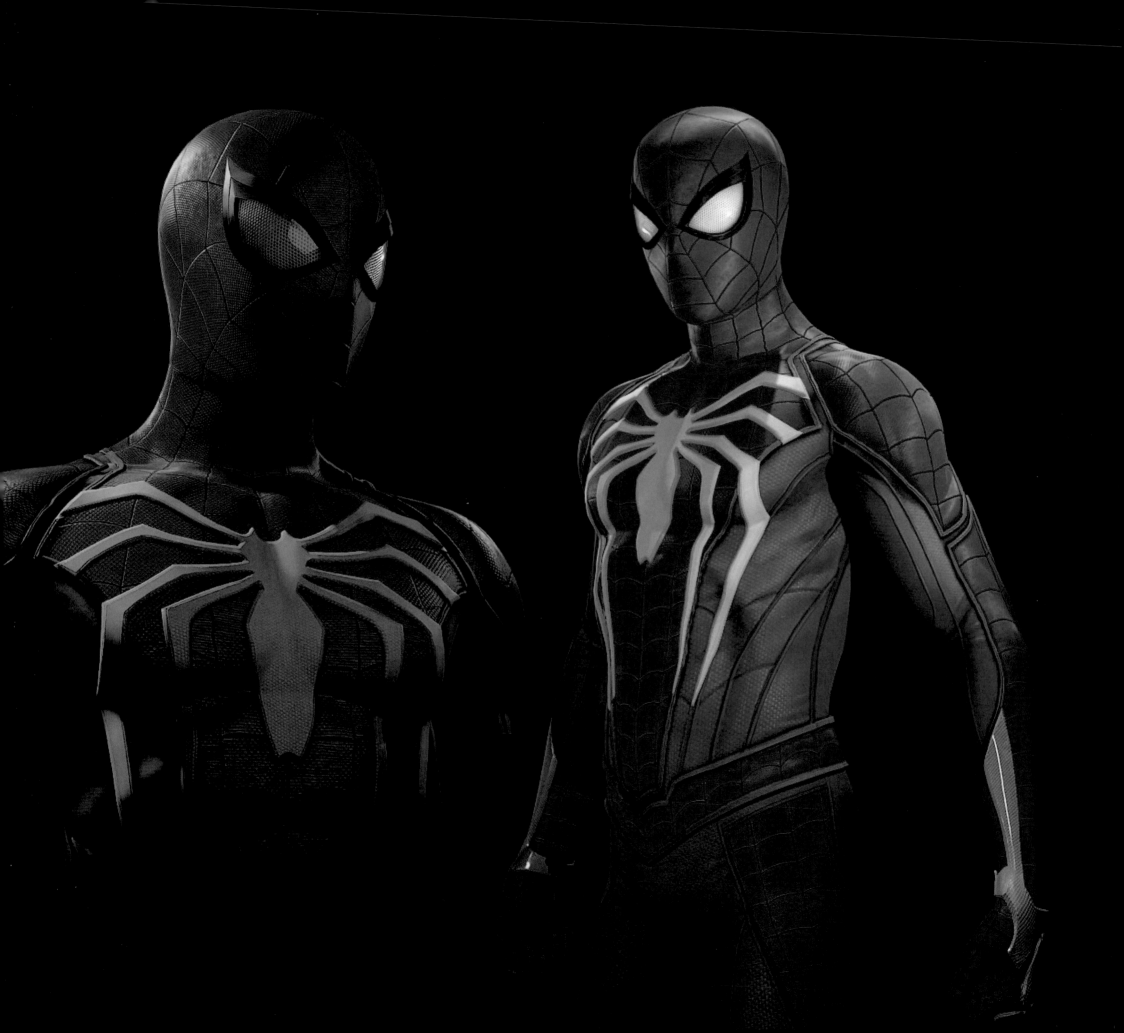

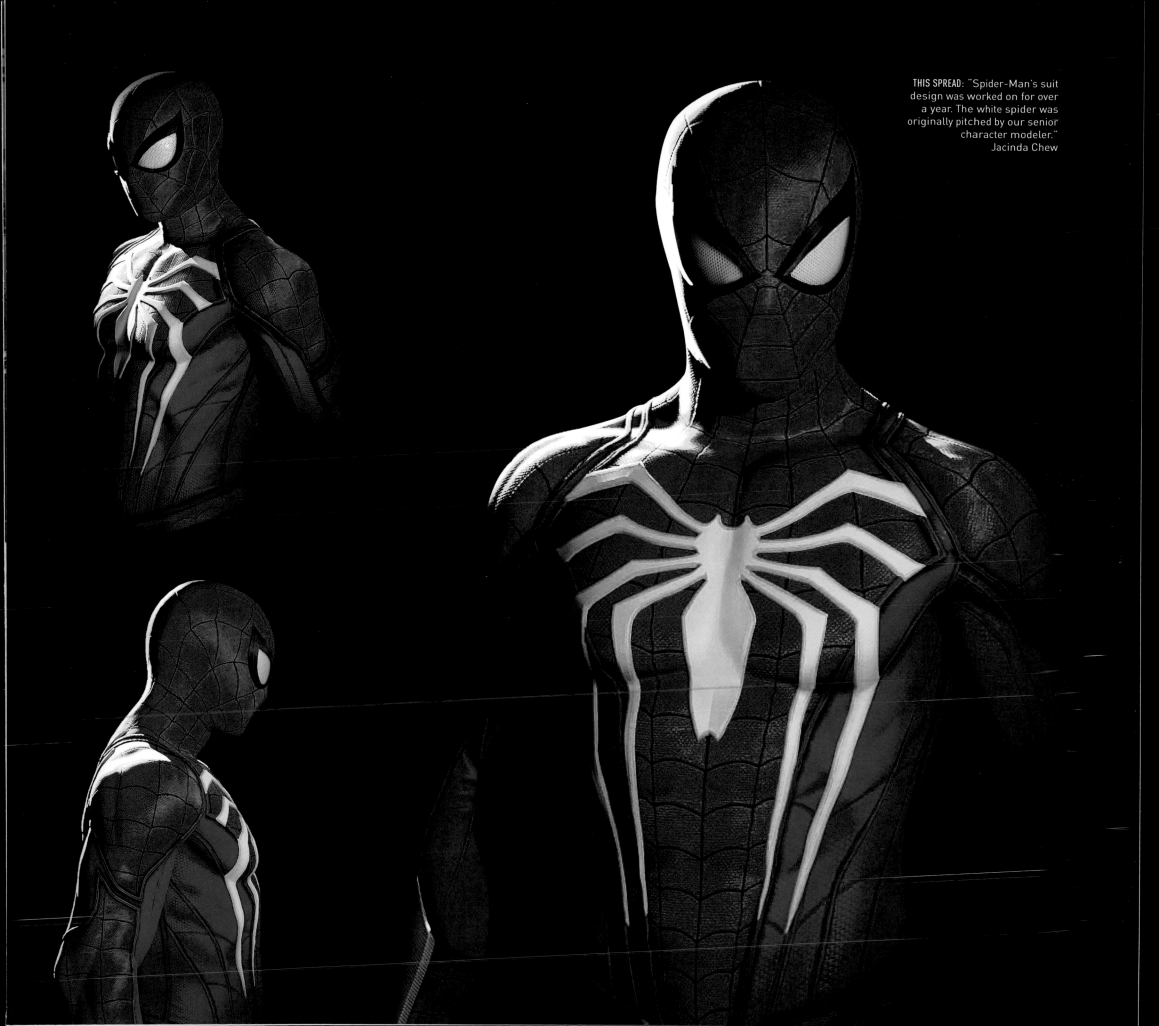

THIS SPREAD: "Spider-Man's suit design was worked on for over a year. The white spider was originally pitched by our senior character modeler."
Jacinda Chew

YURI WATANABE

THE FIRST APPEARANCE OF A noteworthy character is absolutely key, especially when Marvel fans know the bigger picture. Which is why the presence of honor-bound New York City cop Yuriko Watanabe in *Marvel's Spider-Man* feels so energized. For the purpose of this story, Spider-Man remains the solitary hero at the heart of the action, with Yuriko directing his missions. Spider-Man and Yuriko make an effective team, even if for Yuriko this isn't always ideal.

Says Goulden, "Yuri Watanabe is a hard-nosed cop who puts up with Spider-Man's antics. While we could have made her more of a bureaucrat or political type, we really wanted to dwell on her ability to get the job done on the front lines, and not be afraid to get her hands dirty. With this persona in mind, we focused more on the idea of a street cop, or detective, and what they might wear. Dropping typical police attire, and knowing she would never be in a suit, we opted to go for a more casual look that leaves her dressed for the job, but with a little more attitude than your average detective. For her hair, similarly, we wanted something that was practical and true to the comic version of the character. While we toyed with the idea of longer hair and different types of braids or ponytails, this shorter style stood out from other characters in the game and stayed true to the personality of the character."

"While we could have made Yuri more of a bureaucrat, we really wanted to dwell on her ability to get the job done on the front lines, and not be afraid to get her hands dirty. We focussed more on the idea of a street cop, or detective, and what they might wear."
Gavin Goulden

OPPOSITE PAGE: Yuri sporting no-frills jackets and short hair, highlighting her hard-nosed persona.

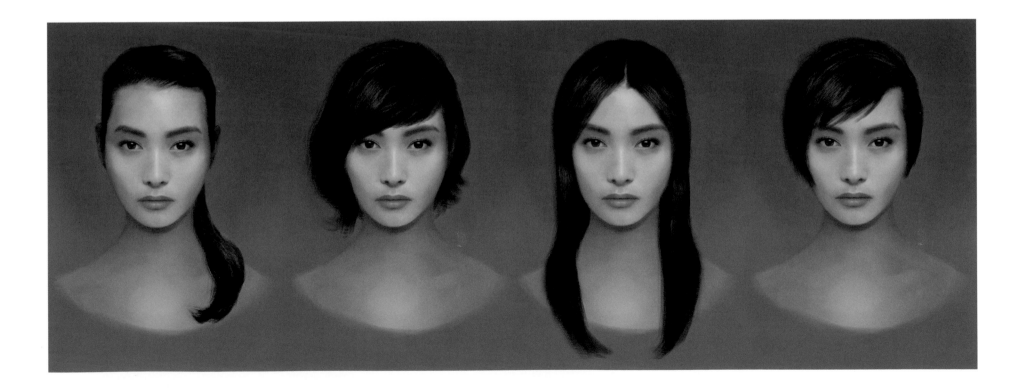

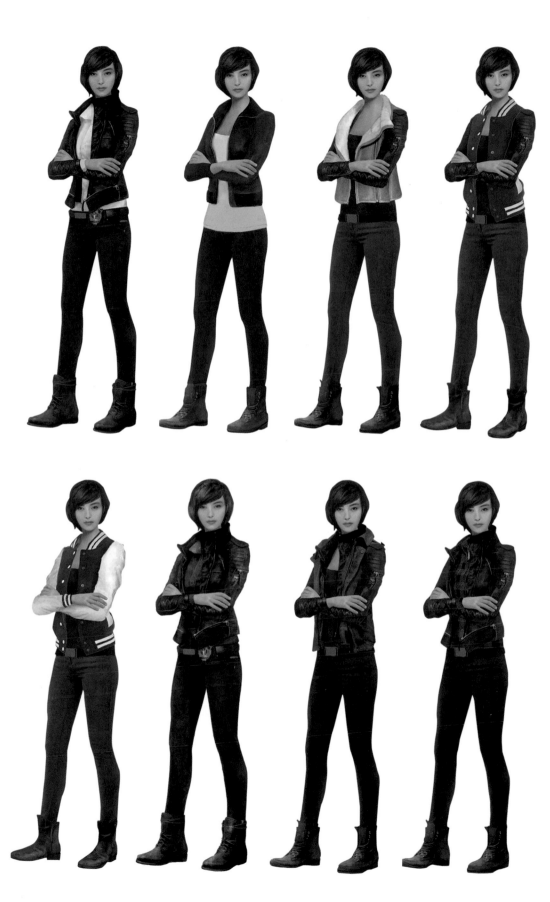
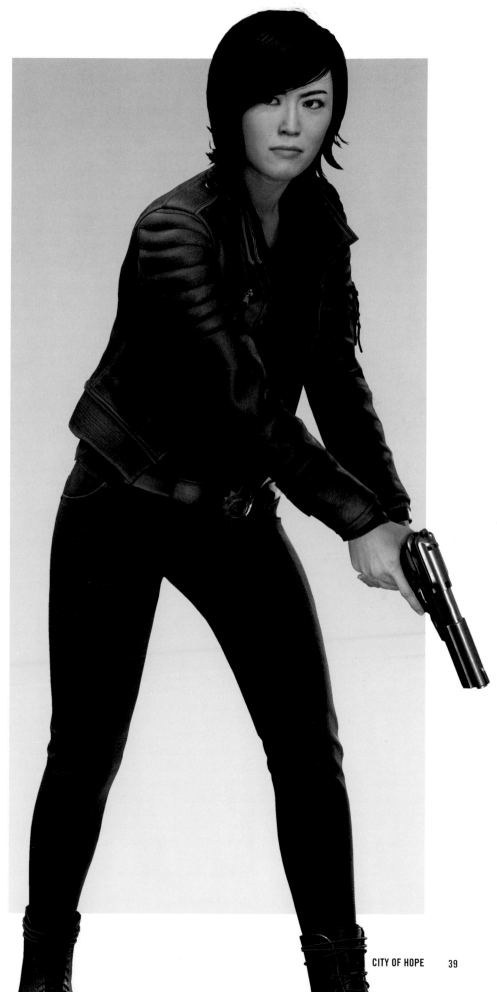

WILSON FISK: THE KINGPIN

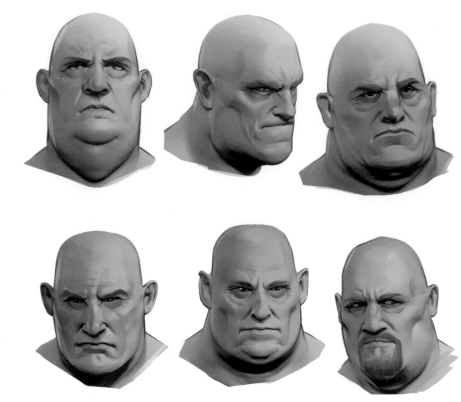

AS ONE OF SPIDER-MAN'S EARLIEST opponents, dating back to the 1960s, Wilson 'The Kingpin' Fisk is the epitome of the fictional New York crime lord: a towering, thickset specimen. Concept artist Daryl Mandryk had decades of reference material to inform his designs, and represent this most immovable of obstacles within the Marvel Universe. Owing to a similarly be-suited Super Villain sharing the spotlight in *Marvel's Spider-Man* (Mister Negative), there needed to be some distinction between not only the cut of their cloth, but the color.

"Most bosses have a certain color that is iconic to their character, like Kingpin's use of purple, which is purposely flashy and historically a royal color that he uses to flaunt his power. This is shown on his minions as a reminder of that fact," explains Gavin Goulden.

"Kingpin was a fun design challenge," recalls Mandryk. "Small changes in accessories and the cut of the suit have a big impact on the way he would come across. The white suit is his traditional look from the comics, but that would have visually competed with Martin Li (page 70) , so black became the better option."

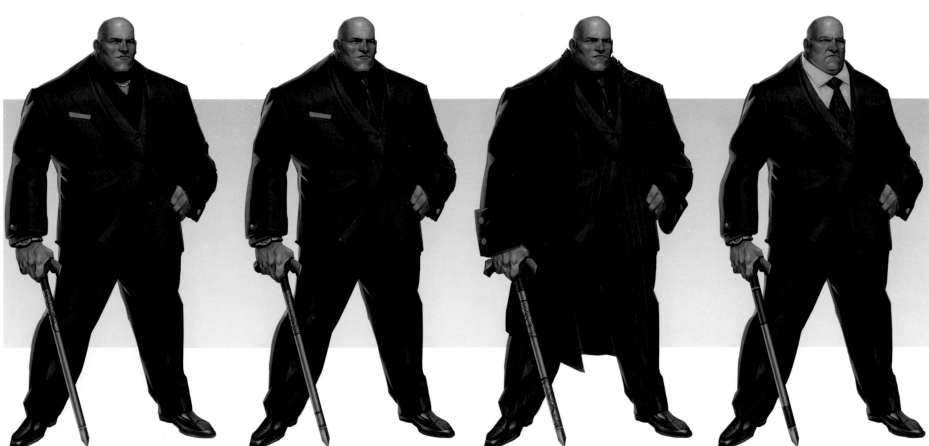

ABOVE: "I remember being partial to the fur and pinstripes—I thought it elevated him a bit." Daryl Mandryk

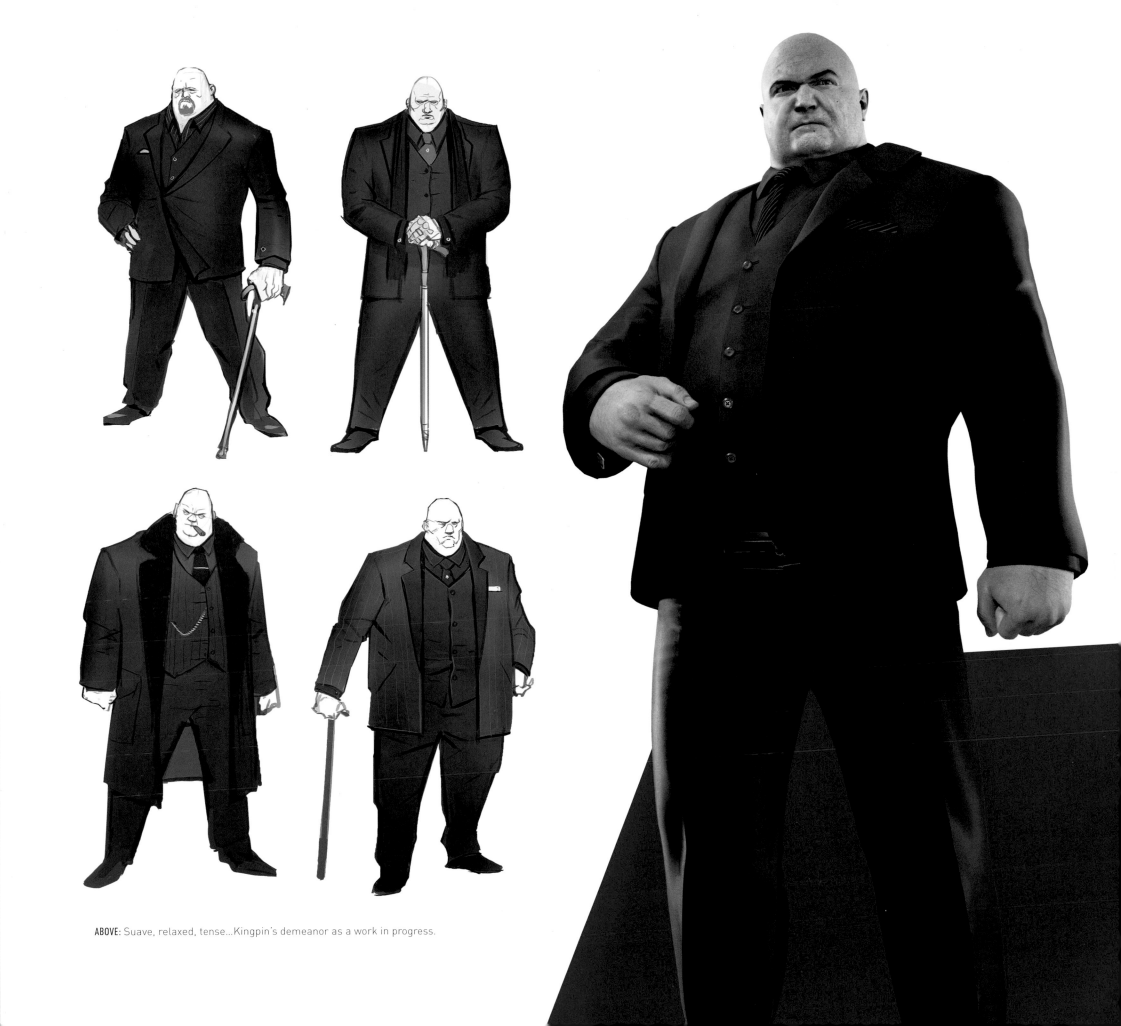

ABOVE: Suave, relaxed, tense...Kingpin's demeanor as a work in progress.

FISK TOWER

HE MAY BE A MOBSTER, but Kingpin likes to show off his good taste, and he can pay the right people as much as they need to create the desired effect. Upon entering Fisk Tower it is clear that its owner is established, and likely unassailable—and woe betide any fool who dares scratch at the façade. There is a municipal sense to the establishment which would feed Fisk's enormous ego, while hiding the organized crime network, and its proceeds as they pour into the vaults.

"Fisk Tower's interior reflects Kingpin's personality," elaborates Jacinda Chew. "In the comics, he has long had a connection and appreciation of Japanese culture. His office has Japanese art and the landscaping has a zen feel. The interior architecture is grand, and features heavy pillars and dividers. It is traditional to reflect his public persona as an upstanding citizen and successful businessman. At the same time, both the interior and exterior is heavyset and imposing—like the man himself."

Of course, Spider-Man sees that Fisk Tower is rotten to the core, and almost certainly revels in the opportunity to break what he cannot pay for. It's the perfect scene for a showdown, though when the action gets heated, the concept artists must be mindful of the audience that *Marvel's Spider-Man* is catering for. Think of the movies, and the way that the action is choreographed; the threat levels are artfully contained. The same applies to *Marvel's Spider-Man*—there can be monsters but it's not a horror show.

Dennis Chan describes the understanding between Insomniac and its freelance contributors: "I try not to have limitations when I present my stuff initially, whether it's games or movies. I let the client say, 'Oh, we can't have this.' Which sometimes happens to me, actually. I take the freedom I'm given and express myself as realistically as possible. The limitations given to me for Spider-Man are: it's a super hero game, it's Marvel, so violence cannot be gory."

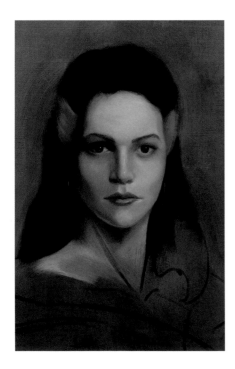

ABOVE: Portrait of Vanessa Fisk.

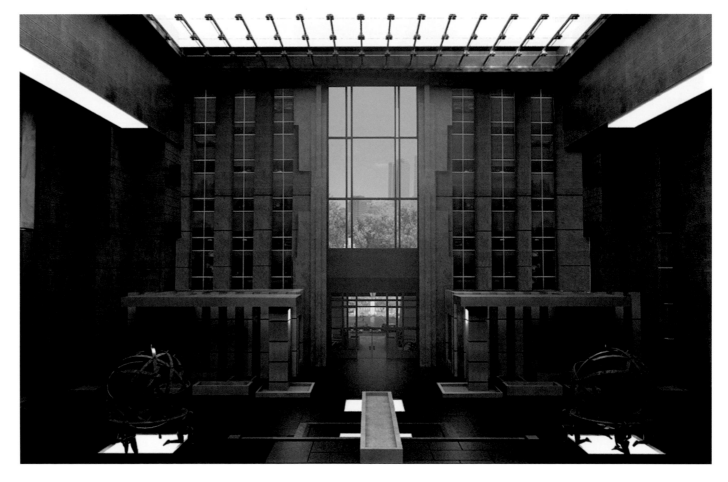

ABOVE: Each art installation is worth more than the average apartment in New York City.

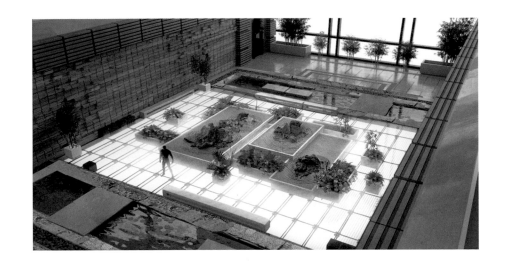

"Fisk Tower was personally my favorite thing to work on. We really wanted to start the game off with a bang! To do this, I borrowed from Fisk's massive physique and his love for Asian culture to create grand, intimidating spaces with elegant Japanese details."
Nicholas Schumaker

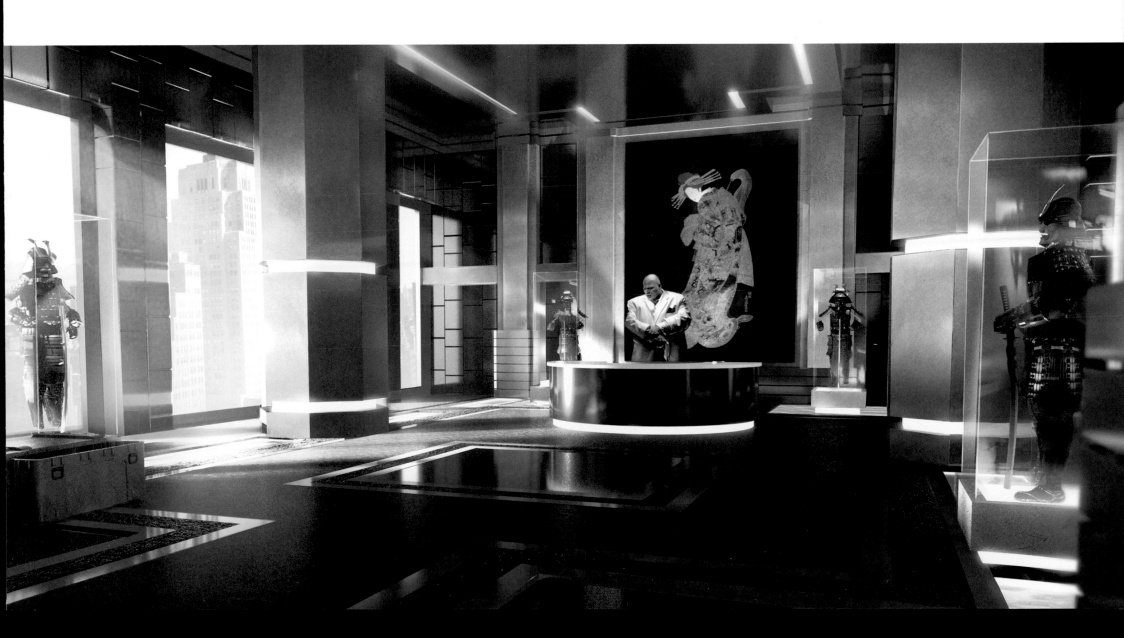

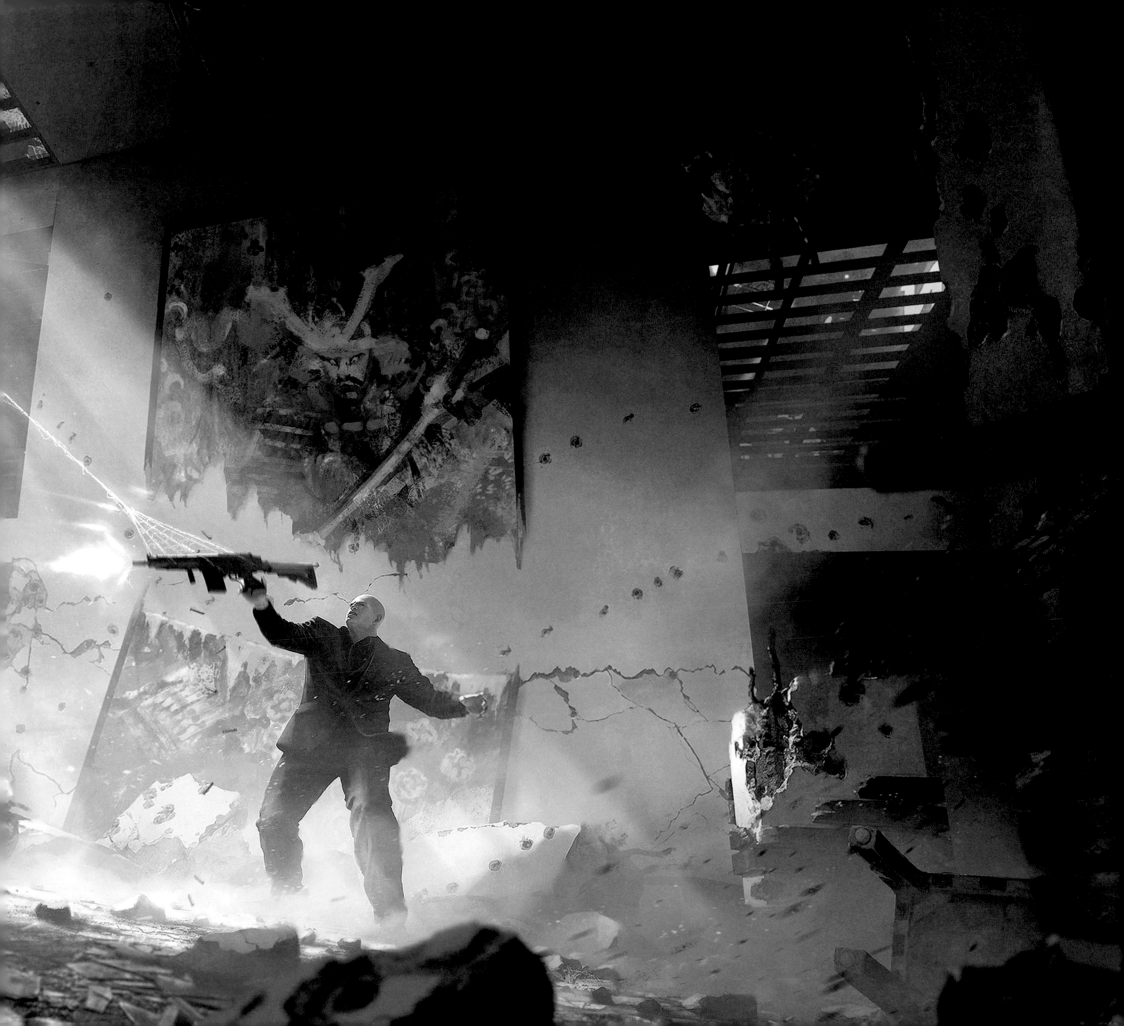

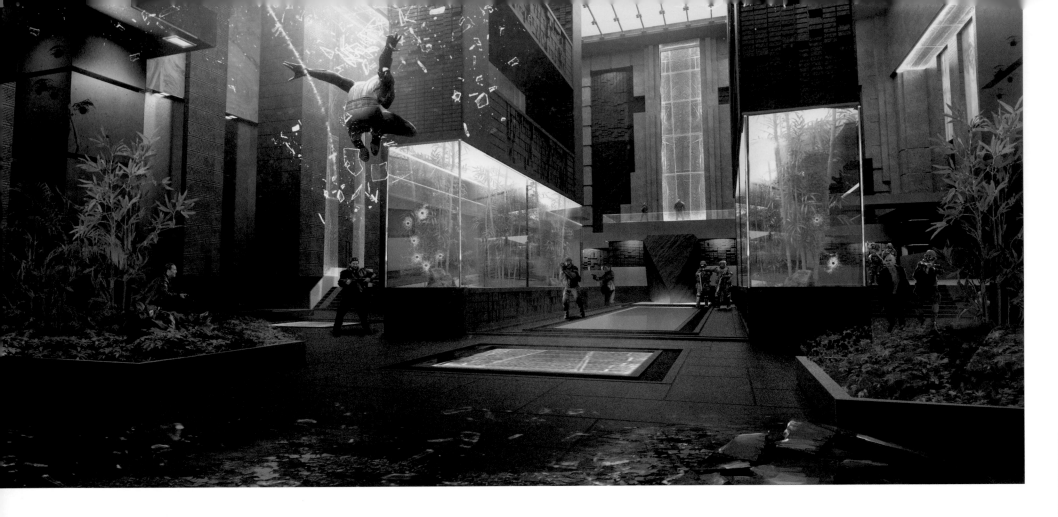

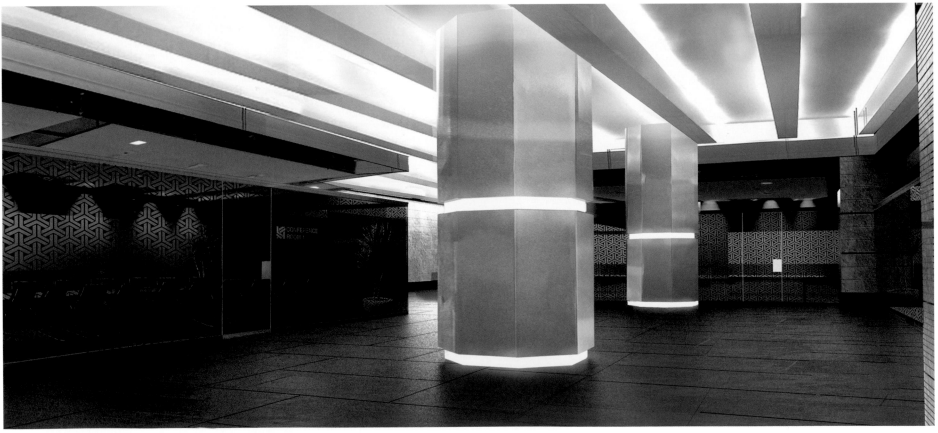

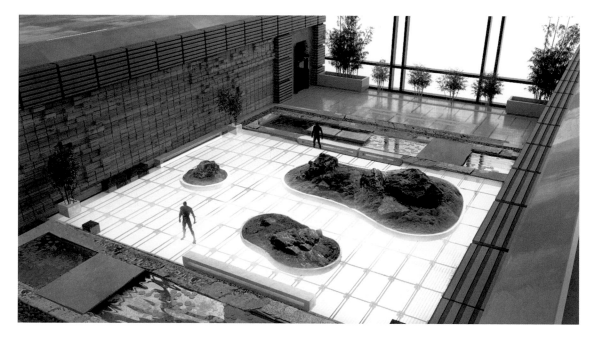

"We kept the planting and architecture clean and simple to reflect a Japanese aesthetic, even though the style is Western."

Jacinda Chew

LEFT: "We tried different ideas for breaking up the space using indoor garden elements." Jacinda Chew

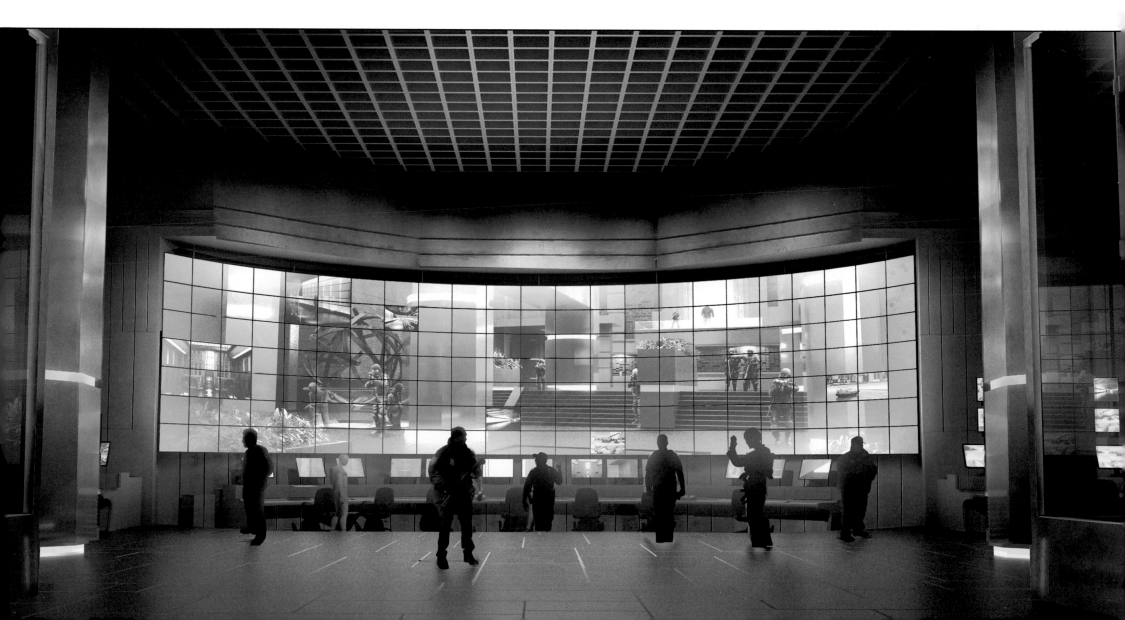

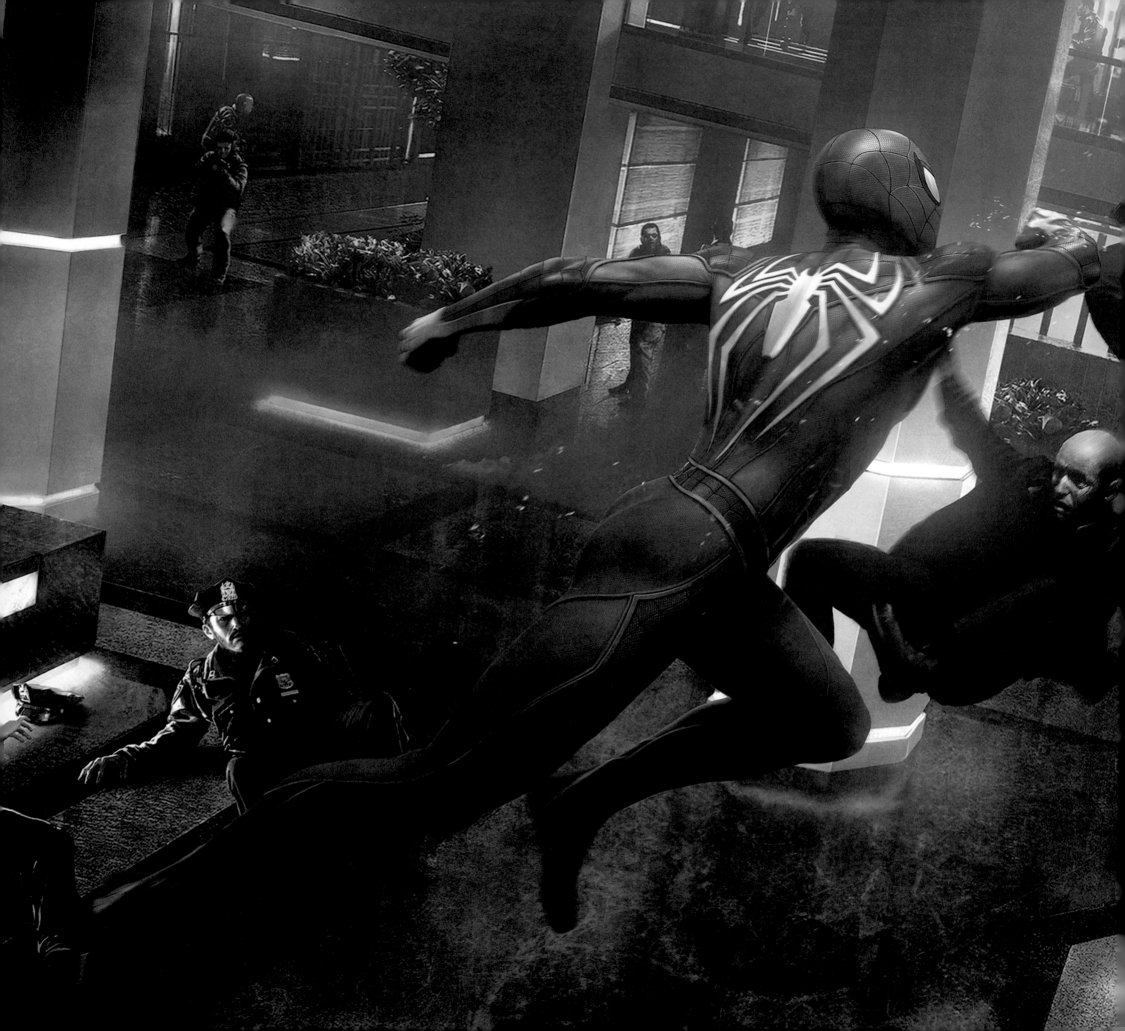

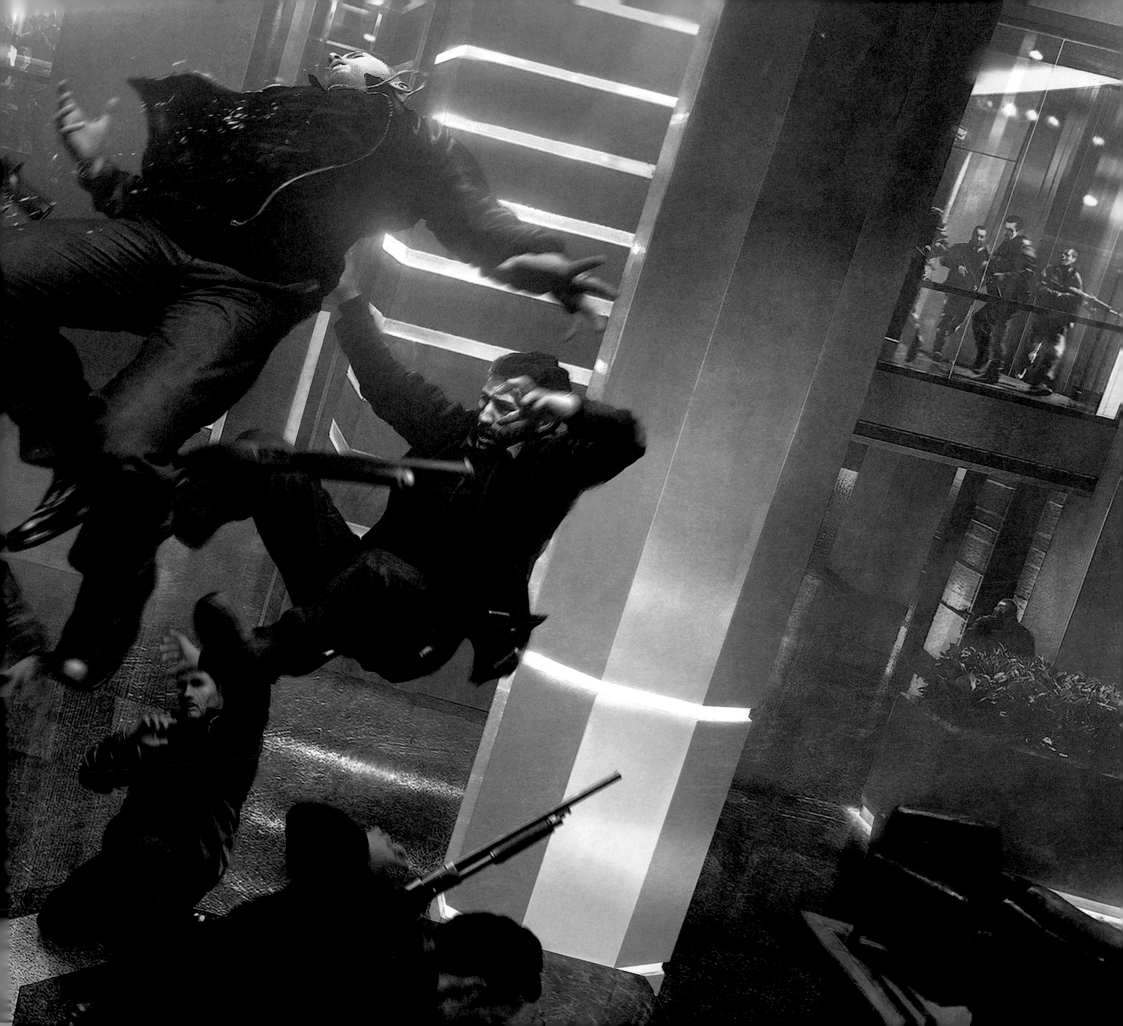

OTTO OCTAVIUS

INSOMNIAC'S APPROACH TO OTTO OCTAVIUS points to the encouragement received from Marvel. According to Bryan Intihar, the golden rule with Marvel was, "Be respectful of the characters in the franchise." Beyond that, "If you want to try something different and you have a good reason why, we'll hear it. Peter working for Otto, that has never happened before. Marvel embraced it because we had a good narrative reason why."

Intihar quotes celebrated writer Dan Slott as inspiration for the direction taken with all the villains featured in *Marvel's Spider-Man*. Slott said, "The best villains are the heroes of their own story." For Intihar, this means, "Everything starts with story.

We didn't want villains who wanted to destroy things for the sake of destroying things. We didn't want the mustache twirling, two-dimensional villains. It's one of the reasons why we chose Otto Octavius for the game."

Says Gavin Goulden, "It was extremely important for us to make every villain in the game as well thought out as our hero. We had to look beyond just making something cool for the sake of it, and dig deeper into why a character dresses the way they do, and what story we were trying to tell with them visually. In order to do that, we went through many iterations that considered the function of the villain and how they would fit into our universe."

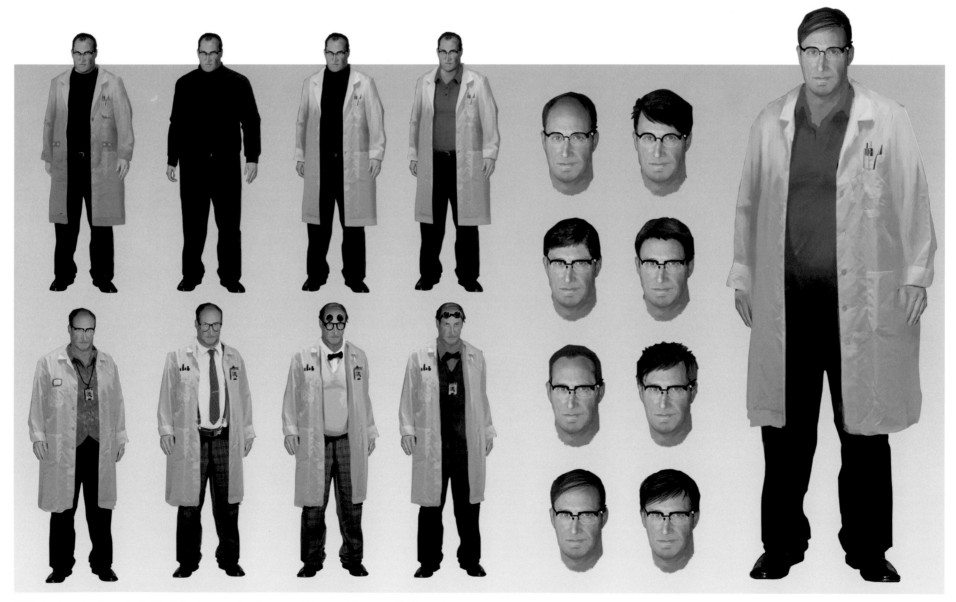

ABOVE: Various treatments of Otto Octavius, ranging from possibly too sinister to affable professor.

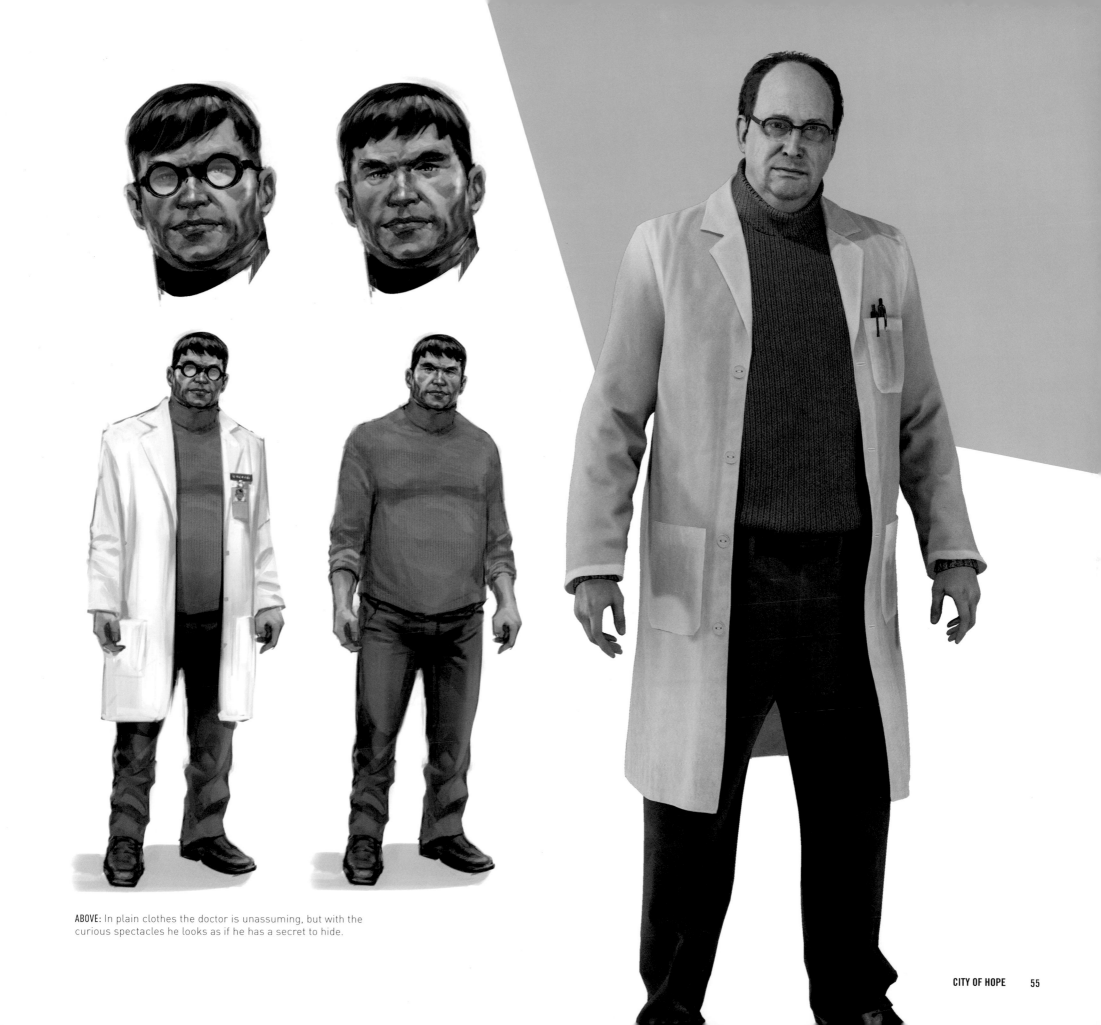

ABOVE: In plain clothes the doctor is unassuming, but with the curious spectacles he looks as if he has a secret to hide.

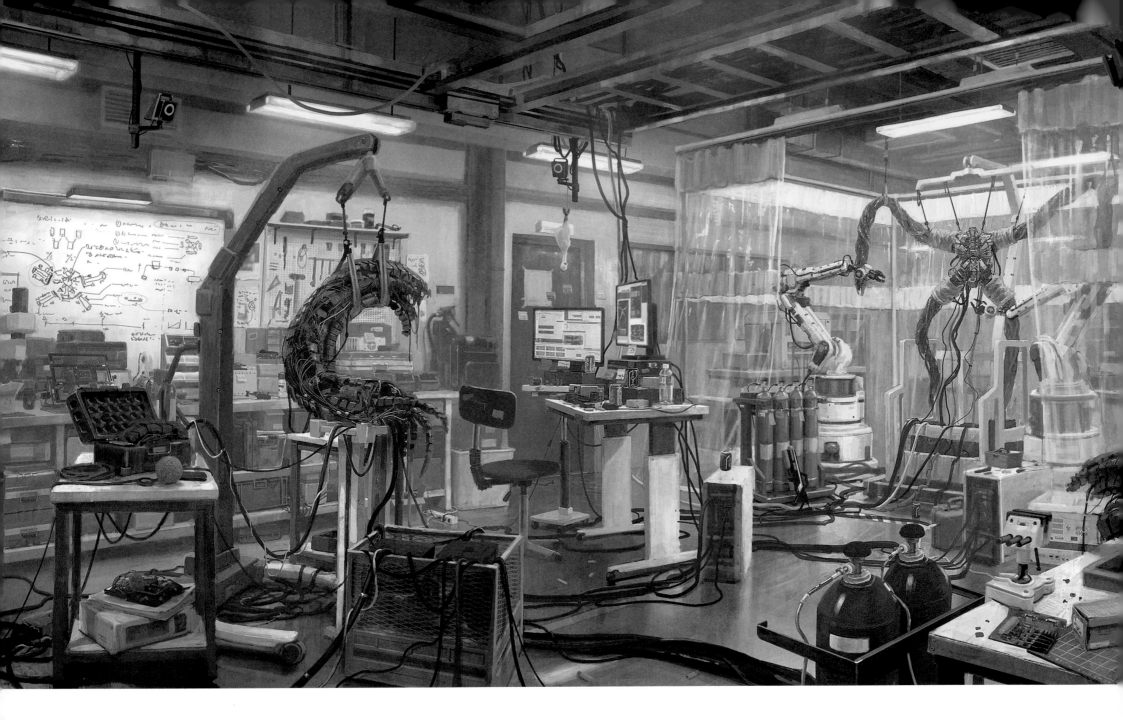

OCTAVIUS INDUSTRIES

WE CAN CLEARLY OBSERVE THE important contribution made by the concept artist on these pages, featuring the work of Dennis Chan. When imagining a laboratory, the majority of us would picture a sparse, sterile environment, with severe white lighting, a uniform layout comprising familiar apparatus, all spick and span. This would be the catch-all solution to serve any kind of story, something you might use for a school play: bench, whiteboard, microscope, guys in white coats: done.

In order to describe Otto Octavius, however, Chan reached for ideas that were less conventional.

"The idea we wanted for Otto's lab was to have the look and feel of a garage setup, and be more like a personal weapons tech lab then a bio/chemical lab," says Chan. "The layout and elements should reflect Otto's personality, but also the friendly relationship between Otto and Peter. Peter considered Otto to be his mentor, so to

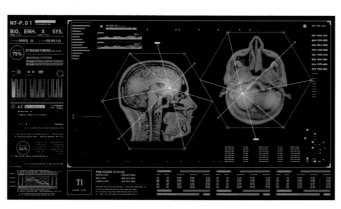 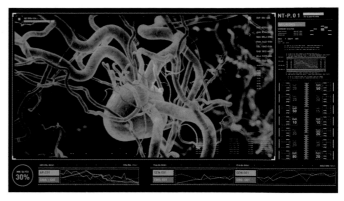

ABOVE: We could perceive this as positive scientific research for the benefit of all mankind.

ABOVE: Notes scribbled on random surfaces, spectacles in the foreground—a busy mind at work.

support that idea we wanted to present the lab as bright, colorful, and welcoming."

This is a workshop, a place where Octavius' almost casual brilliance is displayed through devices in various stages of completion, potentially hazardous elements always within reach and underfoot, but with evidence of playful genius in the form of a rubber chicken strung from the rafters. There's not a great deal of forethought; it's very spur-of-the-moment smarts.

"My work involves the subtle things you don't notice, but that support the overall look and feel of the shot. I love to show realism in my work, but still I try to keep it organic—loose and oily."

Dennis Chan

MARY JANE WATSON

FURTHERING THE MANTRA THAT STORY comes first, Marvel Games Art Director Tim Tsang is swift to point to the writers at Insomniac—led by Jon Paquette and Bryan Intihar—as playing a huge role in what Tsang describes as, "Wonderful new takes on characters and their story arcs."

Bill Rosemann, Creative Director at Marvel Games, helped unify the two teams regarding Mary Jane Watson and Aunt May; both are very different characters to those we have encountered before.

"From day one, the teams at Insomniac and Marvel quickly bonded over the fact that without these two strong individuals in his life, Peter cannot be the hero he must be to save his city," says Rosemann. "When creating our Aunt May and Mary Jane—as with all of the characters—we searched through the source material of their history and focused on the characteristics we admired the most. In many modern stories Mary Jane has displayed her spirit, intelligence and tenacity, which we're expressing through her passion to be a crusading reporter for the *Daily Bugle*. While she may get in tough spots that require teaming up with Spider-Man to escape danger, she is no damsel in distress. Our Mary Jane has clear purpose and

> "We are really happy with how Mary Jane turned out. Our interpretation of her is of a young, attractive and stylish woman, who is also charming, approachable, charismatic, and definitely capable of handling herself."
> Tim Tsang

her agency is pivotal to Peter's evolving sense of self."

"When you become a young adult you have to learn how to trust other people, and that's something that Pete is going to go through with his relationship with MJ," explains Intihar. "Peter and MJ are at odds, they have a hard time understanding how they are supposed to act around one another. MJ wants to be on the front line, she's tired of having Peter rescue her. Whereas Peter wants to know, 'Why are you always putting yourself in danger? I am always going to help you.'"

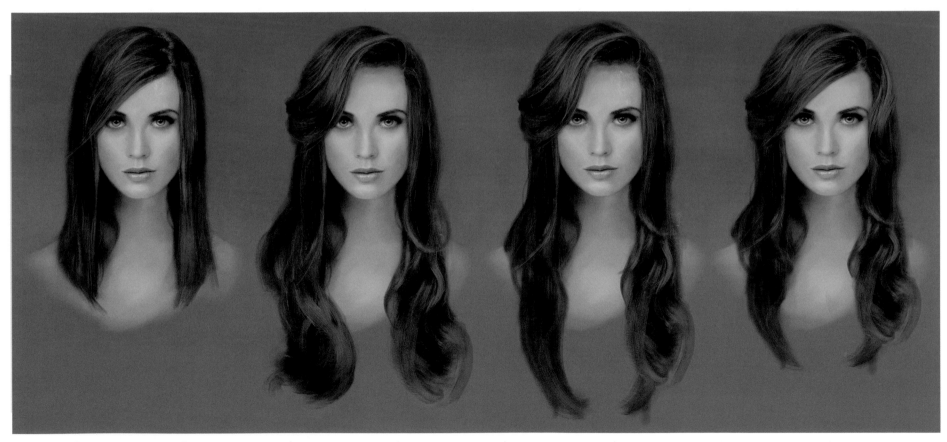

ABOVE: MJ boasting confidence, conveyed by a bold facial expression.

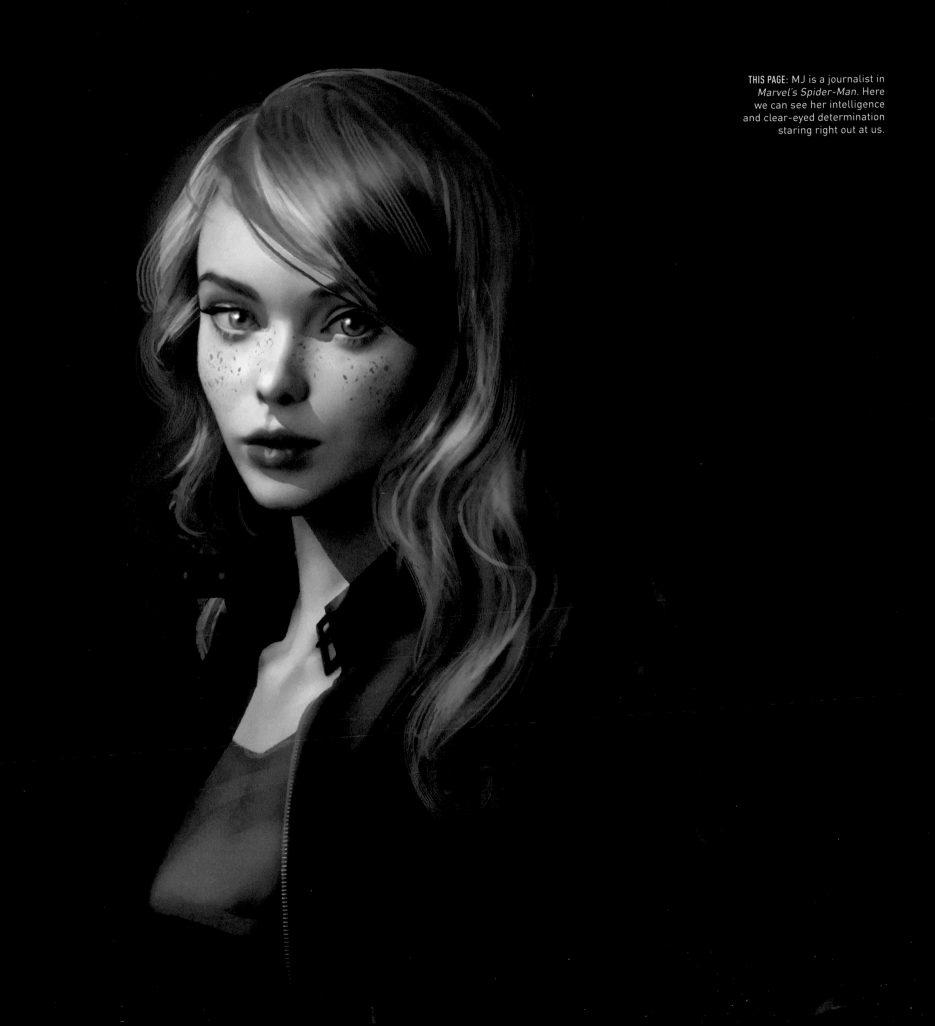

THIS PAGE: MJ is a journalist in *Marvel's Spider-Man*. Here we can see her intelligence and clear-eyed determination staring right out at us.

"WE WANTED MARY JANE TO be a realistic, aspirational character who was becoming a successful journalist," says Goulden on aligning Mary Jane Watson to the story, and the thematic approach chosen by Insomniac. "Throughout the story you will see MJ prove to be strong and effective on her own, while also being a pillar in Pete's life—realizing that he needs the help of his friends to be truly great. While creating Mary Jane we wanted to hold on to elements of the past that make her an iconic character.

"At the same time, we wanted to give MJ a unique look by building an extensive wardrobe that matches her functionality during gameplay. This not only adds diversity to her character, it also gives some foundation to how she operates. For example, while being a journalist she will wear an outfit in line with modern New York fashion, with layers to hold her equipment, and support for physical objects to give her secondary motion while running through the levels. In addition to that, we also have more casual looks for interior cinematics that better reflect what she may be wearing while at home, and more bundled-up outfits for times where she may be sneaking around or not wanting to stand out too much."

"For character design it's always helpful to keep in mind the characters' history and where they come from. With *Marvel's Spider-Man* it's more a case of making sure that nothing in their visual design places them outside New York City."
Daryl Mandryk

OPPOSITE PAGE: Outfits for all occasions, usually linked to the latest assignment. Always identifiably NYC.

BELOW: Concept art of the restaurant where MJ and Peter share a night of recollections.

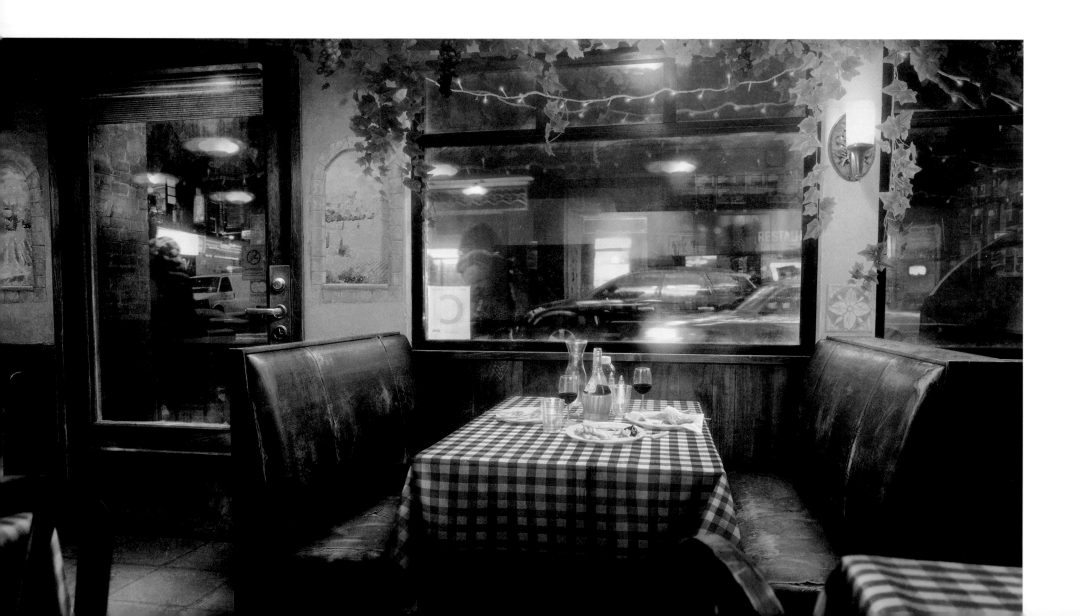

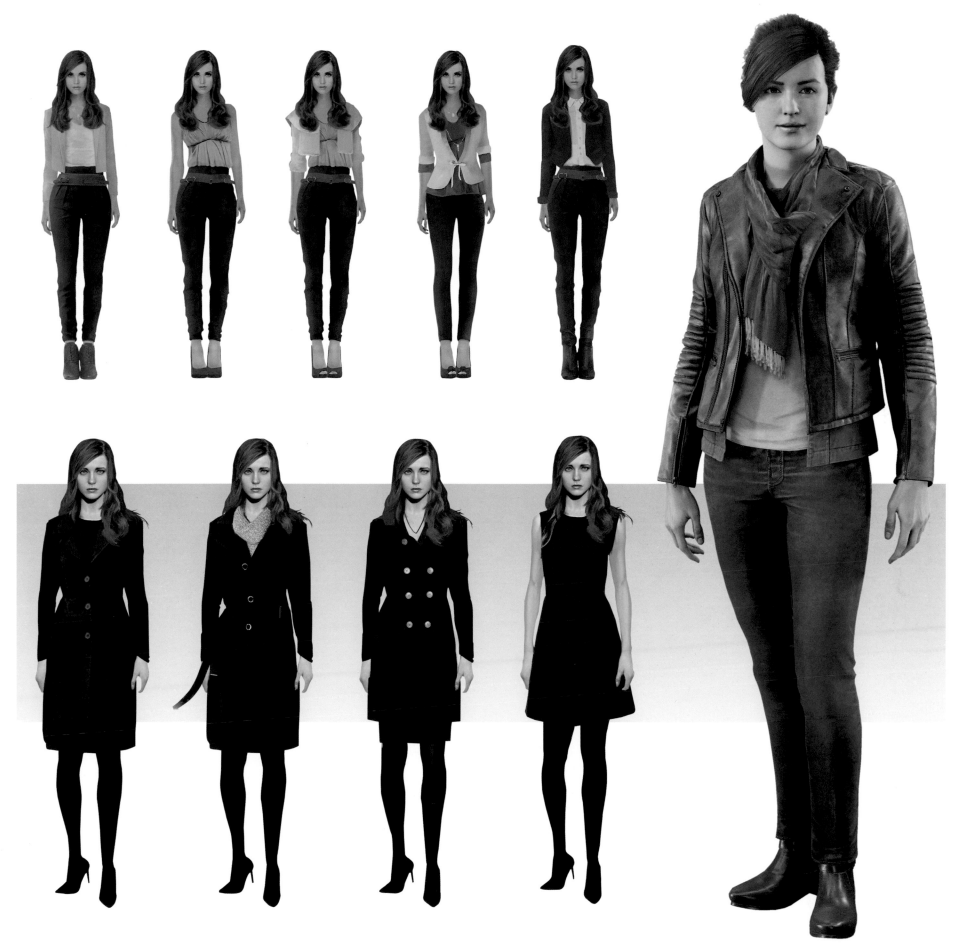

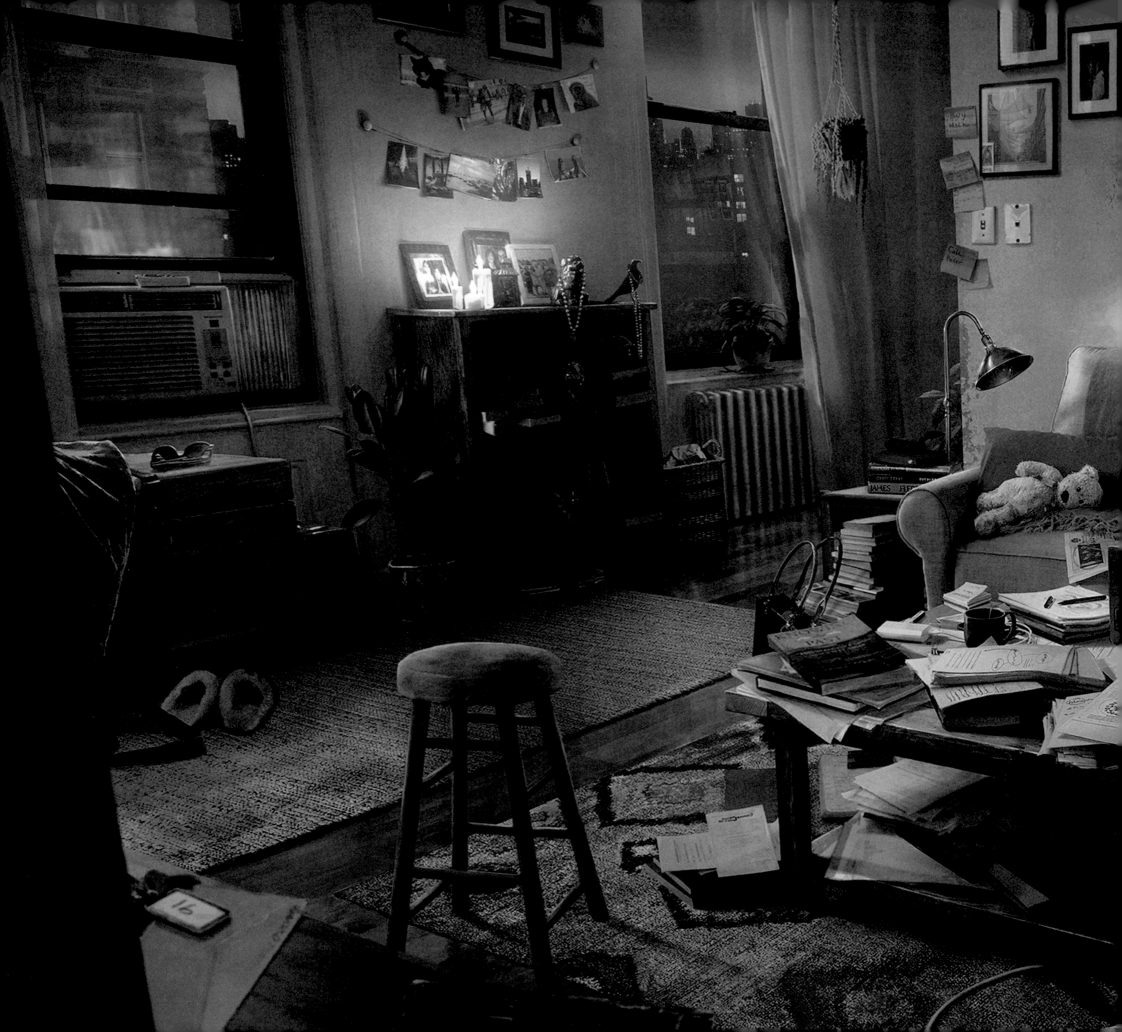

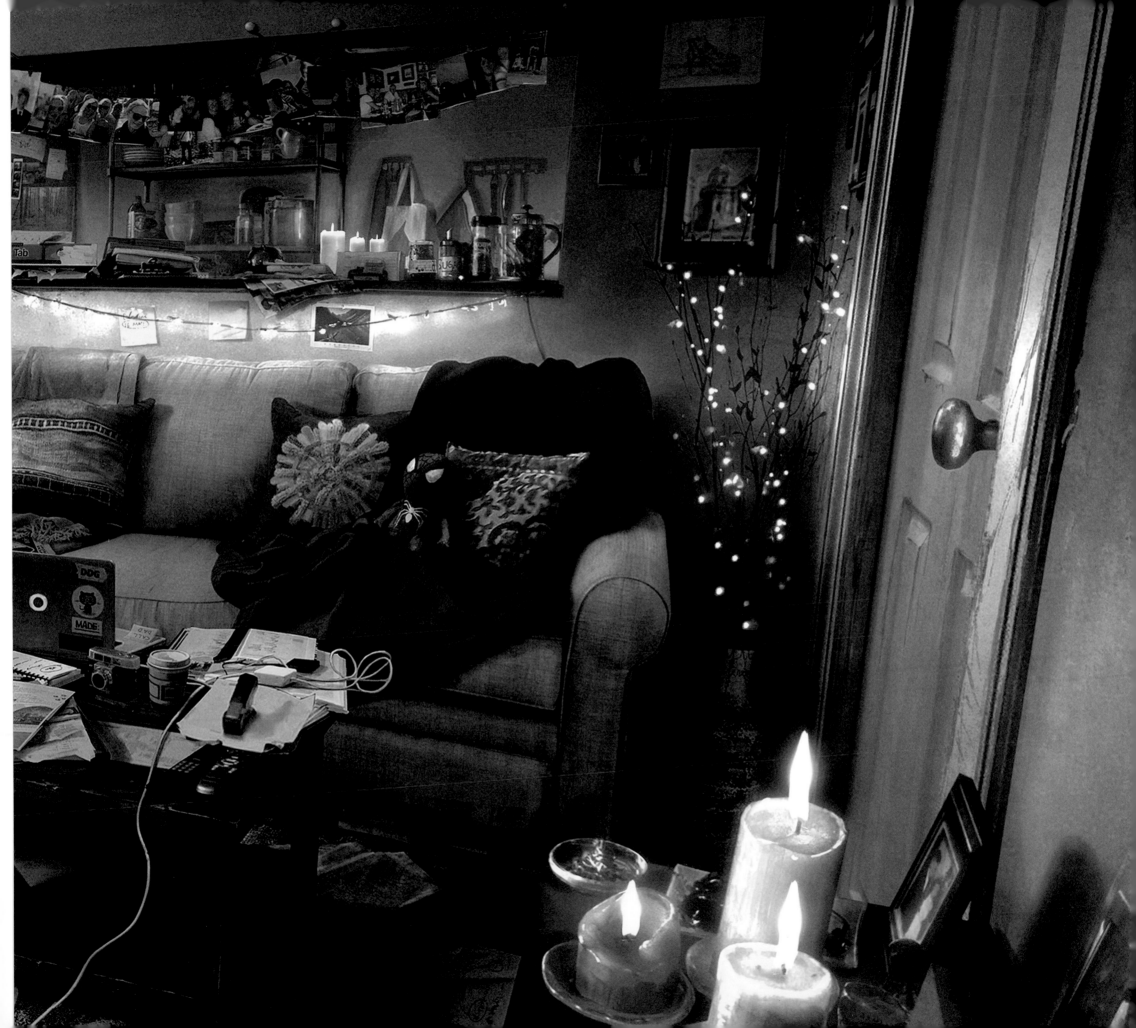

F.E.A.S.T.

THROUGHOUT *MARVEL'S SPIDER-MAN* WE ARE constantly having our eyes trained to see the whole situation, from all sides; to consider the impact, the echoes of what may not be apparent until much farther down the line. At the homeless shelter where Aunt May (and later Miles Morales) works for Martin Li, worlds collide, lives drastically change, and fates are decided. It's remarkable that a place we initially perceive as a humble retreat for the weak and powerless becomes the proving ground for the story's mightiest and most influential.

Explains Jacinda Chew: "F.E.A.S.T. is the passion project of Mr. Li, and Aunt May is a volunteer there. Peter and Spider-Man's worlds collide when he discovers that Mr. Li is in fact Mister Negative. The place itself was styled after a re-purposed gym. Aunt May and Mr. Li both have offices inside that reflect their personalities. F.E.A.S.T. is one of the few places that Peter and Spider-Man return to in the game. It holds a special place in many characters' hearts and has a positive effect on many characters in the game."

In order to visualize F.E.A.S.T., concept artist Dennis Chan received a brief from Chew, setting the scene and summing up the desired effect. From just a handful of words, Chan would create something as emotionally rich and detailed as the concept images seen on the following pages. These concept pieces are a huge help to the game designers as a way to visualise the various gameplay spaces. Chan's briefing from Chew reads:

"Martin Li (Mister Negative) is a philanthropist by day and runs a series of homeless shelters called F.E.A.S.T.. Aunt May works at one of them. The homeless shelter might look a bit like the hospital, so we should try to differentiate them.

For example, since F.E.A.S.T. is obviously well-funded, things will probably look more institutional."

"F.E.A.S.T. doubles as Aunt May's living room, as Pete often drops by to visit her throughout the game," says Chew. "As a college graduate who has moved out of Aunt May's house, it has also become Peter's second home. It allows the player to experience Peter's relationship with his aunt as she gives him advice about life. Many of the F.E.A.S.T. residents know him and will greet him as he walks in.

"As Peter and Spider-Man's worlds become increasingly entangled, Peter will discover that there is more to Mr. Li than initially meets the eye," Chew divulges. "Mr. Li's office looks like that of a typical businessman, but there are also touches that showcase his background. He has won many awards, and has an interest in Chinese history. There is also a picture of a young couple displayed in an ornate cabinet. I want the player to wonder who they are and why they occupy such a prominent place in Mr. Li's office."

She continues: "At some point in the story, F.E.A.S.T. becomes a makeshift hospital. We imagined what kinds of equipment would be hastily moved onto the main floor to treat the citizens suffering the effects of Devil's Breath.

"F.E.A.S.T. was one of the first levels we built, and is full of Easter Eggs. Many of its residents are actually Insomniac employees, or their friends and family. There is also an Employee of the Month wall that features a rotating cast of Insomniacs, who Peter sees every time he walks in. All of the children's drawings were created by Insomniac or Marvel Games children."

ABOVE: A detailed concept of Martin Li's office, packed with characterful detail; a great example of environmental storytelling.

"Later in the story F.E.A.S.T. is converted into a makeshift hospital to treat the citizens suffering from the effects of Devil's Breath."
Jacinda Chew

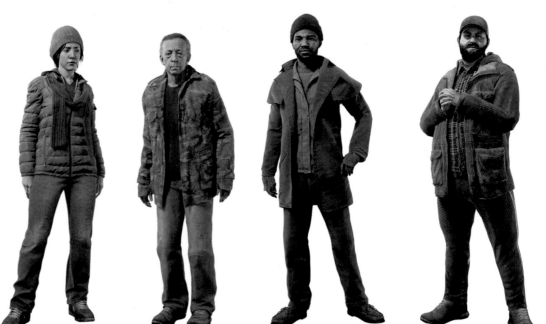

RIGHT: The homeless of New York: people of all ages, down on their luck and vulnerable.

BELOW: "This was a paintover to find the right amount of medical supplies, personnel, and machines to include in the setting." Blake Rottinger

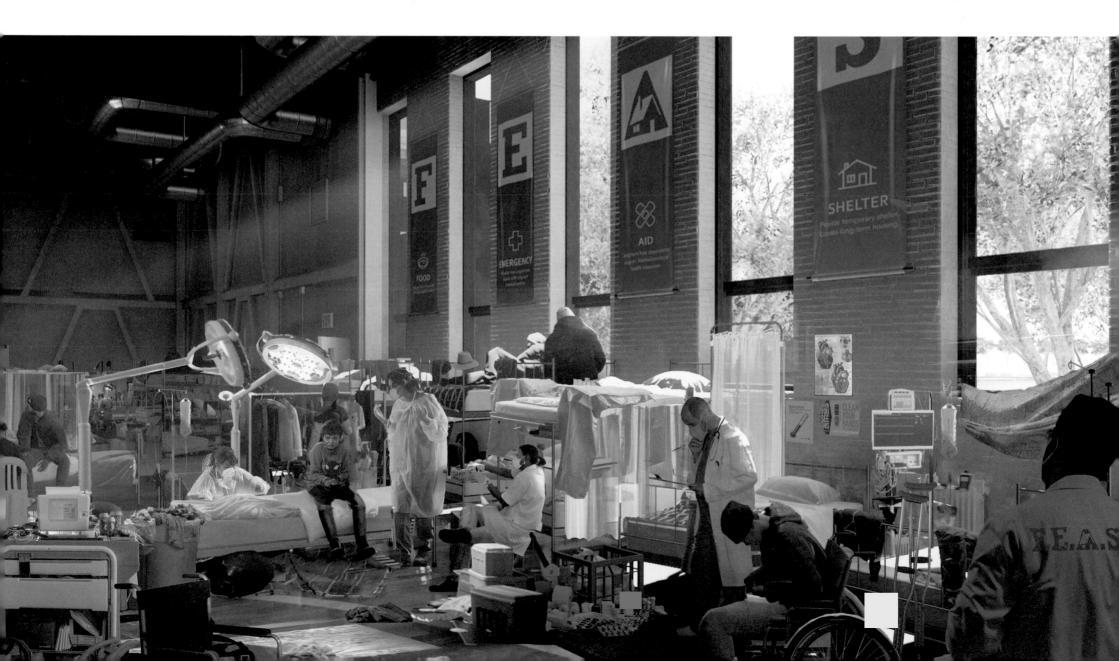

WITH SUCH A HUMAN STORY at the heart of *Marvel's Spider-Man*, Insomniac sought artists whose work would represent aspects of a person's character as convincingly as possible. The life-studies of Dutch artist Samma van Klaarbergen attracted Insomniac's attention, and resulted in the wonderful portrait of a very kindly-looking Martin Li and apparently relaxed Aunt May. Samma van Klaarbergen was originally a student of game design and development, and his work has since involved portraits as well as illustration, and concept art. Samma van Klaarbergen says his portfolio shows pieces that are "dynamic, filled with color, and have a clear focus."

TOP RIGHT: Evidence that Martin Li's homeless shelter is professionally run, and has the best interests of the community at heart.

BELOW RIGHT: Dennis Chan's extraordinary expositional moment-in-time, depicting Peter Parker, Miles Morales and Aunt May.

BELOW: Martin Li and Aunt May in happier times. Note the yin-yang symbol, illustrating the fusion of contrary forces...

"The idea for F.E.A.S.T. was that it should feel more institutional and well-funded: organized chaos with a sense of warmth, and welcoming to the temporary residents. The homeless are already showing symptoms of Devil's Breath, barely noticing what's going on around them."
Dennis Chan

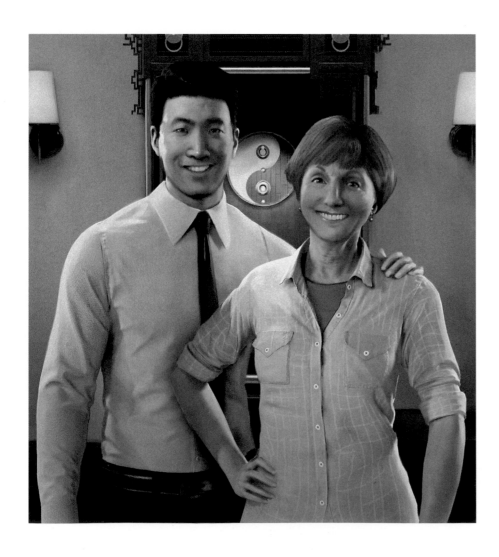

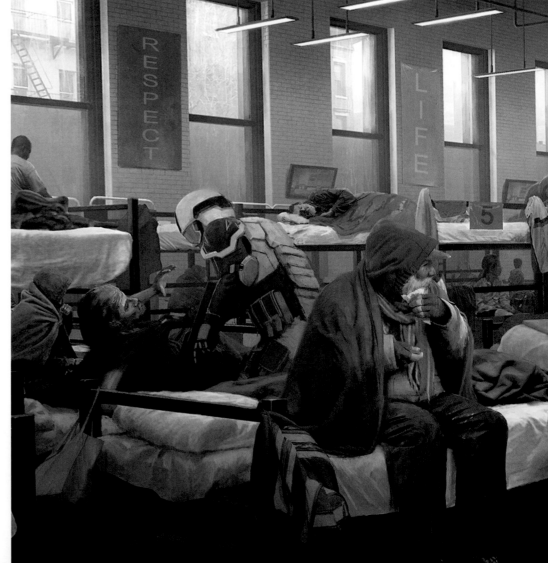

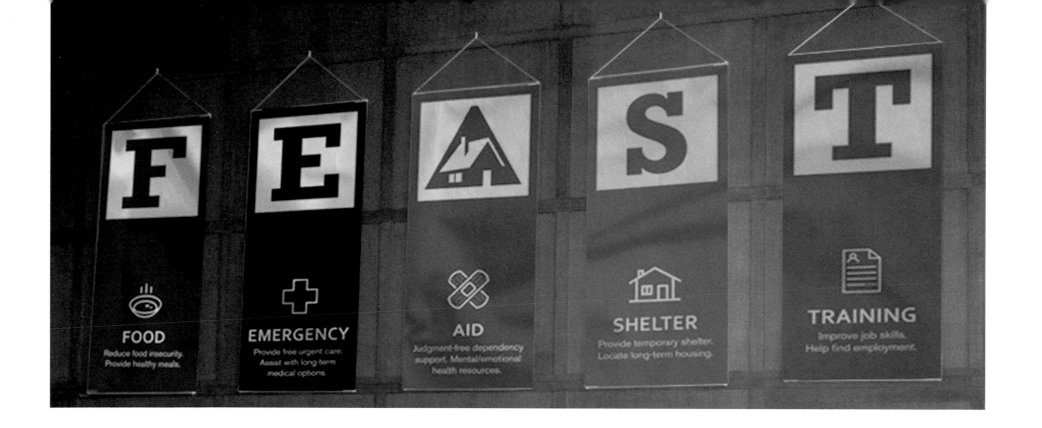

FOOD
Reduce food insecurity.
Provide healthy meals.

EMERGENCY
Provide free urgent care.
Assist with long term
medical options.

AID
Judgment-free dependency
support. Mental/emotional
health resources.

SHELTER
Provide temporary shelter.
Locate long-term housing.

TRAINING
Improve job skills.
Help find employment.

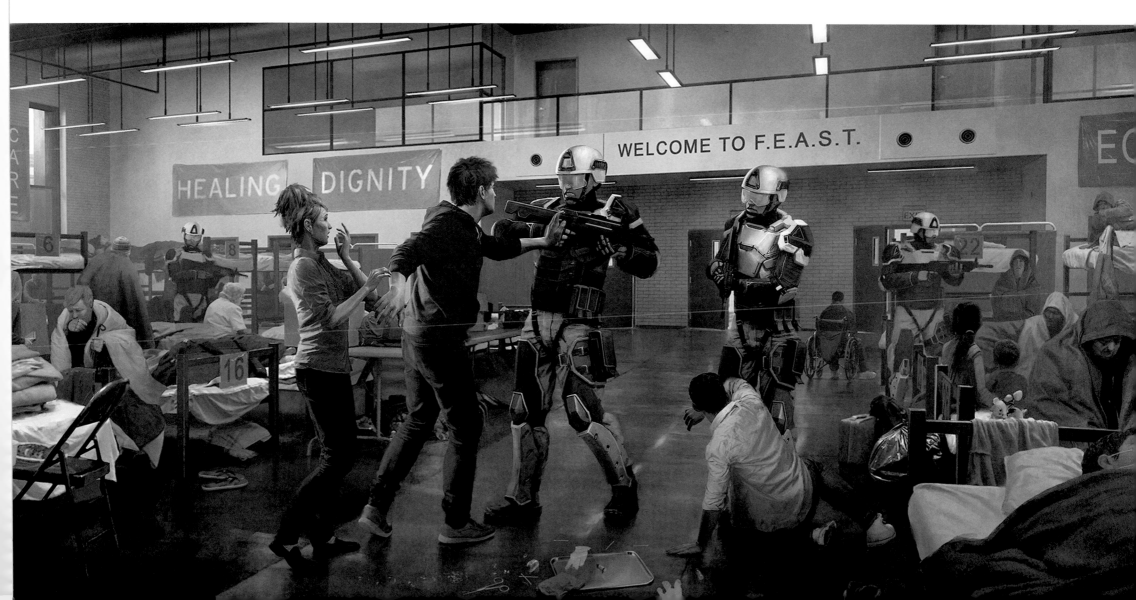

AUCTION HOUSE

IN THIS LOCATION, THE PLAYER is in control of Mary Jane Watson on assignment. It is rich in story-telling potential, poised for explosive action. The stately, almost antique appearance of the building feels calm and reassuring, in contrast to the commotion that's soon to descend on it.

"In true Marvel fashion, the city not only feels alive and bustling, but as a whole will change and transform visually to support the narrative as the player goes through the game," says Tim Tsang. "The city is filled with little bits of world building and story details that help give the place personality and authenticity."

"The exterior design of the auction house needed to look fancy as well as fitting in with New York architecture. For the interior we went through quite a few changes before finding the right decor to fit the personality of the founder."
Blake Rottinger

ABOVE: The auction house was so named as a jokey nod to Bill Rosemann, Executive Creative Director at Marvel Games.

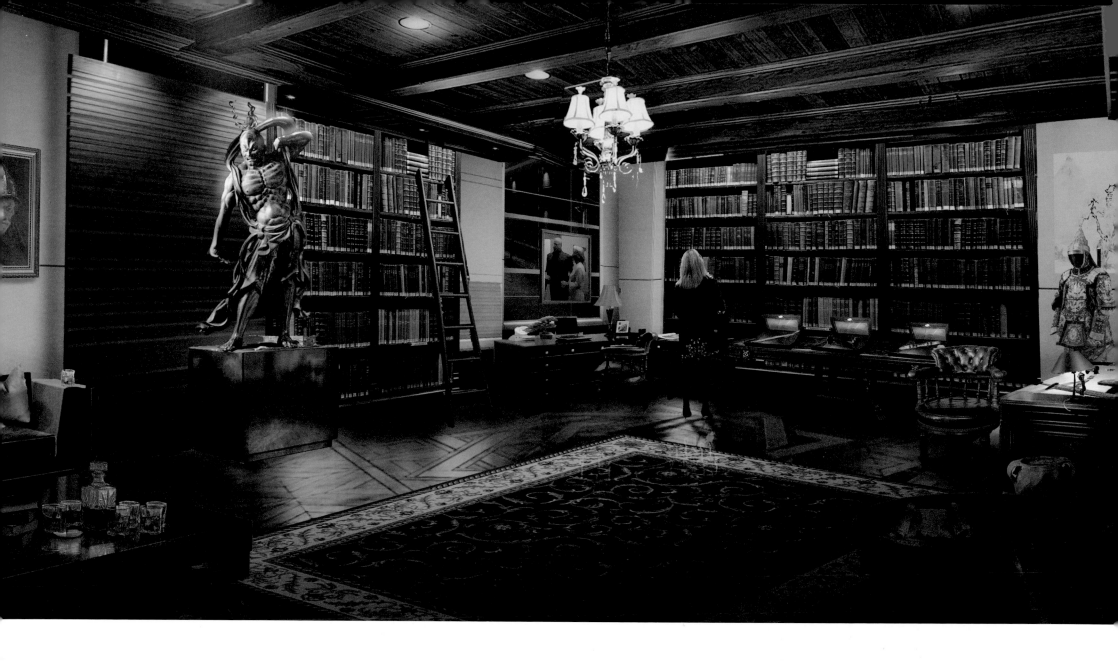

THE SHOCKER

SHOCKER IS ANOTHER GREAT EXAMPLE of how Insomniac's focus on modern, believable character designs produces something surprising, and yet instantly feels right. As Gavin Goulden says, "We aim to take fantastical designs and still have them make sense in a realistic environment. This allows you to believe that Peter Parker, and any of his friends or enemies, could actually have access to their clothing and gear."

"A huge benefit of working with Marvel is the deep well of knowledge within their team on what a character would naturally do, their history, what makes them unique, and how they fit inside the Marvel Universe," Goulden adds. "While a

fan like myself may have a good grasp on the characters, it's incredibly rare to have that great understanding that Marvel is able to provide. During the concept stage, these notes and references helped us greatly, while still giving us a lot of freedom to take established characters and alter them to fit within our own story and universe."

Character artist Daryl Mandryk sheds light on his work: "Shocker's gauntlets generate so much force his costume needs padding to protect him. One idea I had early on was to base his look on bomb-disposal outfits. This had the extra benefit of making him large and intimidating."

BELOW: Ideas exploring how a regular, albeit criminal, guy would reinvent himself as a Super Villain.

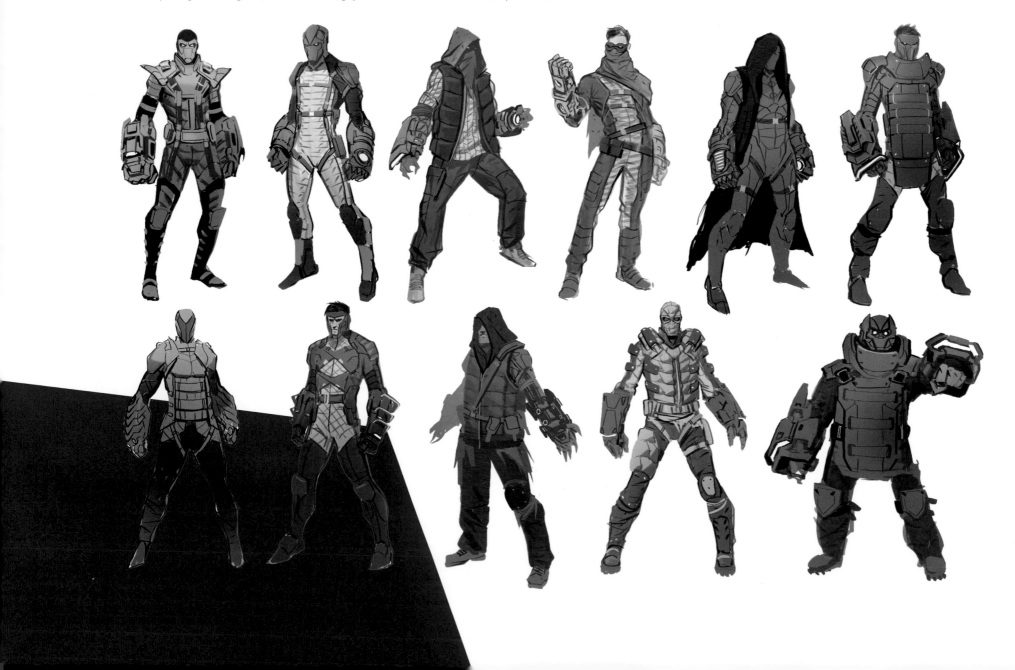

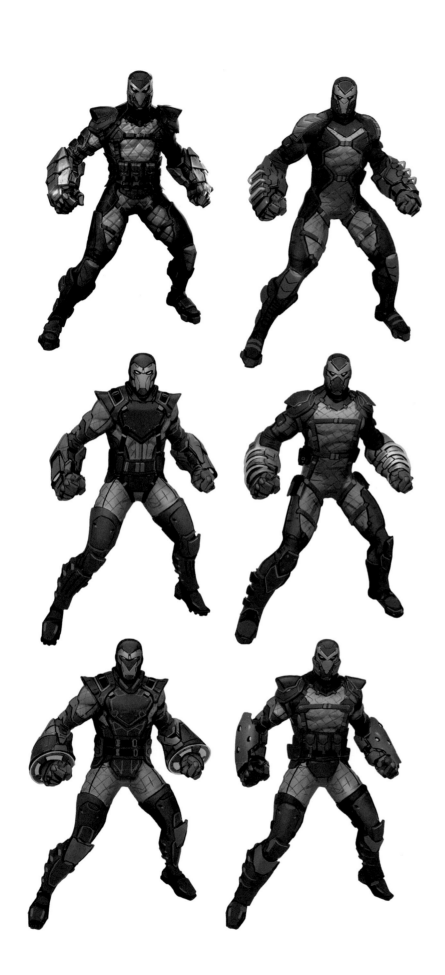

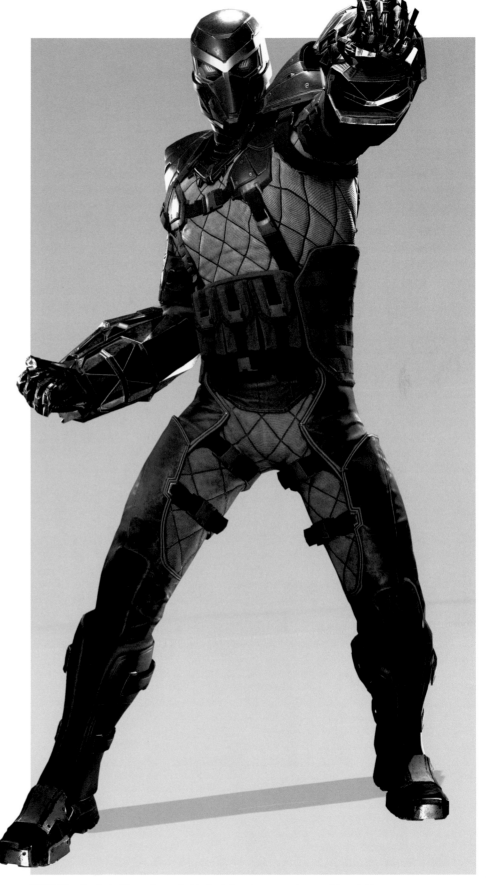

ABOVE: Shocker's battle suit needed to look iconic, menacing, and insulating.

MAYOR NORMAN OSBORN

ART DIRECTOR JACINDA CHEW DESCRIBES the Insomniac version of Norman Osborn as "arrogant and often menacing," and explains how this led to her giving Norman and his apartment "a mid-century modern look to suggest the history of privilege and success in the Osborn family."

Regarding the approach taken to visually identify the various personalities within *Marvel's Spider-Man*, Chew explains, "We have a lot of non-super hero characters like Mr. Li, Norman Osborn, Rio Morales, Mary Jane, Miles Morales, and Aunt May. I could easily have just put everyone in the same suit or jeans and t-shirts, but I spent a lot of time thinking about where these people would shop in

real life and imagining what their homes would look like. In some cases I even had to design their homes. This is how the character and environment art can tell you a lot about a person."

Norman Osborn is among the most famous, oft-depicted super villains within the Spider-Man universe, which is why Creative Director Bryan Intihar is grateful to Marvel for allowing his fellows at Insomniac to cast Osborn as the mayor of New York City. It is convincing that a character like Norman Osborn would work his way into such a position of power and influence, and it allows the game's writers and designers the freedom to explore the character in a different, more political position in society.

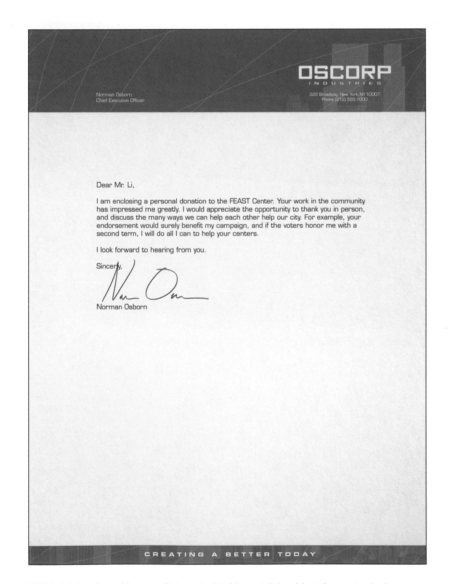

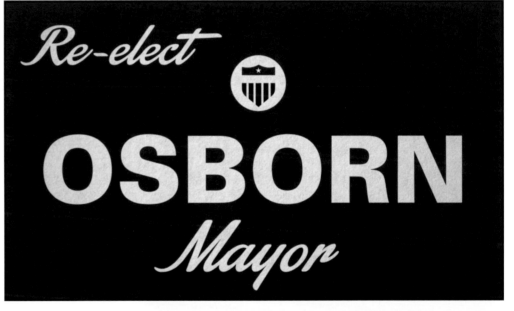

ABOVE: A letter from Norman Osborn to Mr. Li, certainly with strings attached.

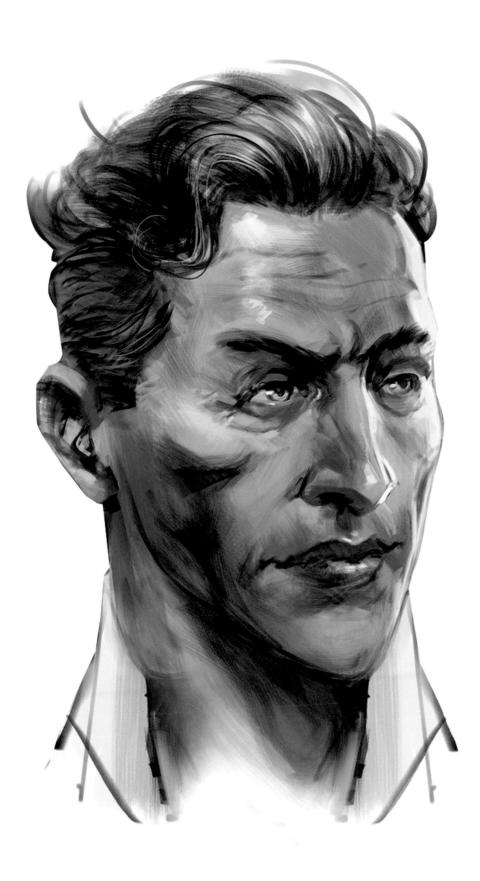

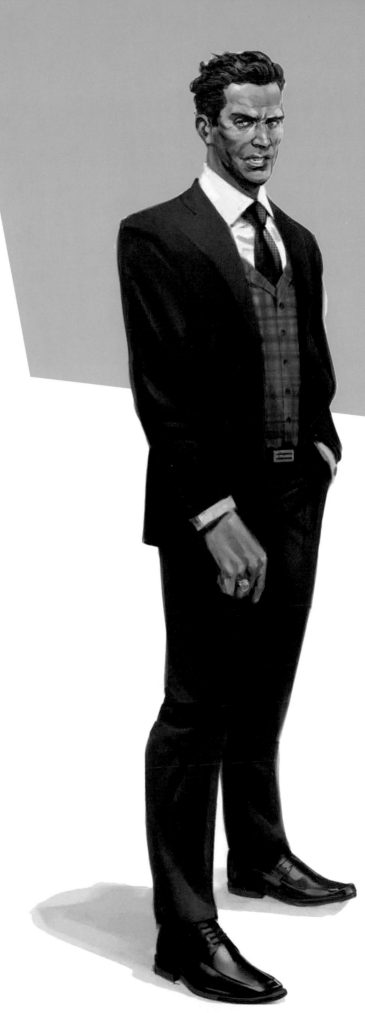

ABOVE: Status brushed into every nuance of Norman Osborn's elaborate coiffure.

FISK SHIPYARD

ALWAYS AT THE BACK OF the minds of concept artists working on video games is the need for protagonists to navigate the environments. With every new console generation, locations become visually more rich, while at the same time the range of movement and interaction within them becomes greater. In *Marvel's Spider-Man* the potential is huge on both counts.

"Our New York City is best described as a superhero playground," says Jacinda Chew. "Spider-Man can travel on every surface: the streets, the walls, and the roofs." During the story, Spider-Man investigates this tumble-down riverside facility linked to Kingpin, which is typical of the challenges facing both the design team and Chew's team of artists.

"At one point in the project, the designers pointed out that fire escapes were a traversal nightmare because Spider-Man would come to a dead stop when he came upon one," Chew remembers. "Of course, it's easier to make traversal work on flat rectangular buildings, but flat rectangular buildings lacked the New York character I was looking for. I pushed back and we figured out how to move Spider-Man around obstacles like fire escapes."

OPPOSITE PAGE, BOTTOM: "Here are some ideas for fuse boxes that Spider-Man can interact with using his electric web shooter. We worked on different variations which fit into different environments." Blake Rottinger

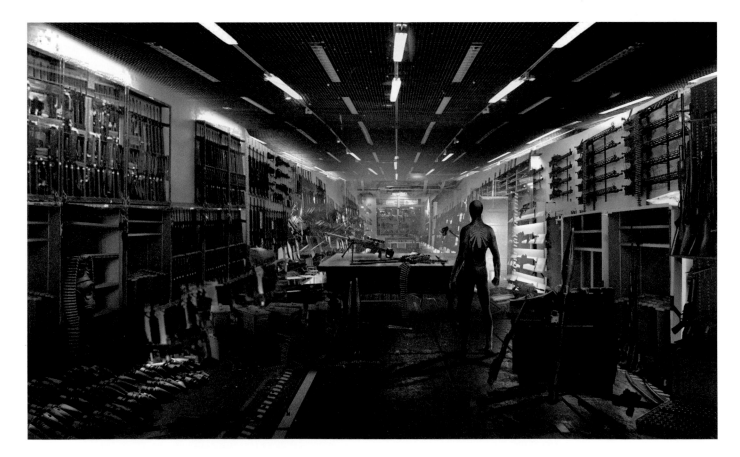

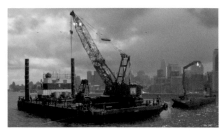

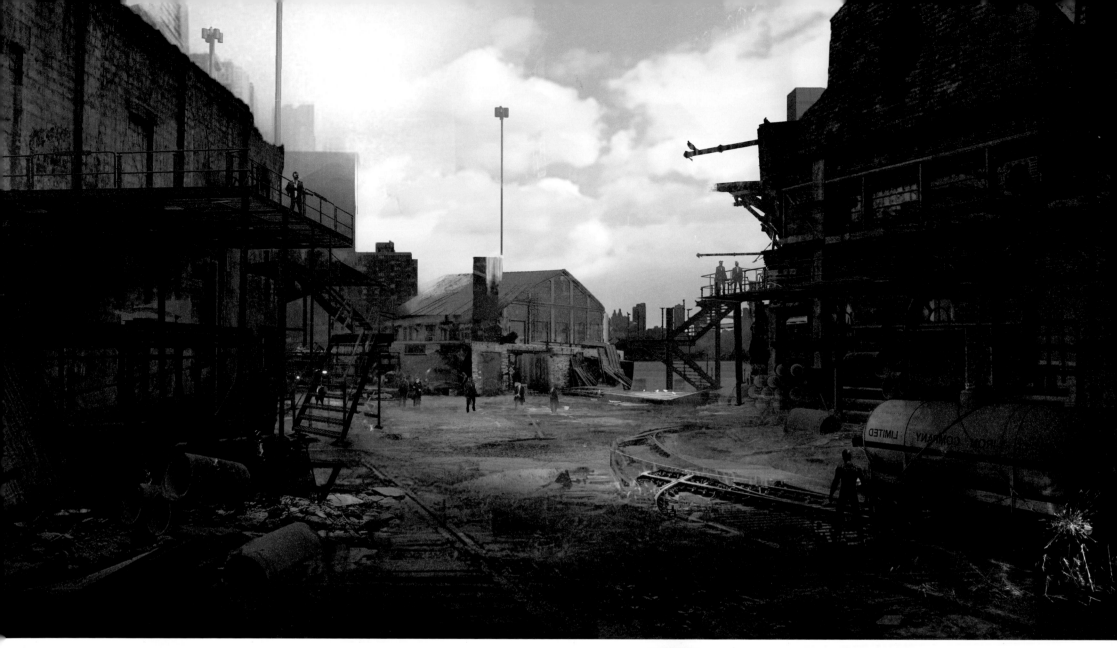

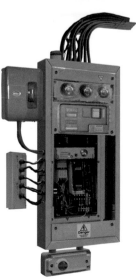
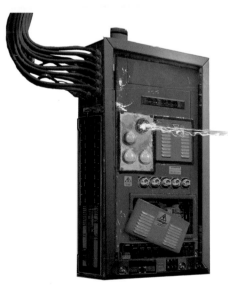
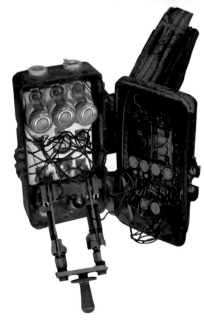
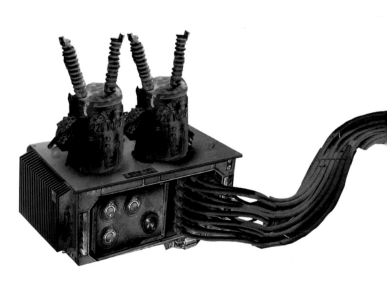

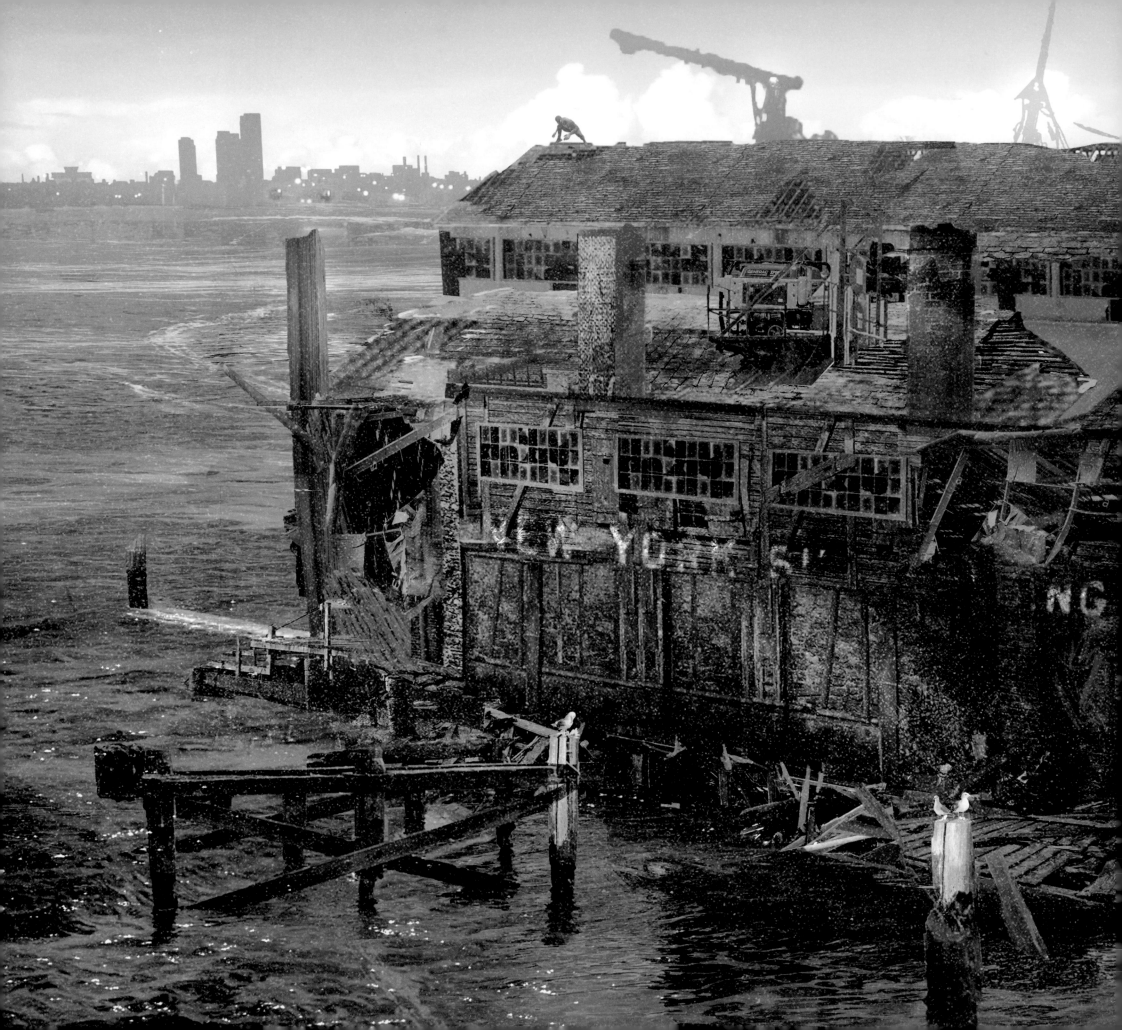

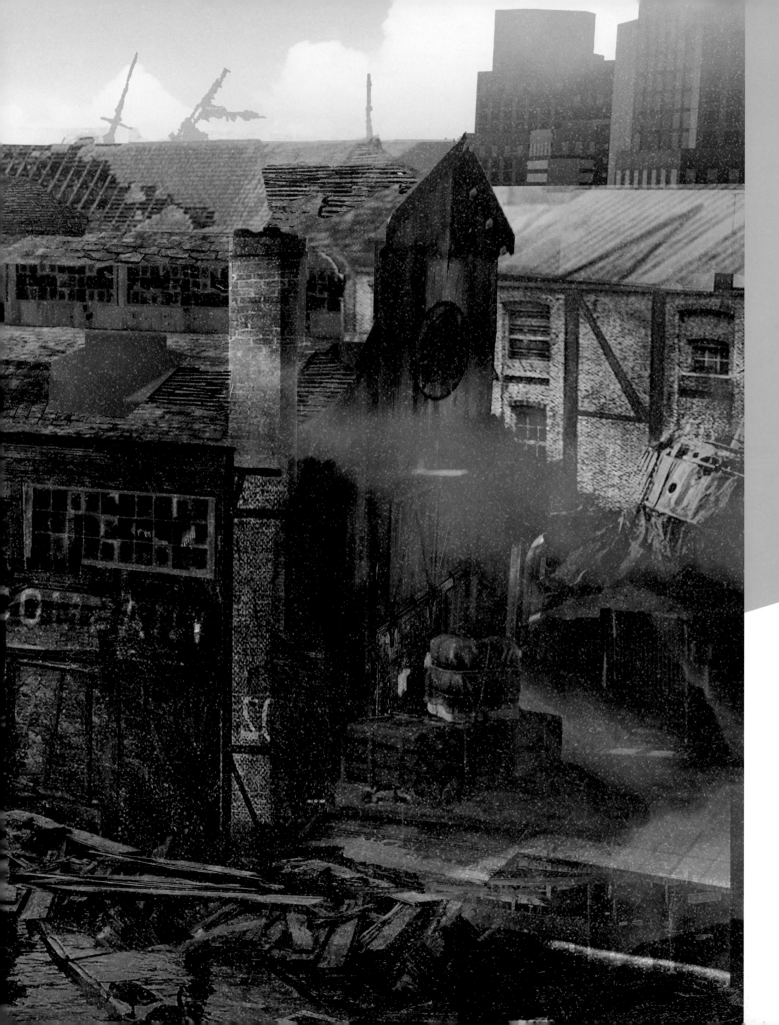

"An overview shot of the shipyard warehouse. A lot of attention was paid to communicating pathways and entry points into the building to the player."

Blake Rottinger

MANHATTAN LANDMARKS

THOUGH MANY OF US MAY have never visited New York City, it remains familiar to us through movies and TV shows taking place in America's bustling center of business and creativity. The magical and enduring metropolis is also synonymous with a certain web-flinging Super Hero.

"Throughout the creative process we've clung to the belief that in the best Spider-Man stories, New York City is a living and breathing character," says Bill Rosemann. "As anyone who has visited or lived in Manhattan has learned, it is an ever-evolving entity that can bring out the best and worst in you. Never static or boring, New York changes and flows with each season, providing the electric heartbeat that pulses through the people that fill it. From the bright lights of Times Square and the iconic water towers, to the frantic taxis and pedestrians, we're striving to deliver all of the delightful and maddening ingredients that make up the city that never sleeps. And since this is Marvel's New York, we're also packing it with all of the authentic and impressive elements you'd expect, from the *Daily Bugle* and Avengers Tower, to The Raft and the Sanctum Sanctorum."

BELOW: Dennis Chan explores some designs for Avengers Tower.

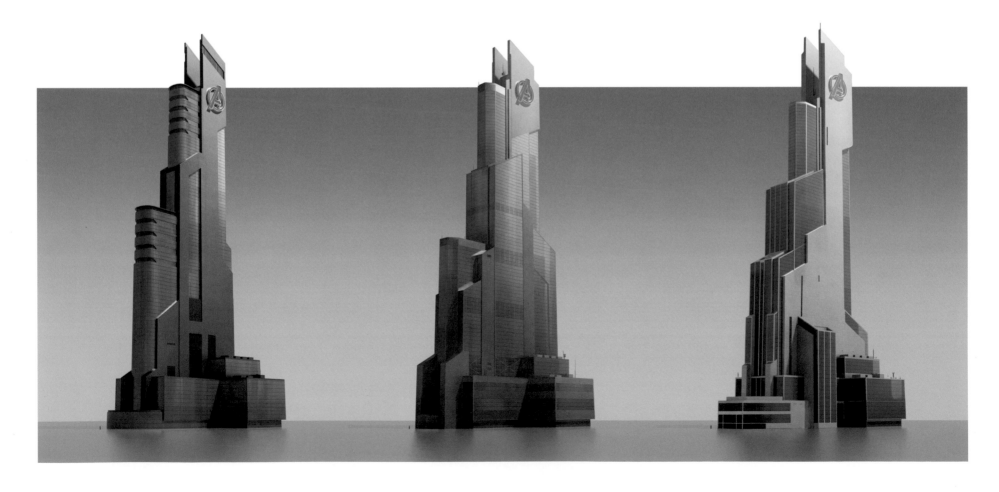

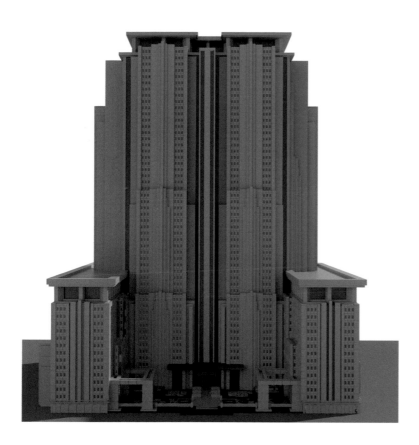

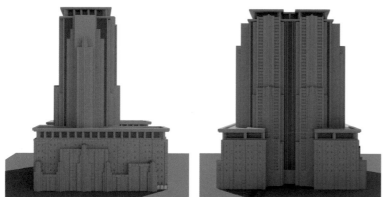

ABOVE: Front, side, and back views of Fisk Tower.

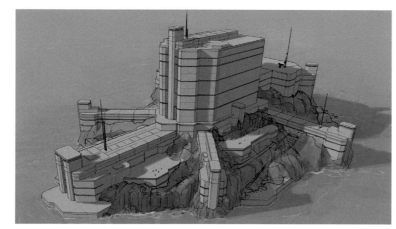

ABOVE: An early concept sketch for Raft Prison, by Dennis Chan.

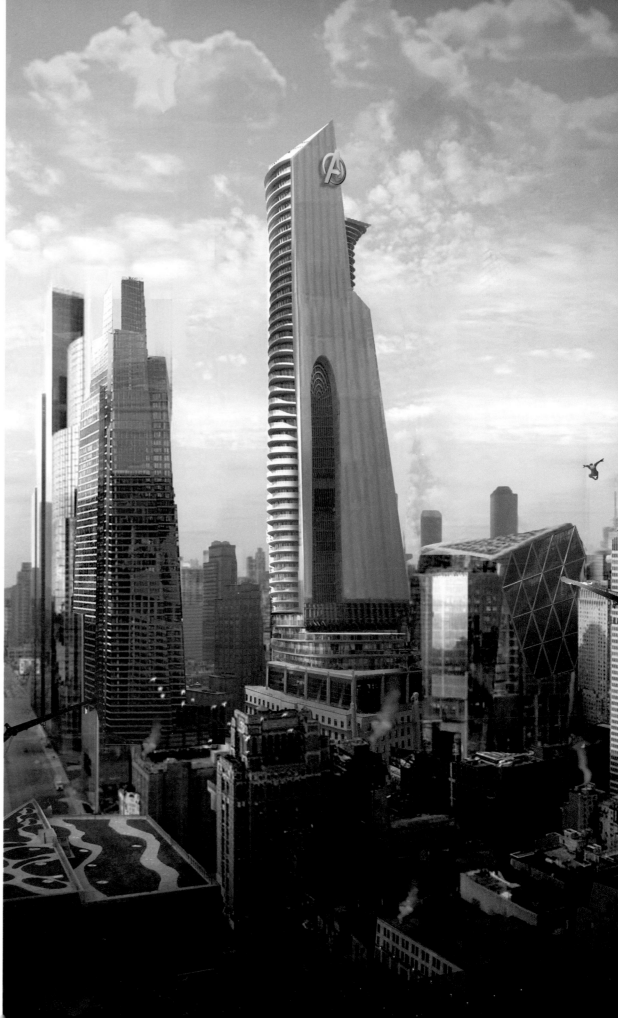

SIGNAGE AND ICONS

JACINDA CHEW SAYS "A BELIEVABLE city needs to be covered in signage in order to feel alive and lived-in. Sign creation was a huge undertaking. We had to come up with all the business types we wanted, and then we had to come up with names for all the businesses that were not already copyrighted. The legal review for names could take months before we were cleared to create the actual logo."

PLAY LeARn DreaM

The Daily Grind

"One of the highest honors one can achieve at Insomniac is to get a store named after you. It's an honor that is bestowed by those doing sign creation. There are many businesses named after Insomniacs. We also had to create logos for Marvel Universe companies and buildings, like A.I.M. and ESU. We looked at the comics for inspiration, and created our own spin on them."

Jacinda Chew

BIG JOHN'S WINE & SPIRITS

GAMER PARADISE
BUY · SELL · TRADE

TOME RAIDER

Just Like Mama's

Just the Facts
With J. Jonah Jameson

LOAVES AND WISHES
BAKERY

Sterling's

The Mark of Excellence

EMPIRE STATE
NEW YORK
1865
UNIVERSITY

AIM
ADVANCED IDEA MECHANICS

AL'S LIQUOR

FOSWELL OIL
SINCE · 1955

Halal
MEATS AND CHEESE

Consolidated Shipping
Always in transit

conshipping
1-800-555-0101

USNYC 666-962

DAILY BUGLE®
WE ALWAYS GIVE YOU MORE!

WE ALWAYS GIVE YOU MORE!

DAILY BUGLE

SAFEKEEP BANKING

MONEY GROWS
ON OUR TREES

Open a New Savings Account Today!
Our friendly account managers are standing by to assist you

SAFEKEEP BANK, N.A. Member FDIC

A
TREASURE
FOREVER

HEIRLOOM JEWELRY

HEIRLOOM JEWELRY

MONEY GROWS
ON OUR TREES
Open a New Savings Account Today!
Our friendly account managers are standing by to assist you

SAFEKEEP BANKING

A BROOKLYN BOUTIQUE HOTEL
THE
AGENCY
YOUR COMFORT OUR BUSINESS

GLUTEN FREE? VEGAN? KALE?
FUHGEDDABOUTIT!
OUR PIE IS THE REAL DEAL

NYC
AUTHENTIC
PIZZA

99¢
12oz
at participating
retailers

OUT OF THIS WORLD FLAVOR?
SWILLCO!
EXPLORE OUR ALL NEW BERRY FLAVORS TODAY!

Swillco
Berry

MILES MORALES

"IF I WAS FIFTEEN YEARS old and I saw this guy with awesome powers swinging around the city, I'd want to be him," says Bryan Intihar. This realization fueled the belief that Miles Morales, from the *Ultimate Spider-Man* Marvel comic book series, ought to play a critical role in *Marvel's Spider-Man*. "Going back to the idea of Peter and Spider-Man's worlds colliding: Miles is part of that collision. I thought it would be a fun, interesting dynamic to see a super hero world through his eyes."

"*Ultimate Spider-Man* took many classic characters and situations and presented them in modern and accessible ways," says Bill Rosemann. "As Bryan and his team read more issues, they encountered Miles and fell in love with him. Even though Miles hails from an alternate reality, Bryan asked: 'Can we have Miles existing in our world alongside Peter?' After asking a few questions about their intentions, we jumped at the chance to weave this new web."

Regarding Miles' appearance, Gavin Goulden adds, "We sought references to find out what a teenager who happens to be into technology, science and robotics would wear. What would a kid who takes it upon himself to build battle-bots wear to school?"

RIO MORALES

AGAIN, NOTHING AND ESPECIALLY NOBODY is entirely incidental within *Marvel's Spider-Man*. Miles' widowed mother Rio is the perfect example. She is optimistic for her intelligent son's future, and comic book fans will know that she too has a tragic future ahead, beyond the story that Insomniac sensitively weaves for this appearance. In order to love and respect Rio, to know and understand her, and draw her closer, Insomniac's artists and scriptwriters devoted the appropriate time to all the ways that Rio could be vividly brought to life.

Jacinda Chew: "Since there are so many 'ordinary' characters in the game, I had to design them as if they were real people. I normally think about where these people would shop in real life, what their living spaces look like, and what might influence their wardrobe choices. Rio has a culturally diverse family, so I imagined her being worldly and open-minded: perhaps she has traveled or has an appreciation for international art. I gave her a bohemian, free-spirited look, with comfortable tunics, colorful necklaces, and a casually messy side-knot."

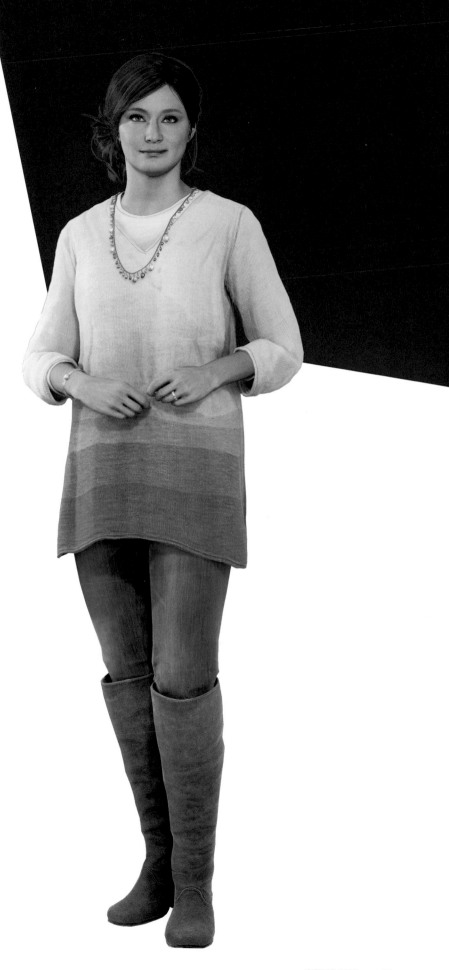

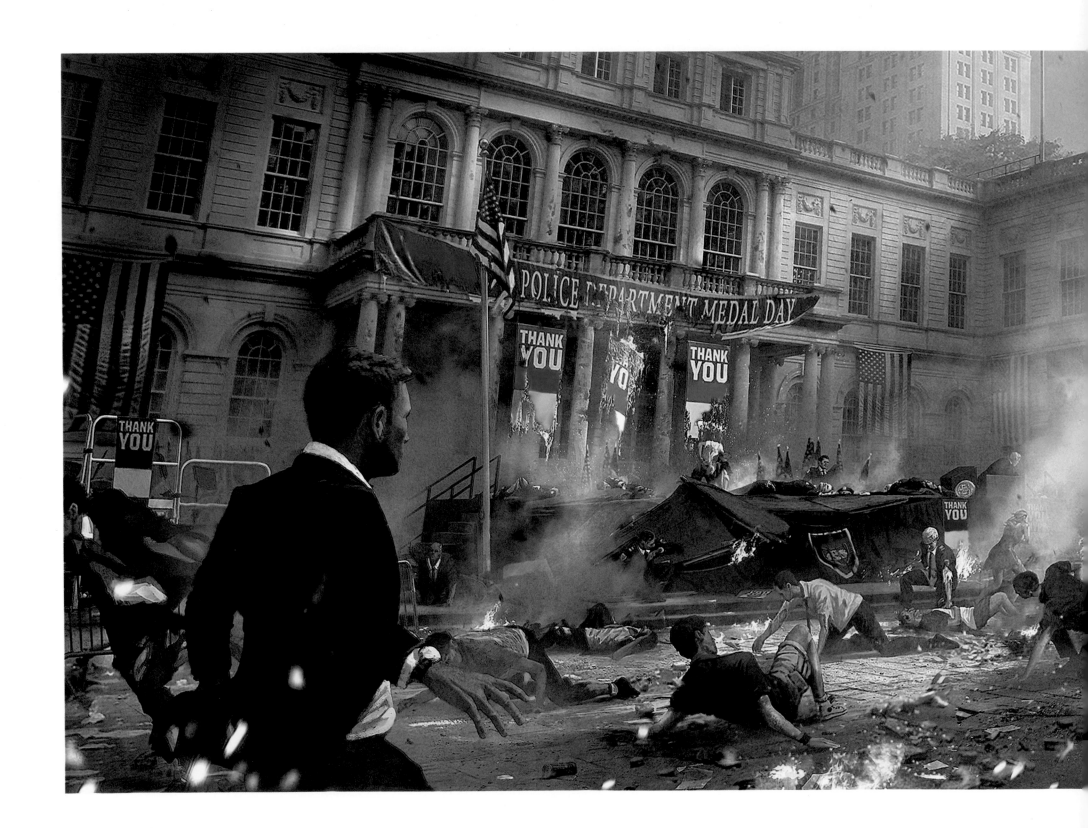

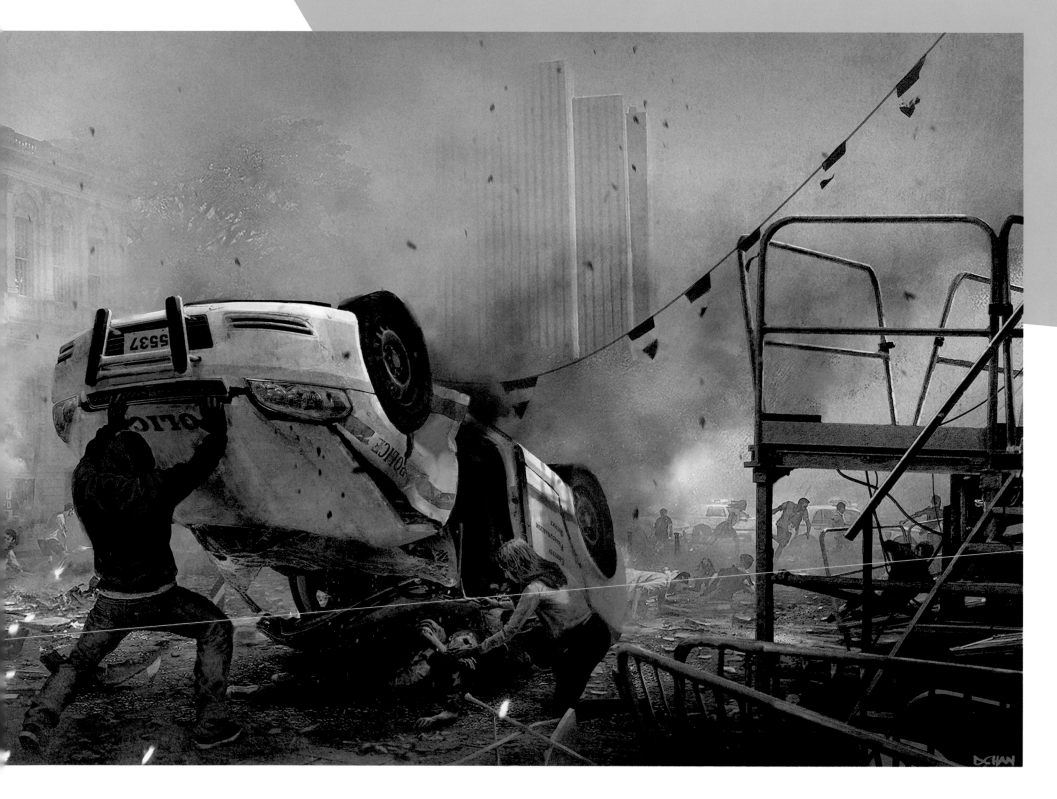

SILVER SABLE

IN THE WIDER SPIDER-MAN UNIVERSE, Silver Sable is known as a collaborator, and players can expect this in *Marvel's Spider-Man*, although not without some tensions. The mercenary leader has made numerous heavily stylized appearances in video games prior to Insomniac's iteration, all putting a modern spin on this very distinctive character who debuted in 1985, and was revived in the 1990s. She is an incredibly strong character who controls a private military that would make Kingpin jealous—plenty for Insomniac's Studio Art Director to work with.

"Silver Sable in the comics reminds me of a 1980s aerobics instructor, what with her headband, curly hair and shiny bodysuit," jokes Chew. "She would have looked out of place if she showed up in our game like that. I looked at what iconic elements we could keep, such as the Y-shaped emblem on her chest, the light hair, and the bodysuit. Originally her identity wasn't supposed to be readily apparent, so I also had to find a way to ground her so she wouldn't look out of place working for Norman Osborn. A trench coat was the perfect solution for this. It covered up her bodysuit, but also gave her a fashionable look.

"Silver Sable has a cool personality, so I wanted to give her a hairstyle that was a bit intimidating as well. We experimented with a variety of blunt-cut hairstyles. Many traditional Marvel heroines wear heels, and although they're not particularly functional, they feel like they're part of the DNA of a character like Silver Sable, so I kept them. We did give her wedges for practicality."

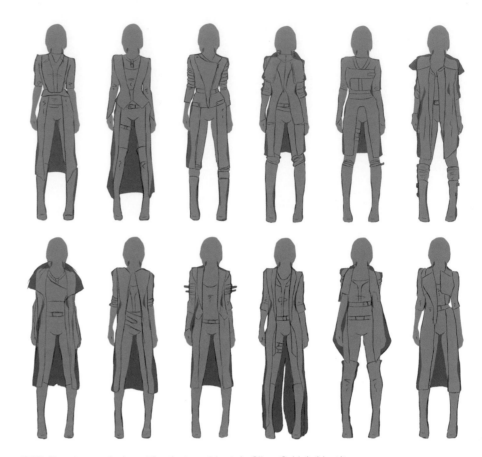

ABOVE: Sketches exploring attire that would retain Silver Sable's identity.

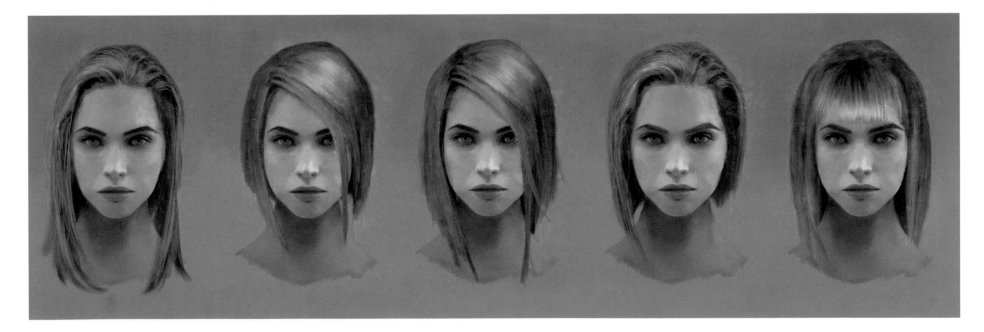

ABOVE: Artist Eve Ventrue worked on these concepts for Silver Sable.

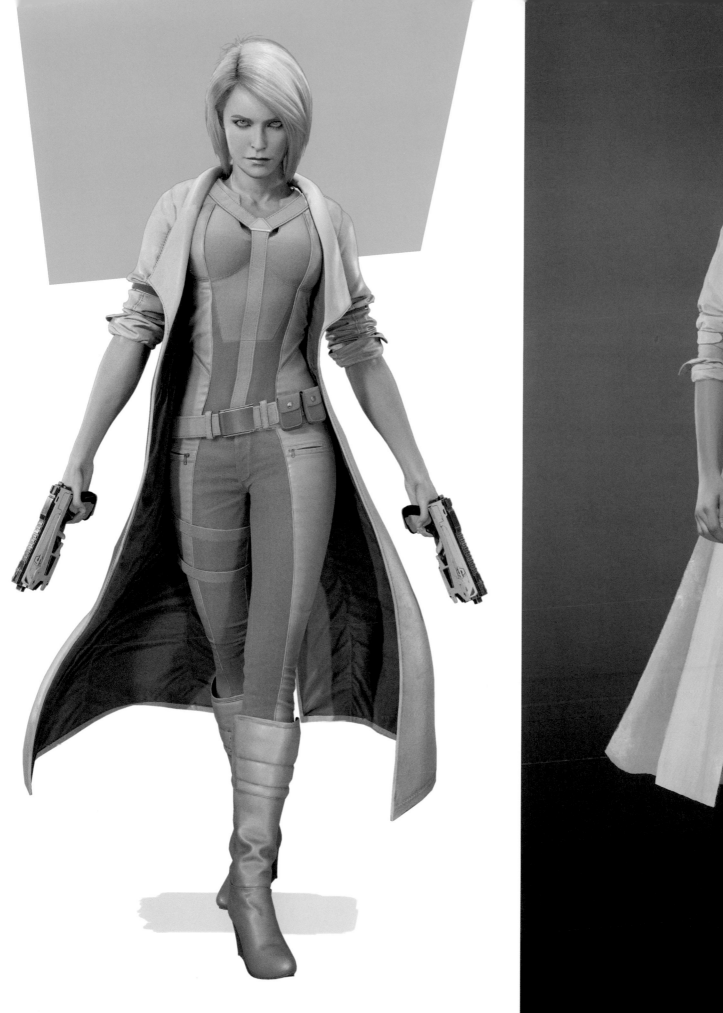
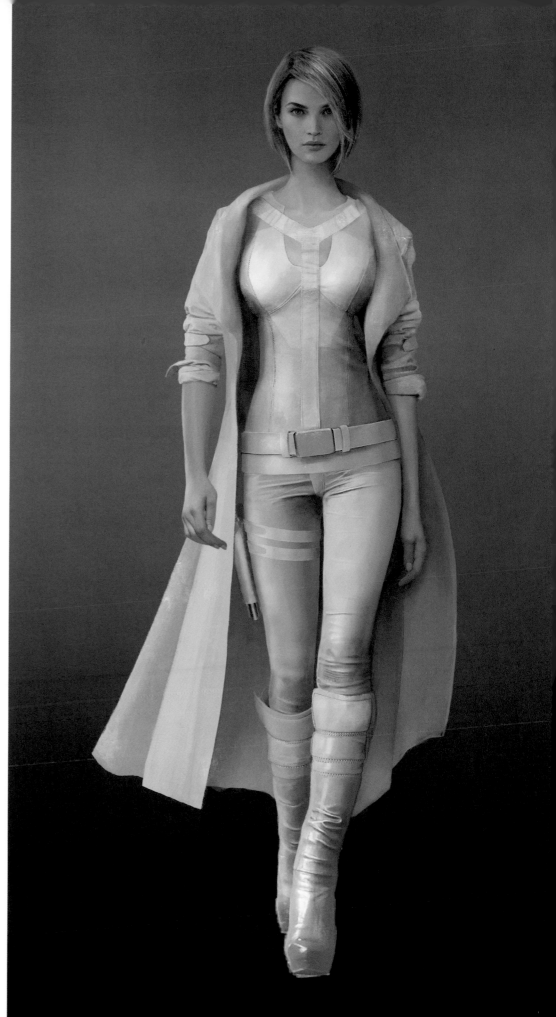

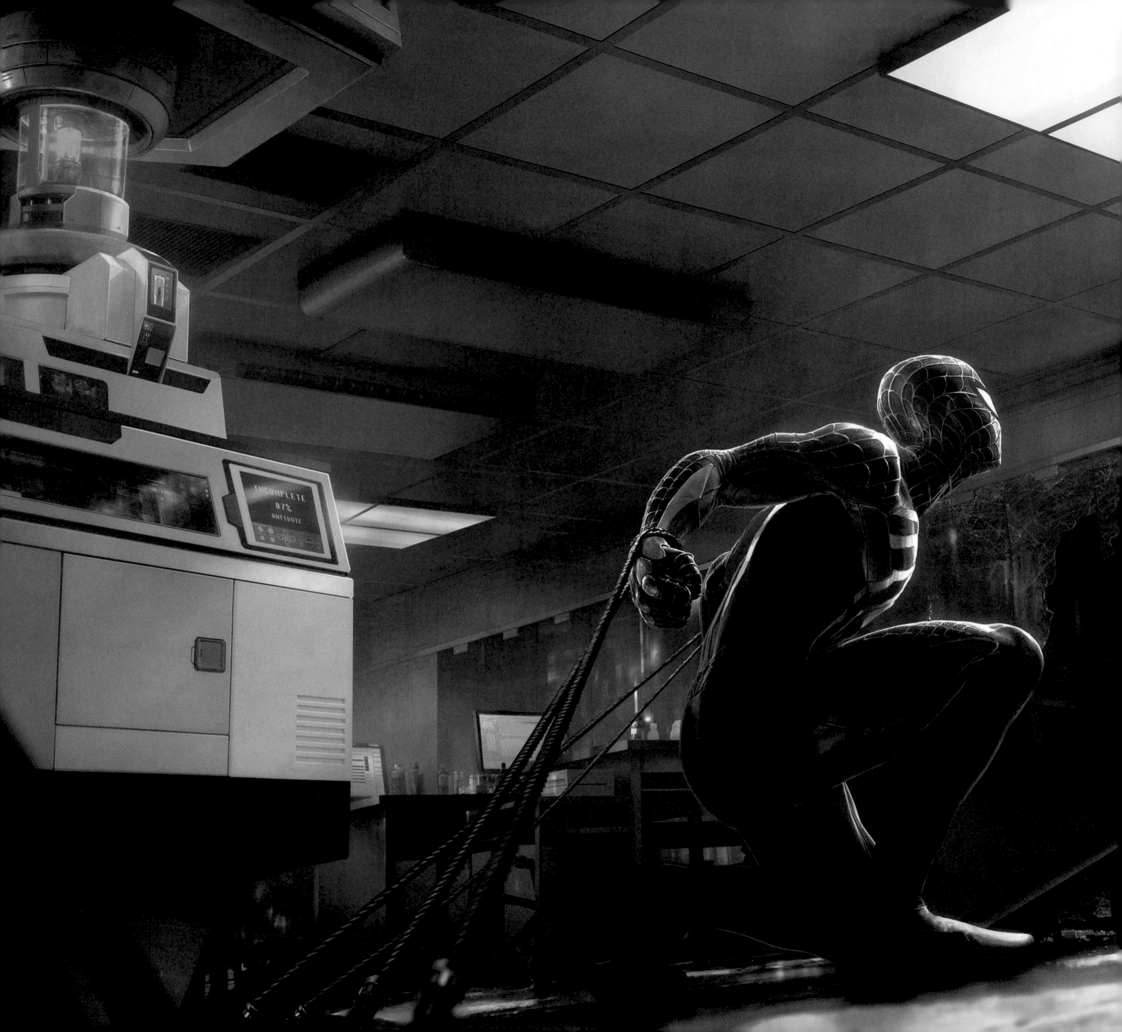

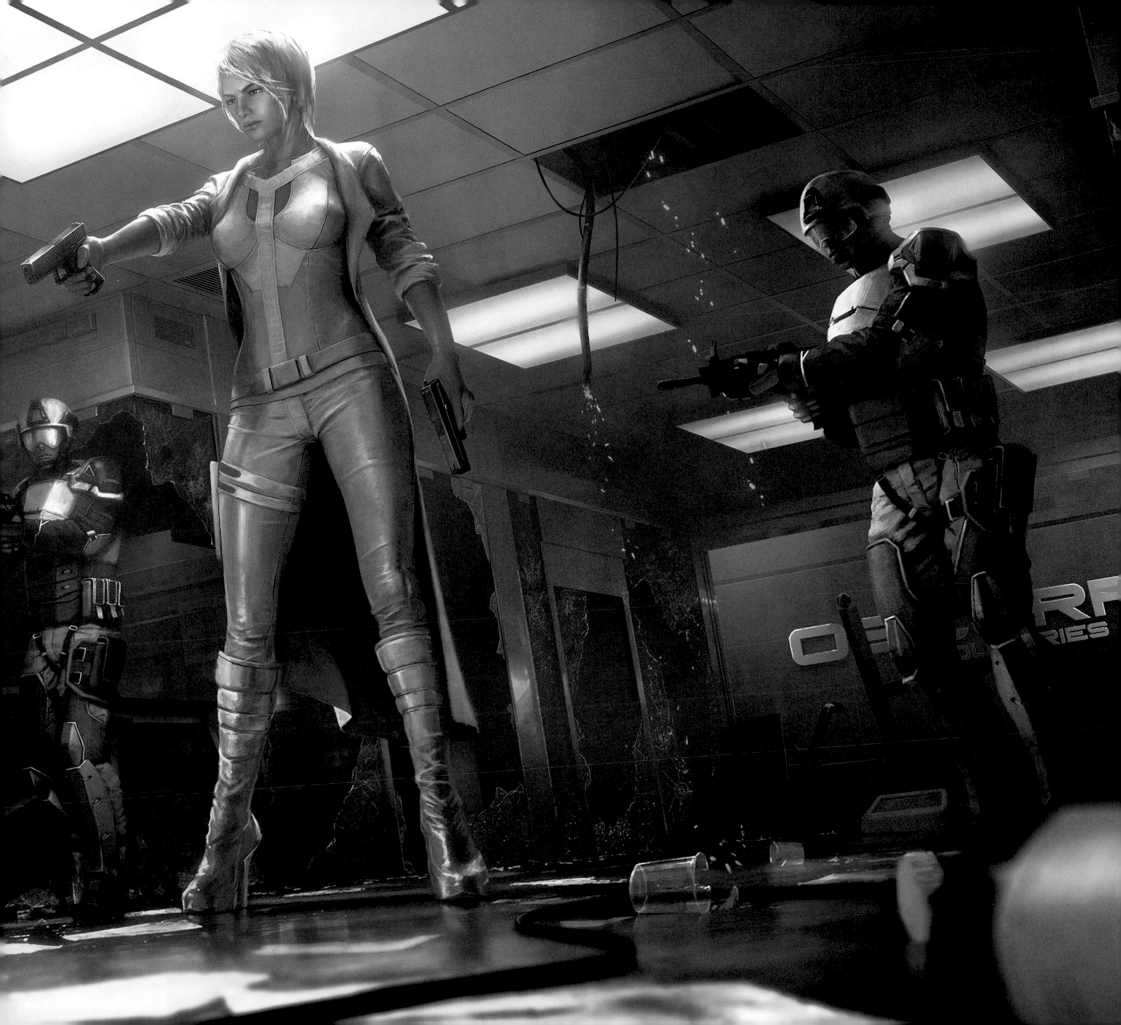

SABLE SECURITY INTERNATIONAL

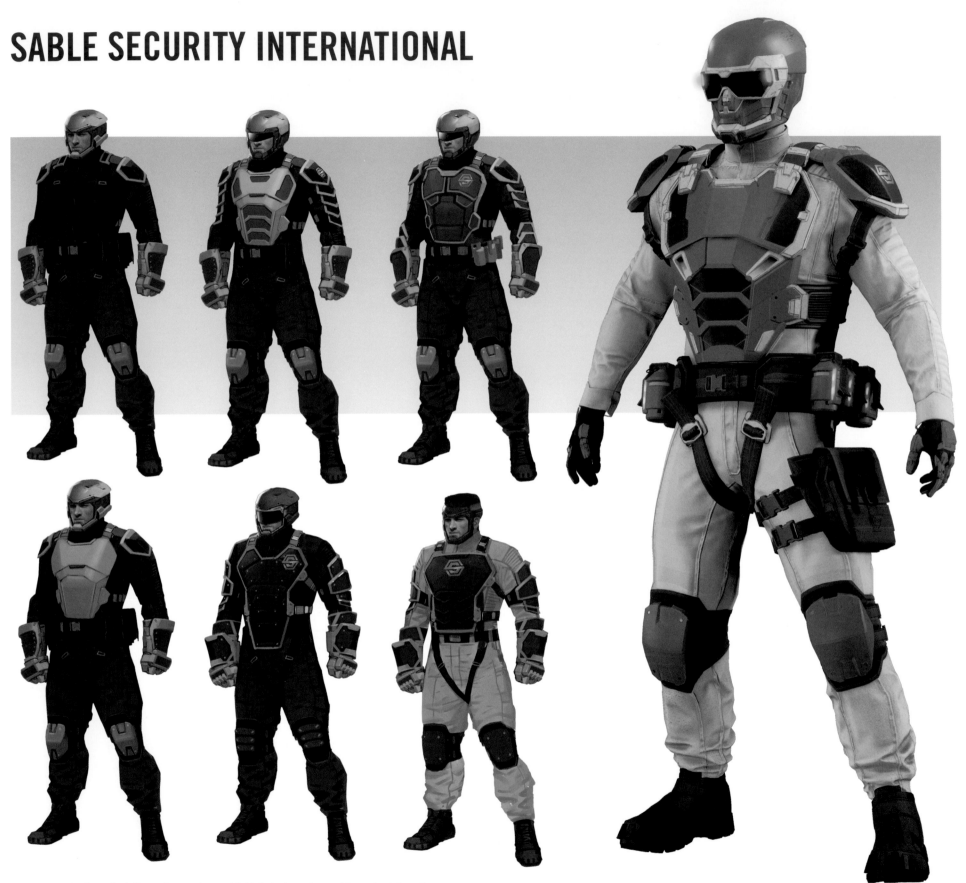

THIS PAGE: Sable Security fully outfits workers with high-tech equipment to protect the city.

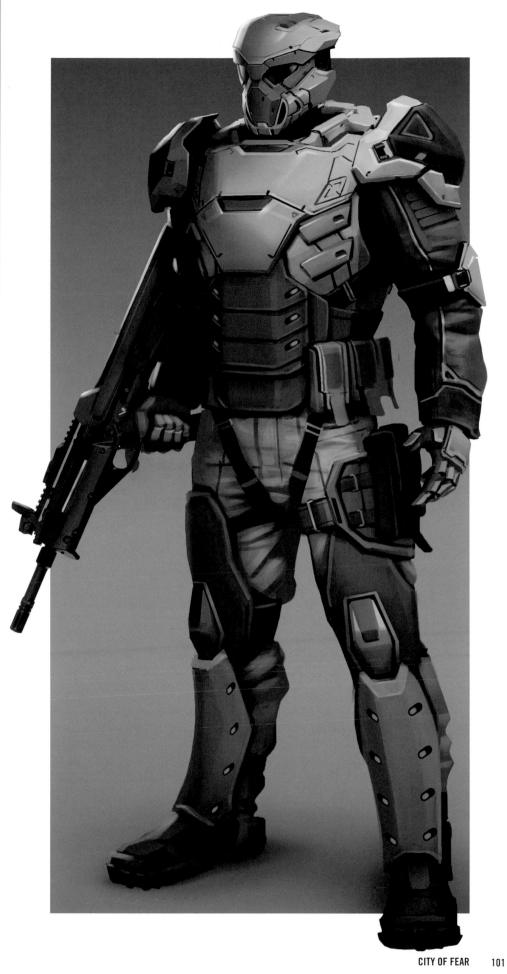

"Silver Sable International is a mercenary group. They're the strongest enemy faction in the game, and their design reflects that. They have a lot more body armor than other factions. Although their weapons are powerful, they aren't alien or magical—they're grounded with contemporary military elements."

Jacinda Chew

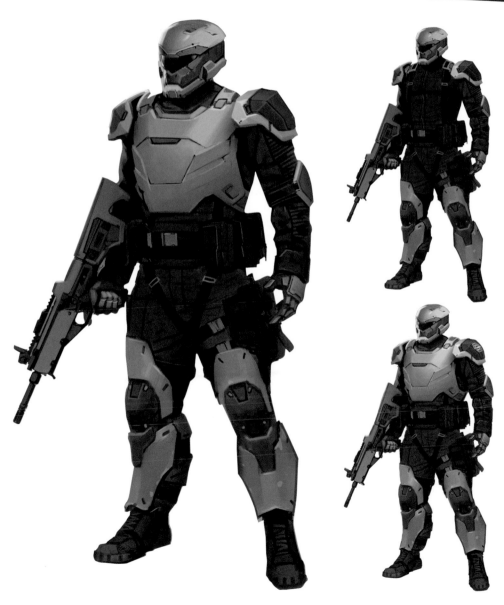

ABOVE: Daryl Mandryk worked up these complex designs for Silver Sable's armed forces.

"Factions normally retain the color scheme of their leader. Silver Sable is almost entirely white, so greys were also used to make it easier to differentiate them from one another."

Jacinda Chew

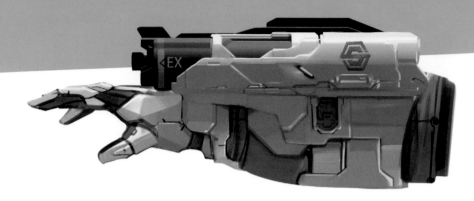

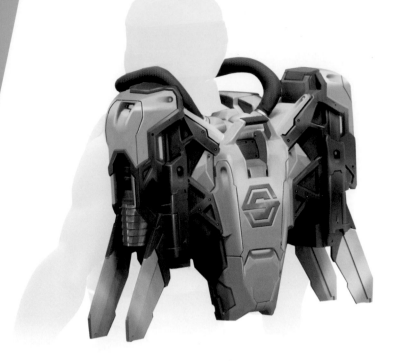

THIS PAGE: Daryl Mandryk's jetpack design needed to look impressive yet practical.

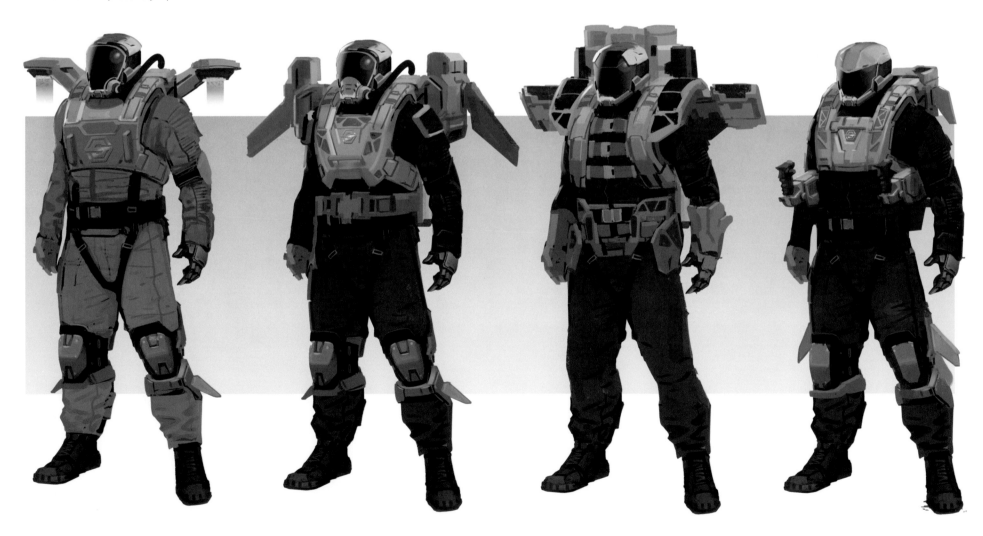

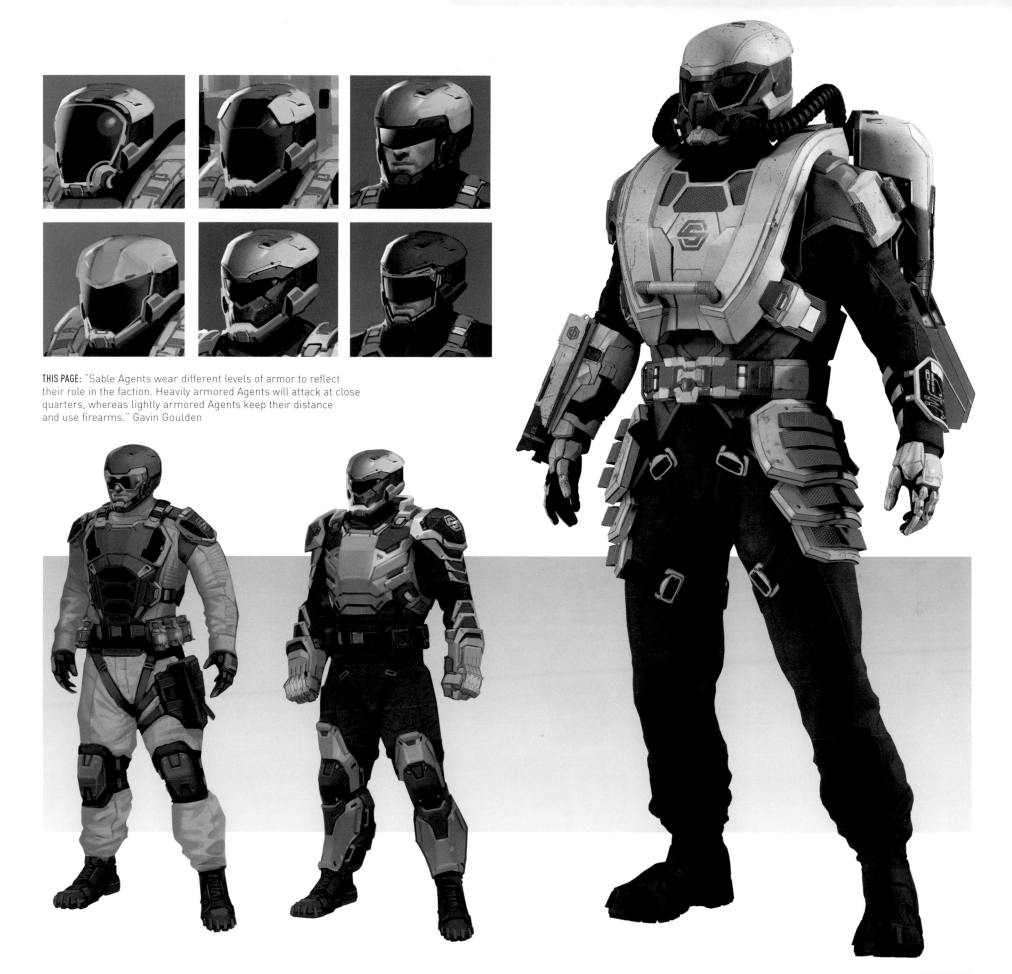

THIS PAGE: "Sable Agents wear different levels of armor to reflect their role in the faction. Heavily armored Agents will attack at close quarters, whereas lightly armored Agents keep their distance and use firearms." Gavin Goulden

SABLE SECURITY EQUIPMENT

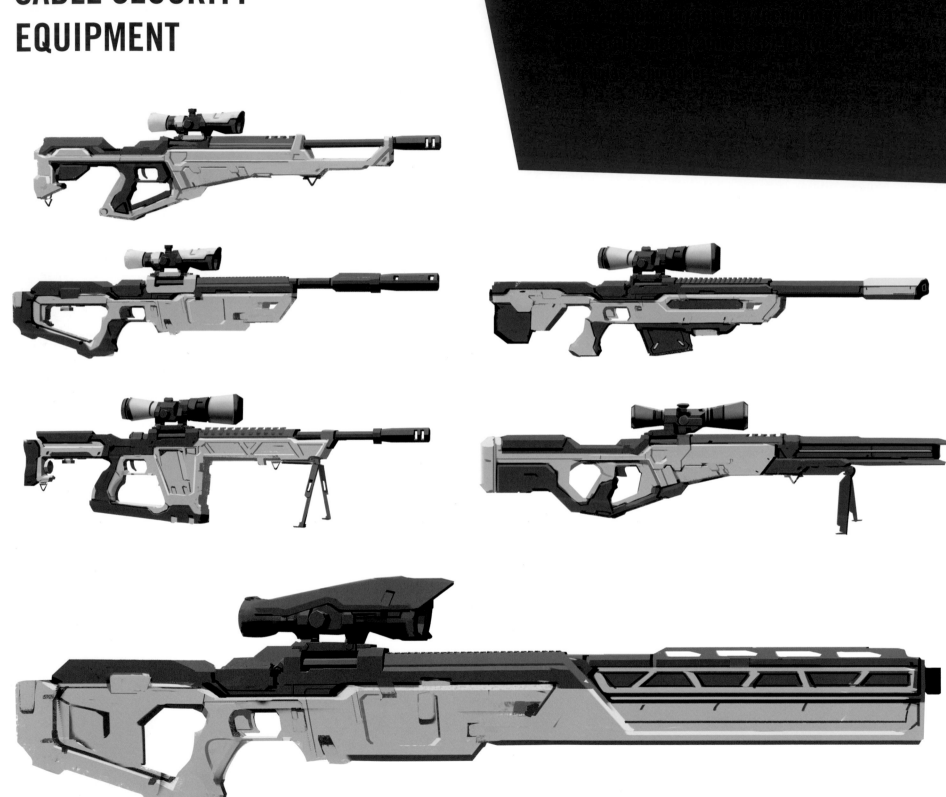

THIS SPREAD: "All of the Sable Security equipment has the same color scheme." Jacinda Chew

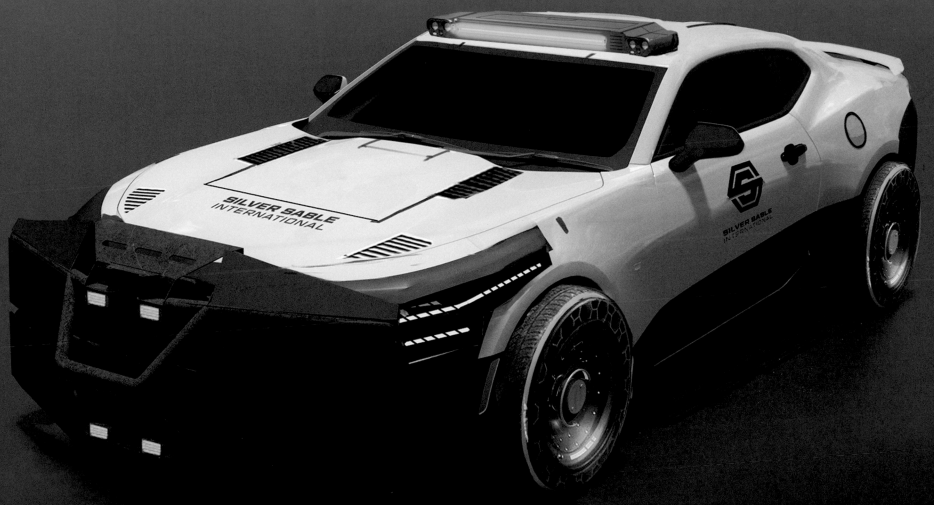

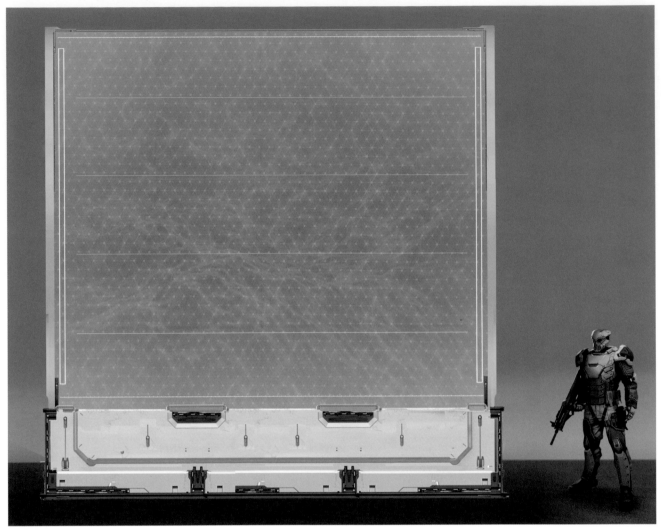

"There will be Sable Security checkpoints scattered throughout the city at some point in the game. These are the full-body scanners located at the checkpoints. We looked at airport body scanners for inspiration."

Jacinda Chew

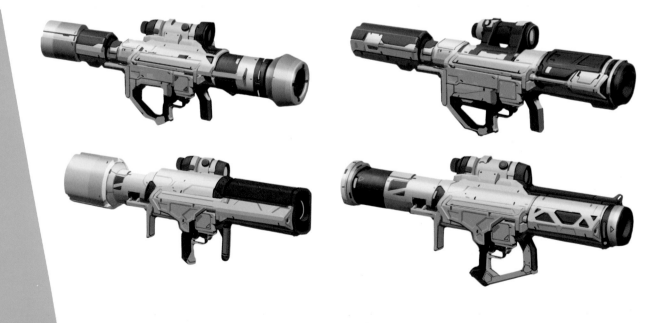

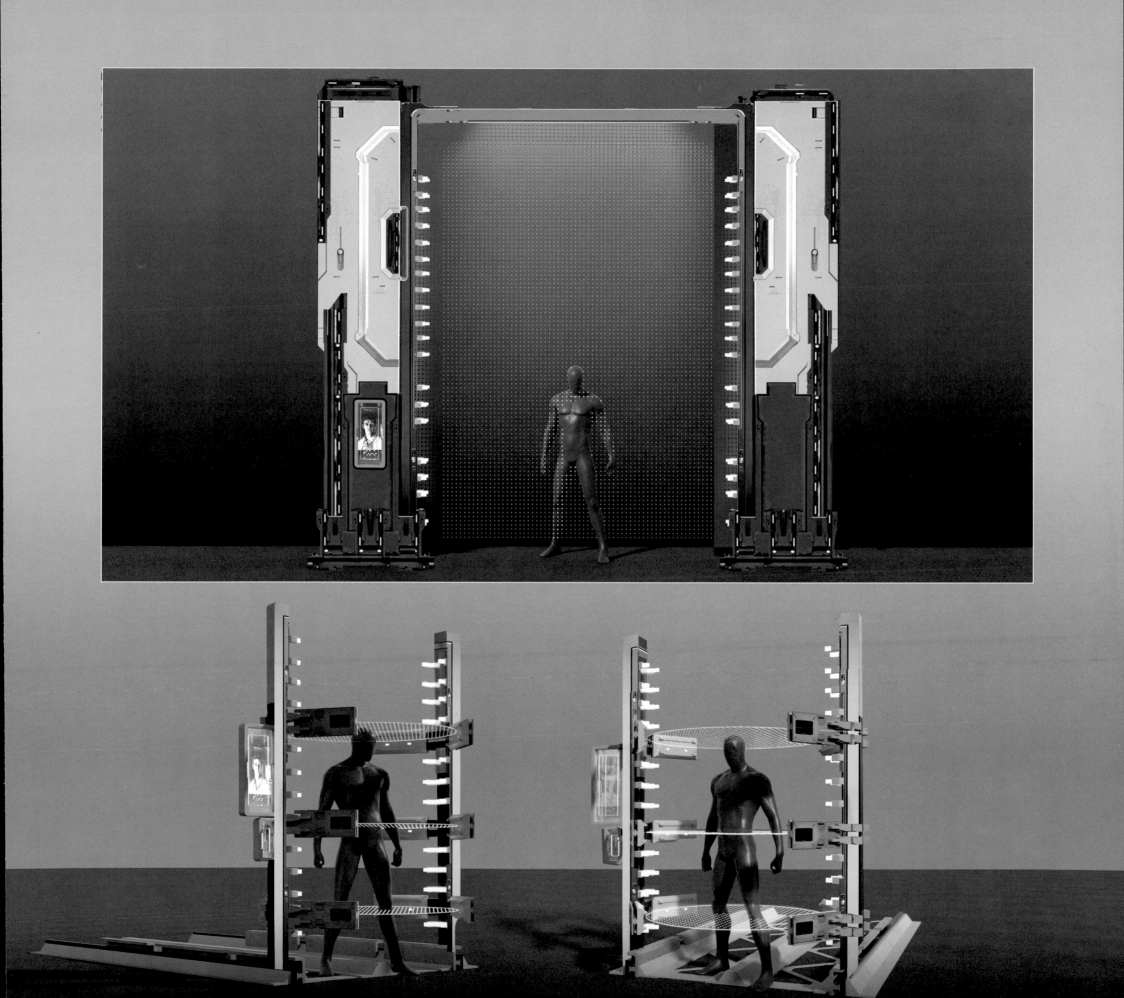

STREET ART

TOMBSTONE

"TOMBSTONE IS A NOTORIOUS CRIME lord in the Marvel Universe and, in our game, leads a gang of thugs in New York City," Gavin Goulden says. "Originally we took his past look [of an albino African-American hitman] and attempted a simple updated version—either in a suit or a studded leather motorcycle jacket. While these rang true to original designs, the story of being a heartless crime lord wasn't being told. Working with our writing staff, we wanted to give Tombstone more of an identity through the use of a biker gang. This gives purpose to his crimes, and a natural structure most viewers can see through history and other media. By choosing this path, we began developing strong branding for his gang to reinforce his power."

RIGHT: Daryl Mandryk's final rendition of a towering Tombstone feels credible as a road-hardened biker.

BELOW: Several concepts that led to the final design, and which still convey aspects of Tombstone at first glance.

"We tried several looks for Tombstone, and I was originally inspired by urban 'biker boyz.' The final look of him and his gang is more rooted in traditional motorcycle culture."

Daryl Mandryk

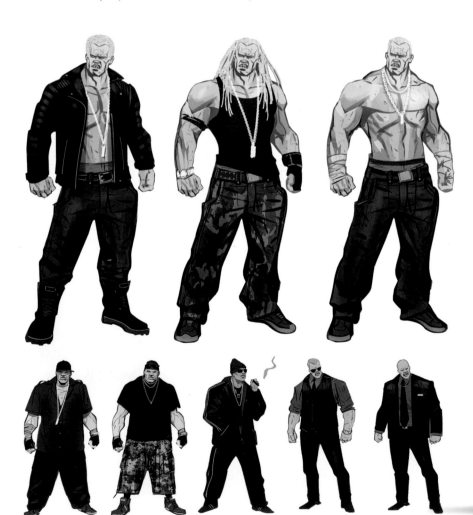

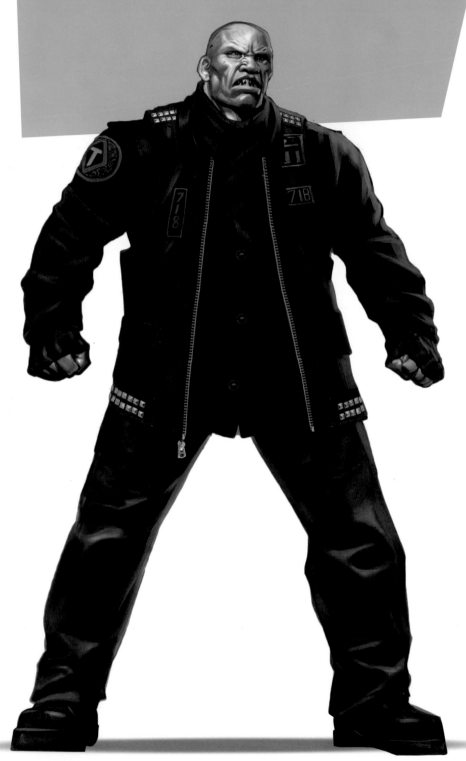

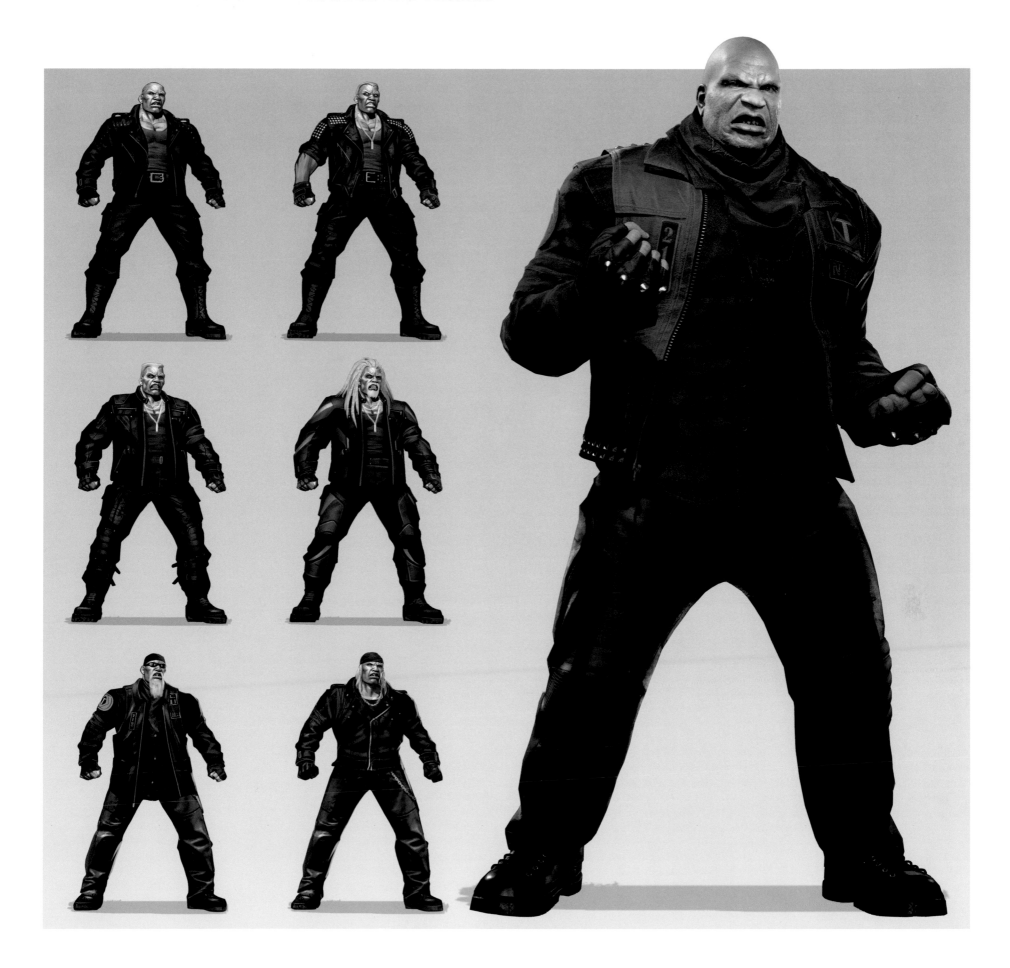

TOMBSTONE'S GANG

IN THE MOST SUCCESSFUL COMBAT-ORIENTED video games, the enemy's appearance gives clear indication of increasing threat levels and capability, and Insomniac has been organizing the inhabitants of fantasy worlds for two decades. However, in *Marvel's Spider-Man* their degree of mastery has been more extensively challenged. In order to emphasize progression from the basic outfits of chaotic and disorganized minor villains, to magnificent, expertly trained and expensively equipped super villains, the transition needed to be subtle. Indicators such as a mixture of ill-fitting clothing compared to designer suits are among the ways that Gavin Goulden's team of character artists made it easier for players to detect the opposition's rank and file.

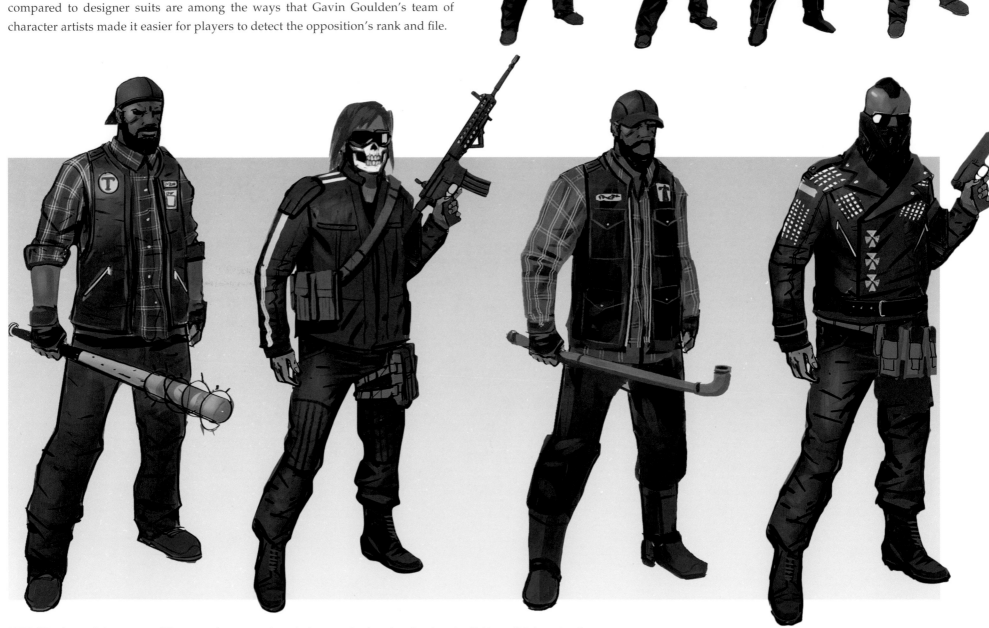

ABOVE: "Tombstone's gang uses different equipment to show their gameplay functionality. A melee fighter will take notes from mechanics and bikers showing a standard shirt and cut, while a ranged enemy will have more gear for their weapons." Gavin Goulden

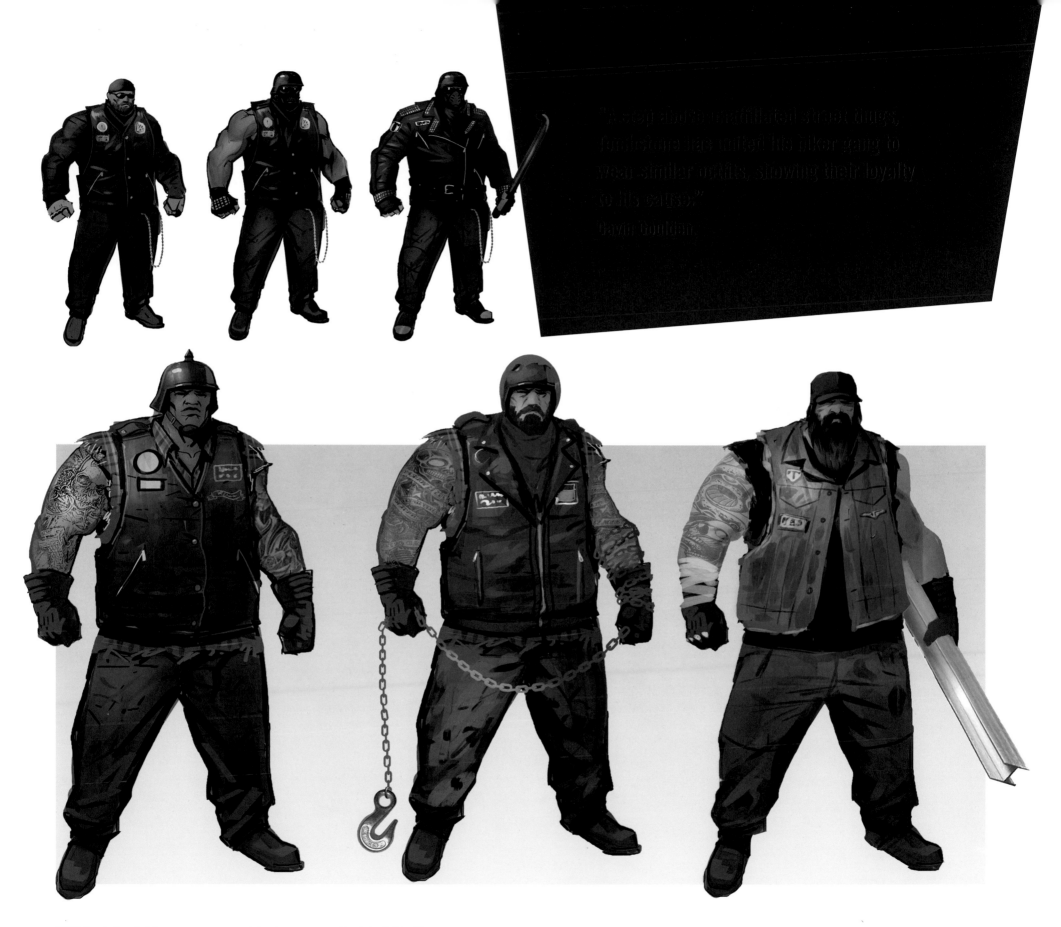

"A step above unaffiliated street thugs, Tombstone has united his biker gang to wear similar outfits, showing their loyalty to his cause."
Javier Goulden.

ABOVE: Tombstone's biker gang uses a variety of weapons and tools to fight with.

TOMBSTONE'S CHOP SHOP

"Once the world looked natural, we employed moviemakers' tools. For example, there is a grain over the game, and we made use of color correction to help achieve different moods."
Jacinda Chew

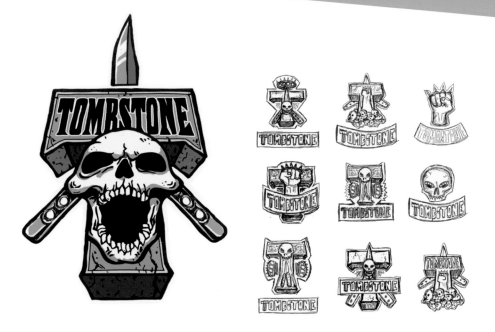

UPON ENTERING TOMBSTONE'S CHOP SHOP we spy clues to its occupants' taste in music, level of finance, and general approach to organization. Everything is considered by the concept artists, who create the entire scene from scratch and a handful of notes. Based on this type of reference, Insomniac's artists and designers can develop each scene.

"For the bikers' hangout I thought about which style of decor would lend itself to the grunge aesthetic," says Blake Rottinger, who Insomniac recruited specially to aid with visualization. "I also alluded to things the bikers would do in their spare time, such as tattooing and playing darts. The goal for Tombstone's hangout was to find the right blend of garage and office."

Marvel's Spider-Man is described by Art Director Jacinda Chew as being like a movie. "There are a lot of Insomniacs who have worked on movies. There are two ways to get a movie look. The first is making sure that the rendering is natural-looking. Even if you have 20/20 vision, you would never see objects with razor-sharp polygonal edges like you see in video games. Edges normally look quite soft in real life, so I softened as many as I could. I also made sure that objects had the right material response and range by looking at them in real life."

Acquiring a sense of place, together with the ambience required, involved applying tricks observed from the movie industry; techniques that the PlayStation was able to support. Says Chew, "Once the world looked natural, we employed moviemakers' tools. For example, there is a grain over the entire game, and we made use of color correction and other post processes to help achieve different moods. This look adds a warmth and believability to the characters as well. After all, we've been consuming stories through movies for over a hundred years, and we're used to it as a medium to convey emotion."

ABOVE RIGHT: "A key part to defining our Tombstone and his gang was to have an iconic emblem he and his minions would wear. Not only does this clearly identify them in the game world, it is also used as a symbol in his space, making it stand out from the rest of the city." Gavin Goulden

ABOVE: "Originally, we had mobile meth labs hidden inside trucks. These were eventually cut from the game." Jacinda Chew

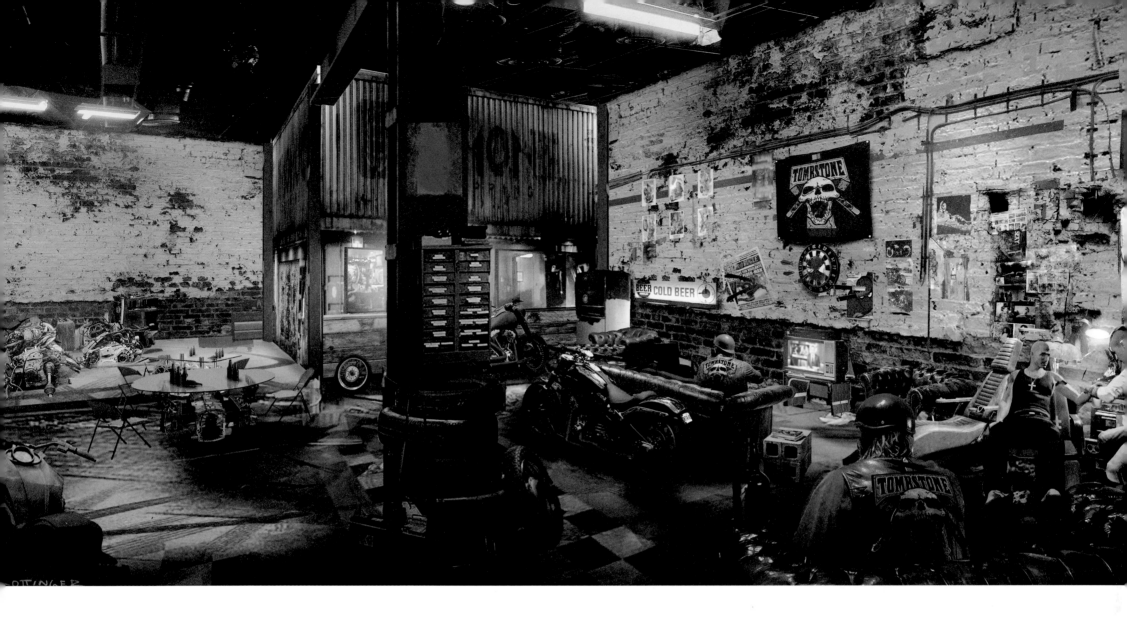

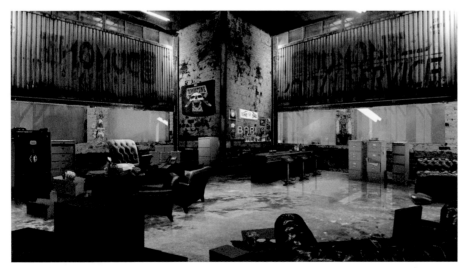

ABOVE: "In order to remain grounded, Tombstone's hangout needed to feel like the character himself—like he belonged in this environment." Gavin Goulden

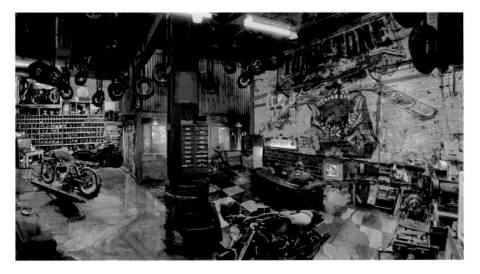

ABOVE: "Telling the story of a functional space with iconography and heavy machinery shows how this gang lives in the world, and conducts its business." Gavin Goulden

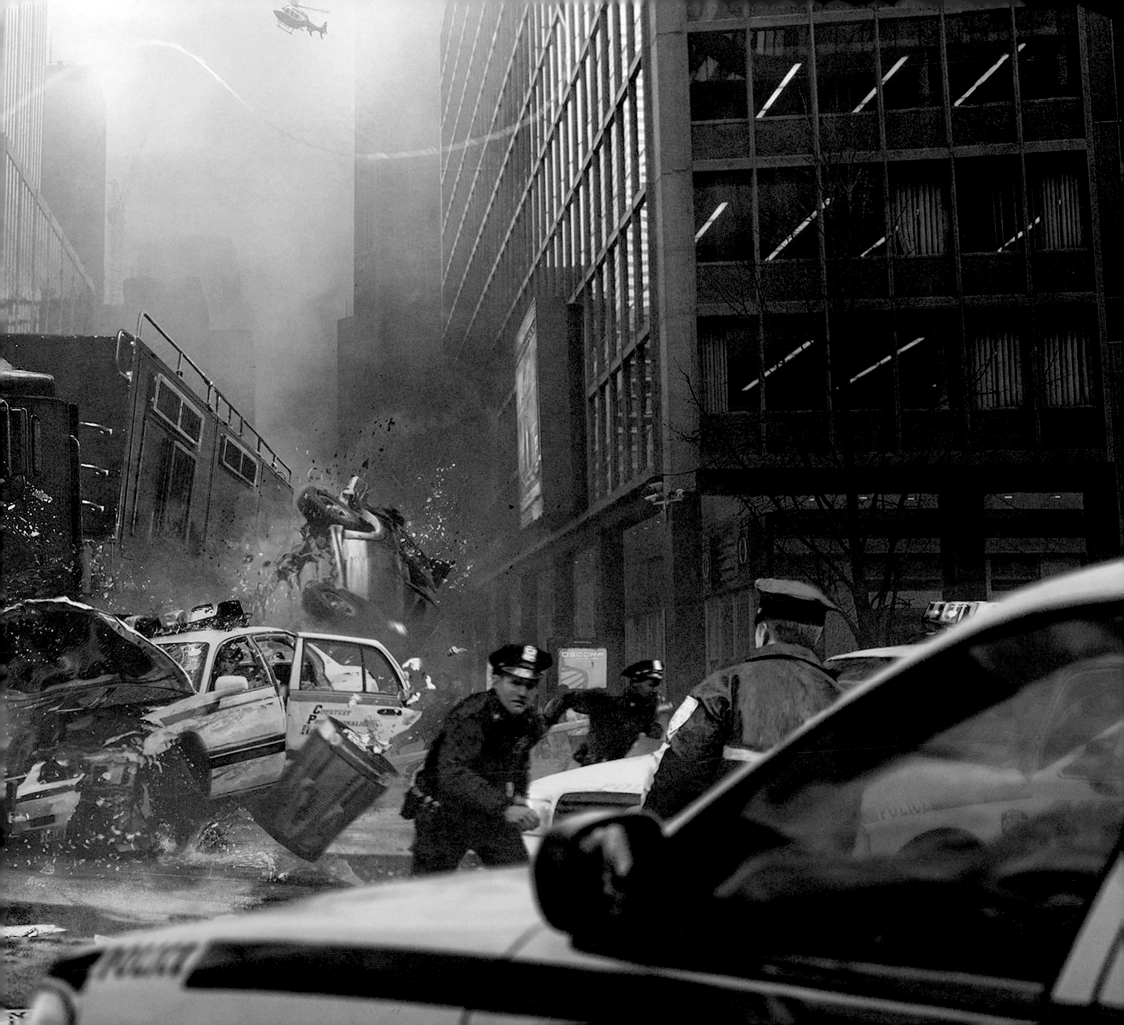

OSCORP TECH

OSCORP IS OF HUGE SIGNIFICANCE to the story in *Marvel's Spider-Man*, linking narrative threads and a key setting that we return to throughout the game. Any player's spider-sense would be tingling whenever they enter this environment, and thorough investigation is encouraged in order to learn about the work carried out here in the fiction, while simultaneously appreciating the extent to which Insomniac weaves valuable exposition into the DNA of these locations. "The displays are interactive," informs Jacinda Chew. "Players can walk up to each screen and watch a short presentation on various Oscorp innovations."

OPPOSITE PAGE, BOTTOM: Oscorp is a leading technology company. This is a design for an Oscorp exhibition at Grand Central Terminal showcasing some of the new technology it is working on.

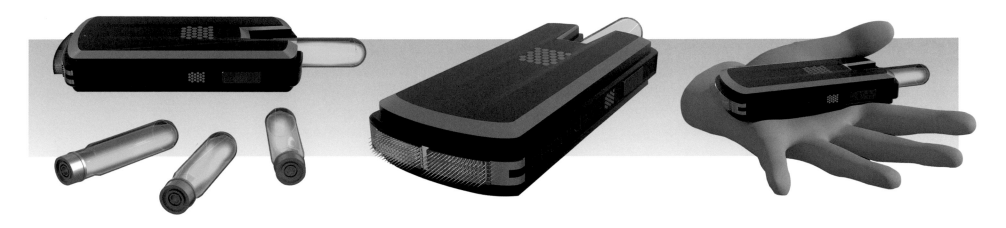

ABOVE: Prototype syringe injector.

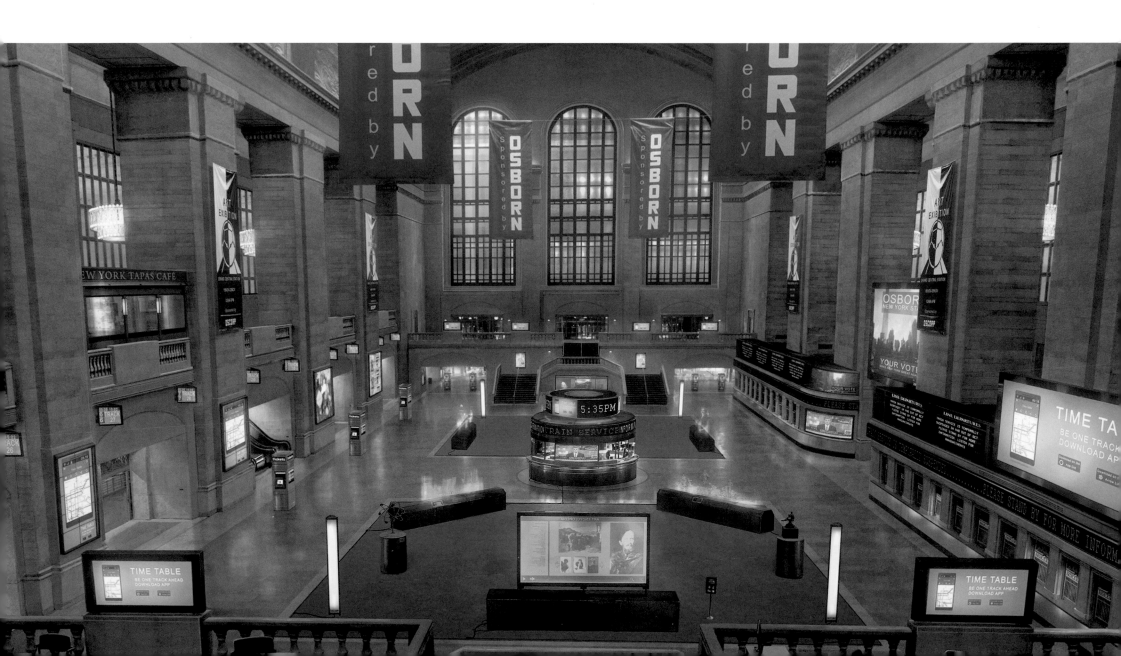

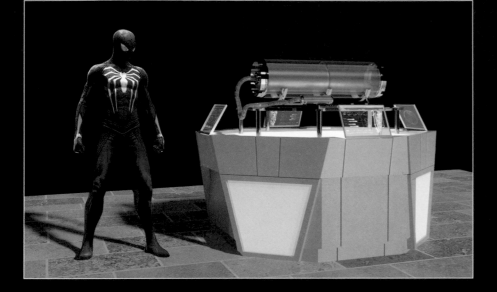
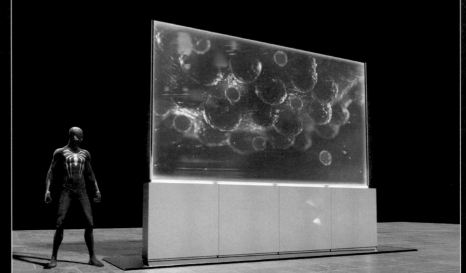

ABOVE: Dispersal device display (left). Spider-Man posed next to a display, to provide a sense of scale (right).

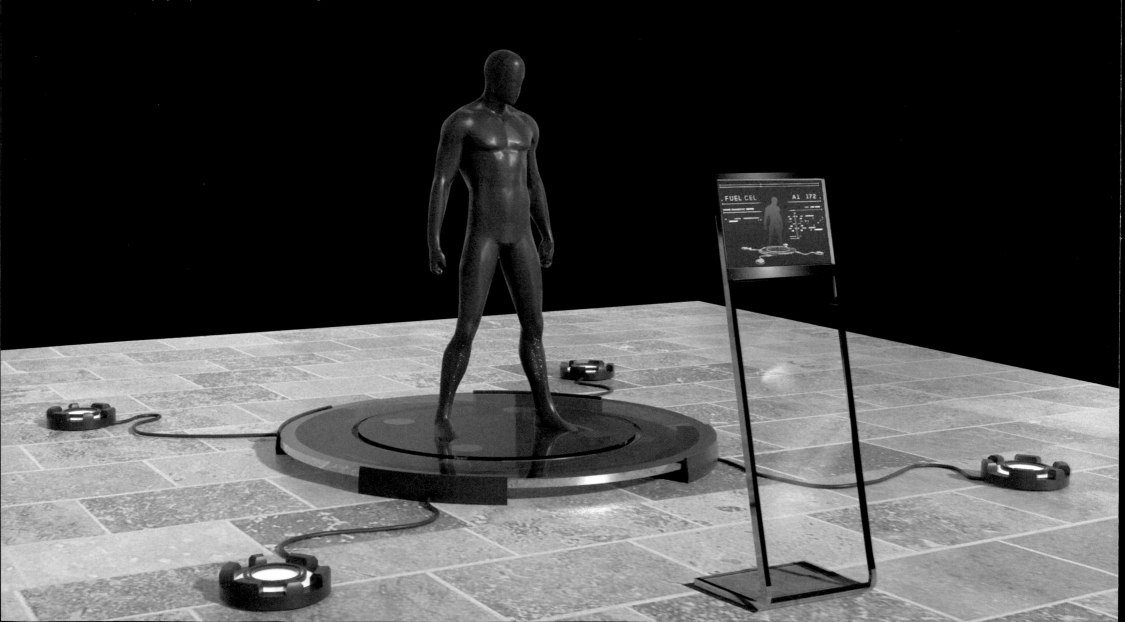

BELOW: "Some of Oscorp's technology also has military applications, and may seem familiar to Spider-Man comic book fans." Jacinda Chew

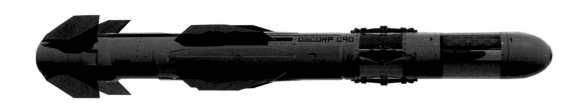

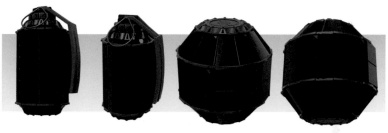

"A tremendous amount of our time and resources were devoted to creating videos. People spend a lot of time staring at screens these days, and we had to incorporate that aspect of life into our New York City, to simulate the visual noise of modern life."

Jacinda Chew

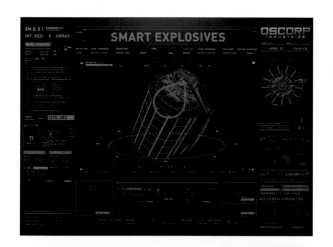

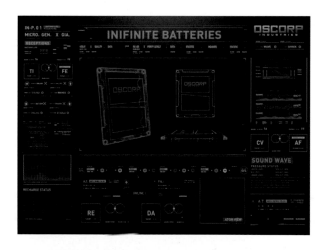

MISTER NEGATIVE

INSOMNIAC'S MODERNIZED SPIDER-MAN REQUIRED SIMILARLY stylized super villains with whom to tussle. The bar rose higher as time went on. "We started out a little more conservative," says Bryan Intihar. "But as we started to do more research on the characters and thought about embracing the super with the human, we wanted to make sure that they felt larger than life: for example by amplifying not only their powers, but also the way they look."

"The team had a lot of fun early on experimenting with Mister Negative's design," says Tim Tsang. "Ultimately, since this was his first big appearance outside of comics, and because of how his character was developed in the story, it made more sense for his design to be distilled down to the key elements that more closely reflected his original comic-book look."

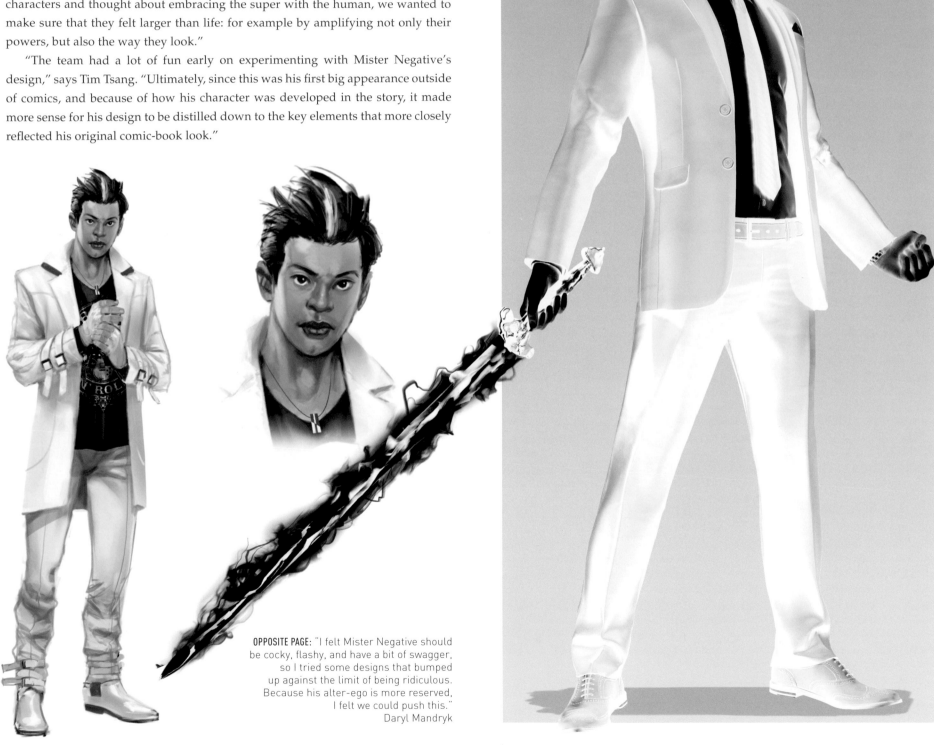

OPPOSITE PAGE: "I felt Mister Negative should be cocky, flashy, and have a bit of swagger, so I tried some designs that bumped up against the limit of being ridiculous. Because his alter-ego is more reserved, I felt we could push this."
Daryl Mandryk

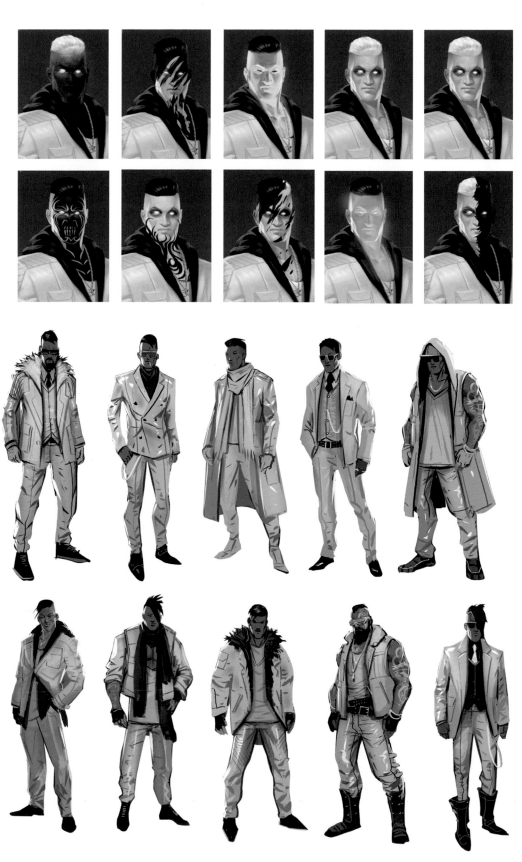

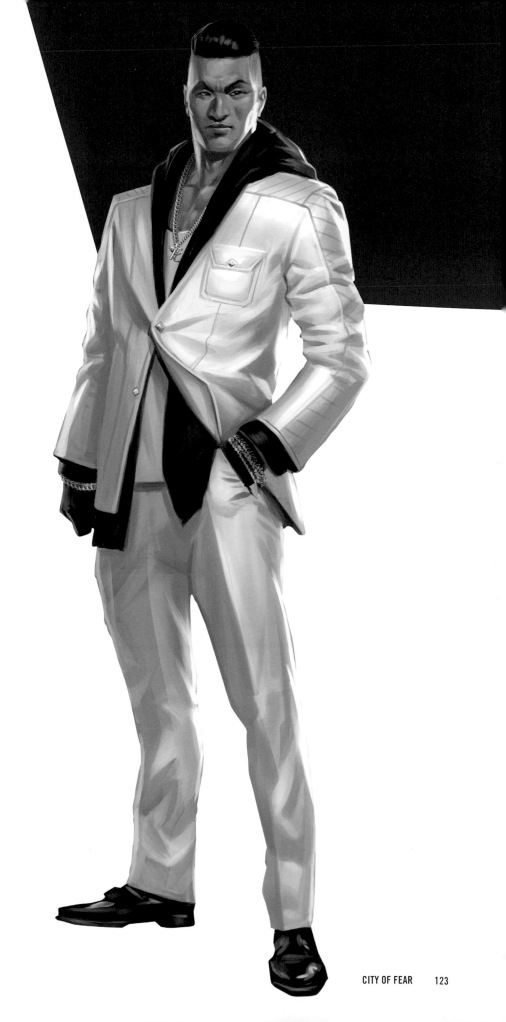

ABOVE: "Li's transformed state offered several potential looks. It was important that he's still recognizable, but also scary and shocking at the same time." Daryl Mandryk

DEVIL'S BREATH DISPERSAL UNITS

AS MENTIONED EARLIER, THE CREATIVE process at Insomniac is scrupulously managed. Concepts evolve with everyone kept in the loop. Insomniac had a design in mind for the dispersal units, but somebody came up with an idea to make it better, and align it more effectively with the story's main antagonist.

"Originally there was a normal bomb in Grand Central Terminal. It was also a puzzle that Mary Jane had to unravel against the clock," explains Jacinda Chew. "Eventually it had to be changed when the story evolved: the bomb was replaced with a device that can be used to disperse chemicals into the atmosphere. Although Oscorp's intent was pure, Mister Negative has other plans, and inserts Devil's Breath into the unit.

"These vastly different interpretations of a similar puzzle are a good example of a common problem game artists have to solve. Art has to be functional. In this case, both designs are puzzles. Art also has to serve the narrative, and is often critical to story comprehension. Concept artists are often asked to rethink items, but retain

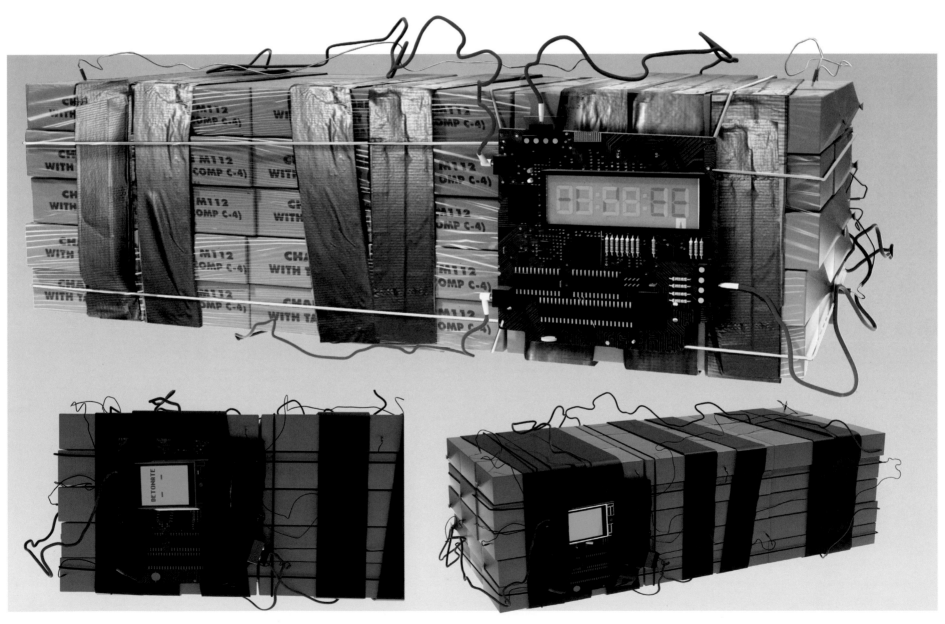

ABOVE: The original explosive bomb designed for Mary Jane Watson to contend with.

their functionality. Ultimately, changing the appearance and story behind the bomb made the narrative stronger."

According to Chew, "The key to making sure time and concepts aren't wasted is to make sure that communication is good at all times. The creative and design directors have to communicate their ideas clearly, and I need to provide clear direction to the concept artists.

"I communicate relevant information to Marvel. Approvals were done online, so I made sure they understood the gameplay and story purpose of everything they were reviewing, along with my art direction, so they could evaluate everything in context."
Jacinda Chew

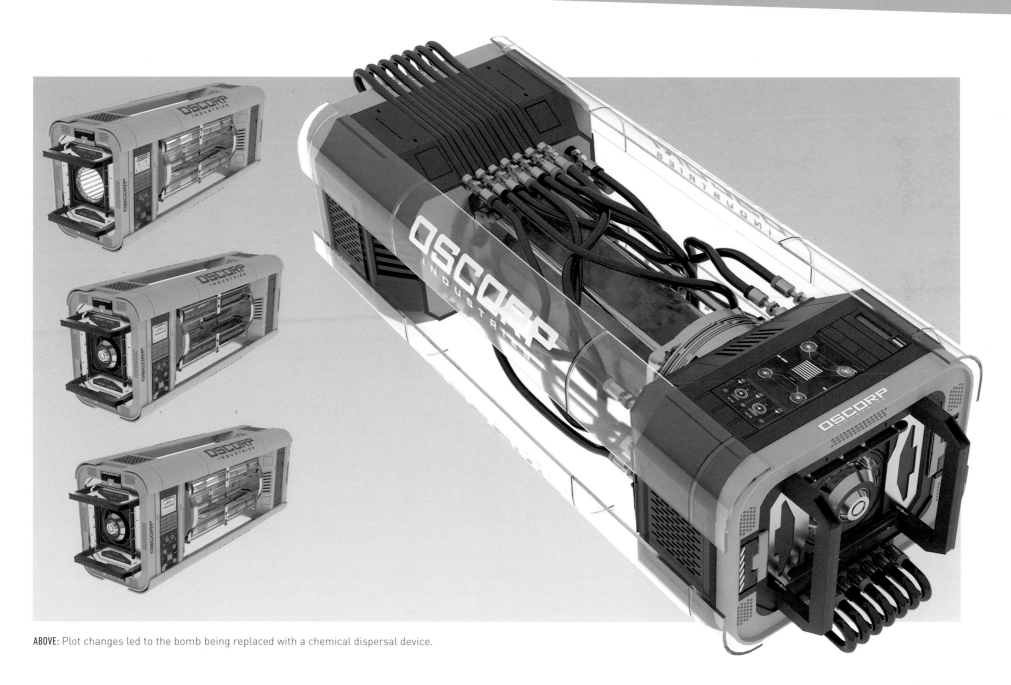

ABOVE: Plot changes led to the bomb being replaced with a chemical dispersal device.

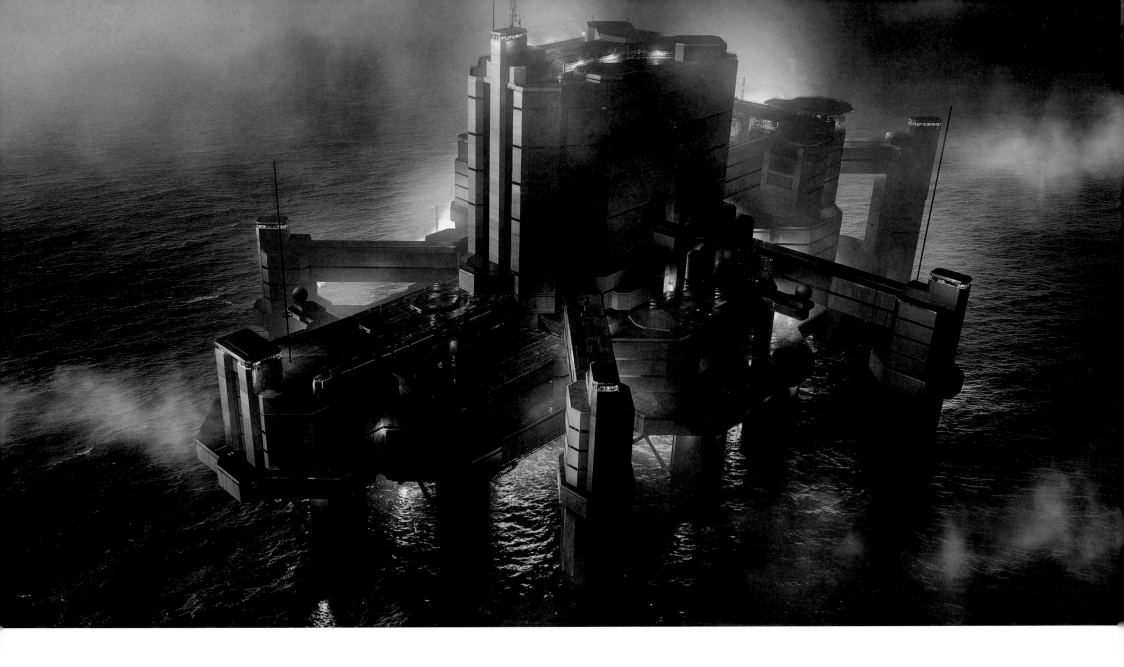

RAFT PRISON

IN ORDER TO HELP THE team imagine the world in which *Marvel's Spider-Man* would take place, Insomniac sought the assistance of concept artists Blake Rottinger and Dennis Chan.

"My initial task was to create realistic environments," says Chan. "This evolved into key frame art, with more environments including characters in specific story-based 'beats'. It was pretty much based on a small script or description they had; ideas they wanted to explore."

Bryan Intihar found that Chan's contribution helped enormously. "Dennis was one of the first artists we had working on the project. I call him one of my

inspiration peers," says Intihar. "Jacinda would come to me and say, 'Hey, what are you thinking about for the next mission? What do you think of this character? What about this moment in the game?' I would write a couple of sentences on each one, and Dennis would create literally what I had in my head. When somebody is working on one of our missions, and has that piece of artwork, it really inspires us to consider how this is going to feel, look, and play."

Explains Chan, "All my interpretations were based on the descriptions that I got for every piece. It was almost like a puzzle for me: 'Ah, now I understand the direction they're going for.' I wasn't involved in the backstory. It's just the script. A

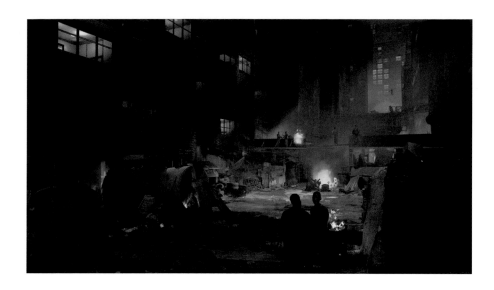

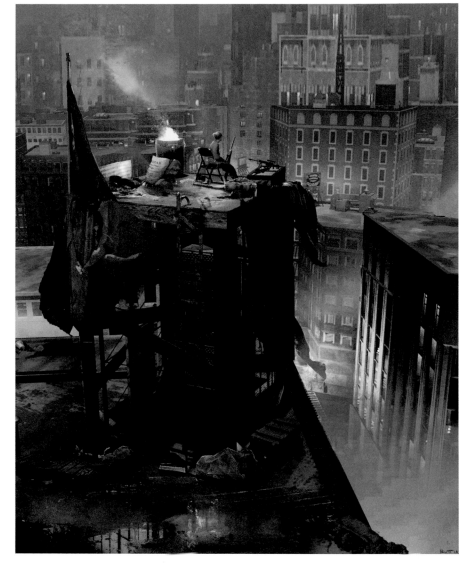

specific part of the script for a specific shot."

"What kind of environment could it be?" asks Chan. "Maybe it's a restaurant next to this place, and they would throw their trash into the back alley. I really want to get those subtle details that you usually don't pay attention to—but they are there, and they support the overall look and feel.

"For The Raft we wanted to try a different idea. Instead of being on a rock/island we explored the concept of the prison being on a man-made base, like an oil rig. To make for more interesting gameplay, we created towers with bridges to enable Spider-Man to swing above and under."

"Every place has a story. A dirty village will look very different from a dirty street downtown. I want the player to almost smell and taste these places. There are a lot of details—and every detail is planned."
Dennis Chan

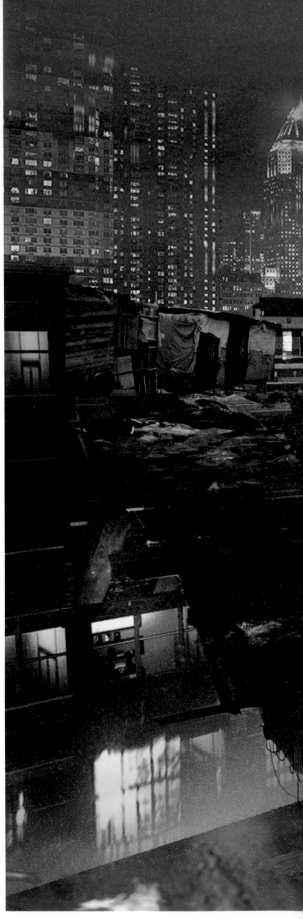

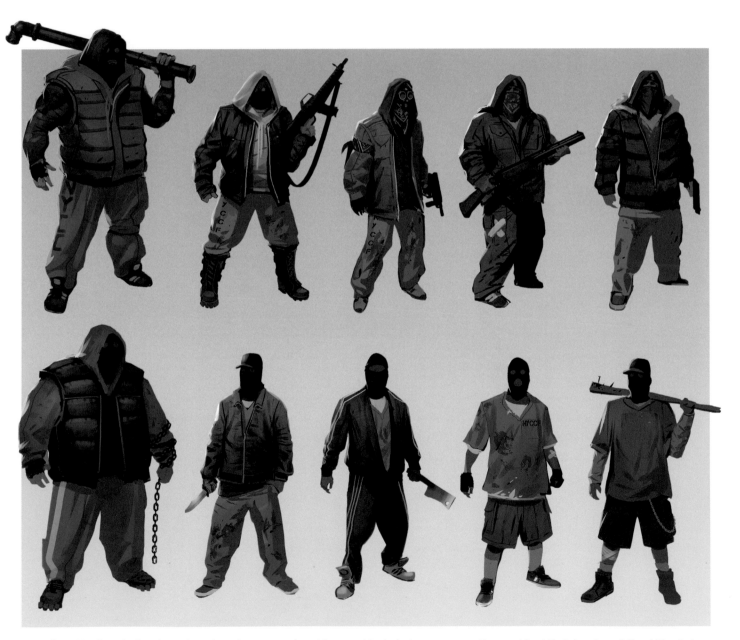

ABOVE: "The idea here is that these thugs have just escaped, and have grabbed whatever weapons they could get their hands on." Daryl Mandryk

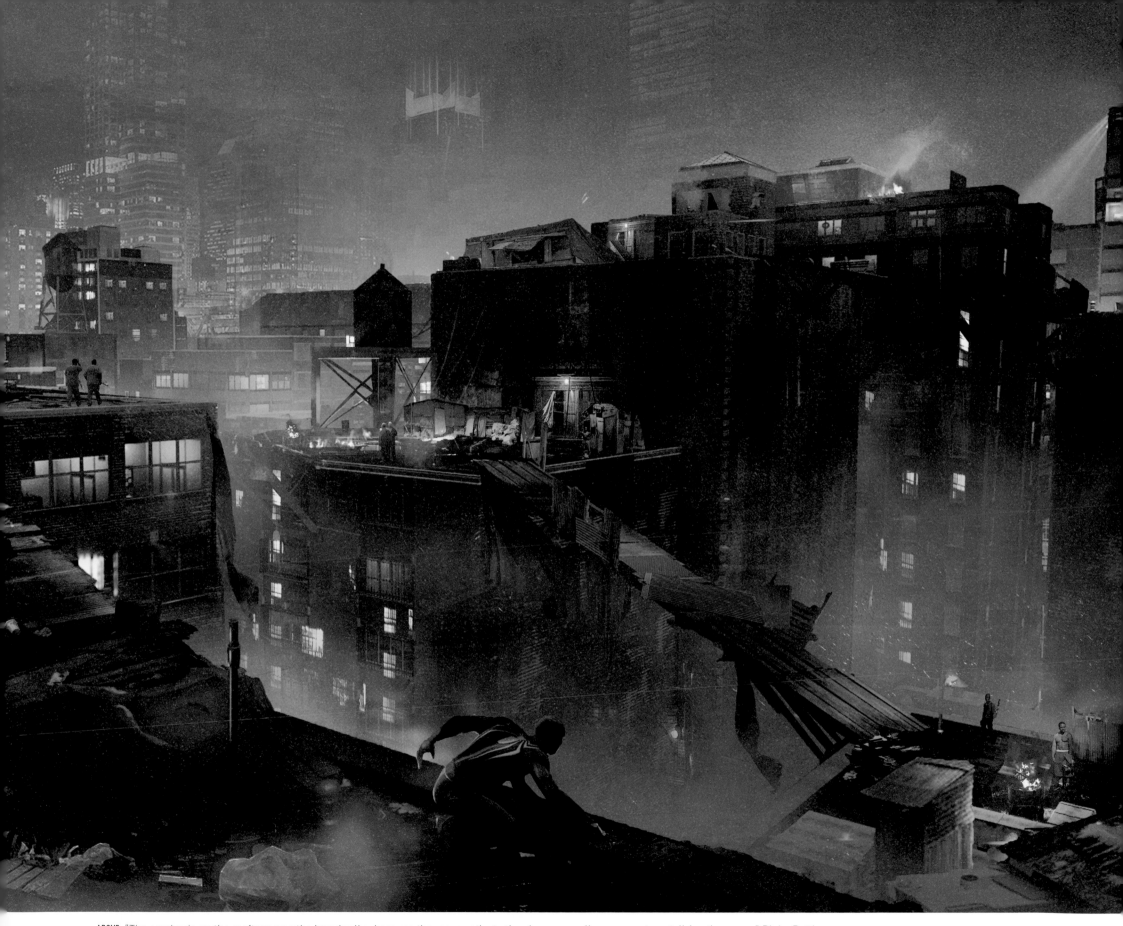

ABOVE: "The emphasis on the rooftops was the boardwalks, because they gave paths to the player, as well as compartmentalizing the space." Blake Rottinger

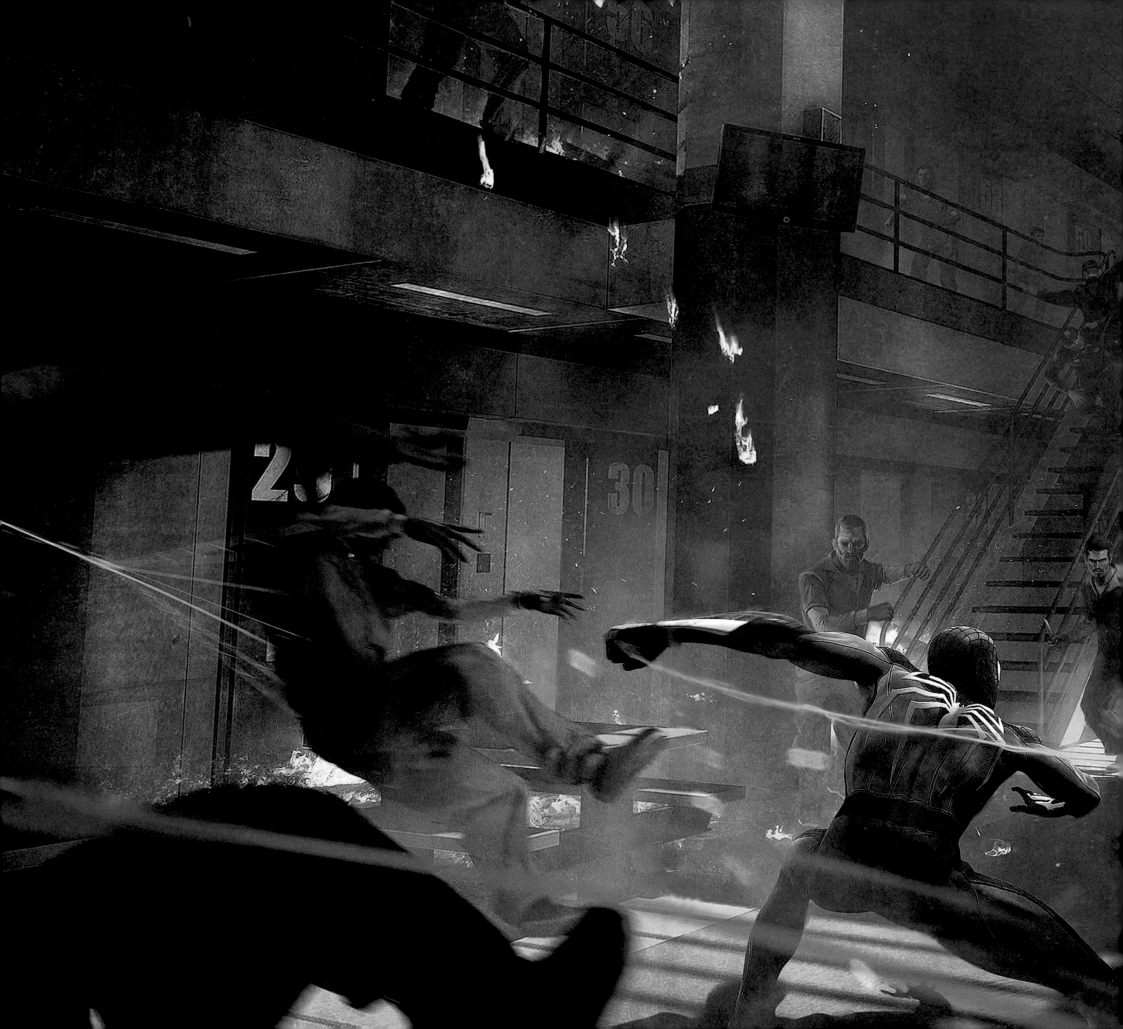

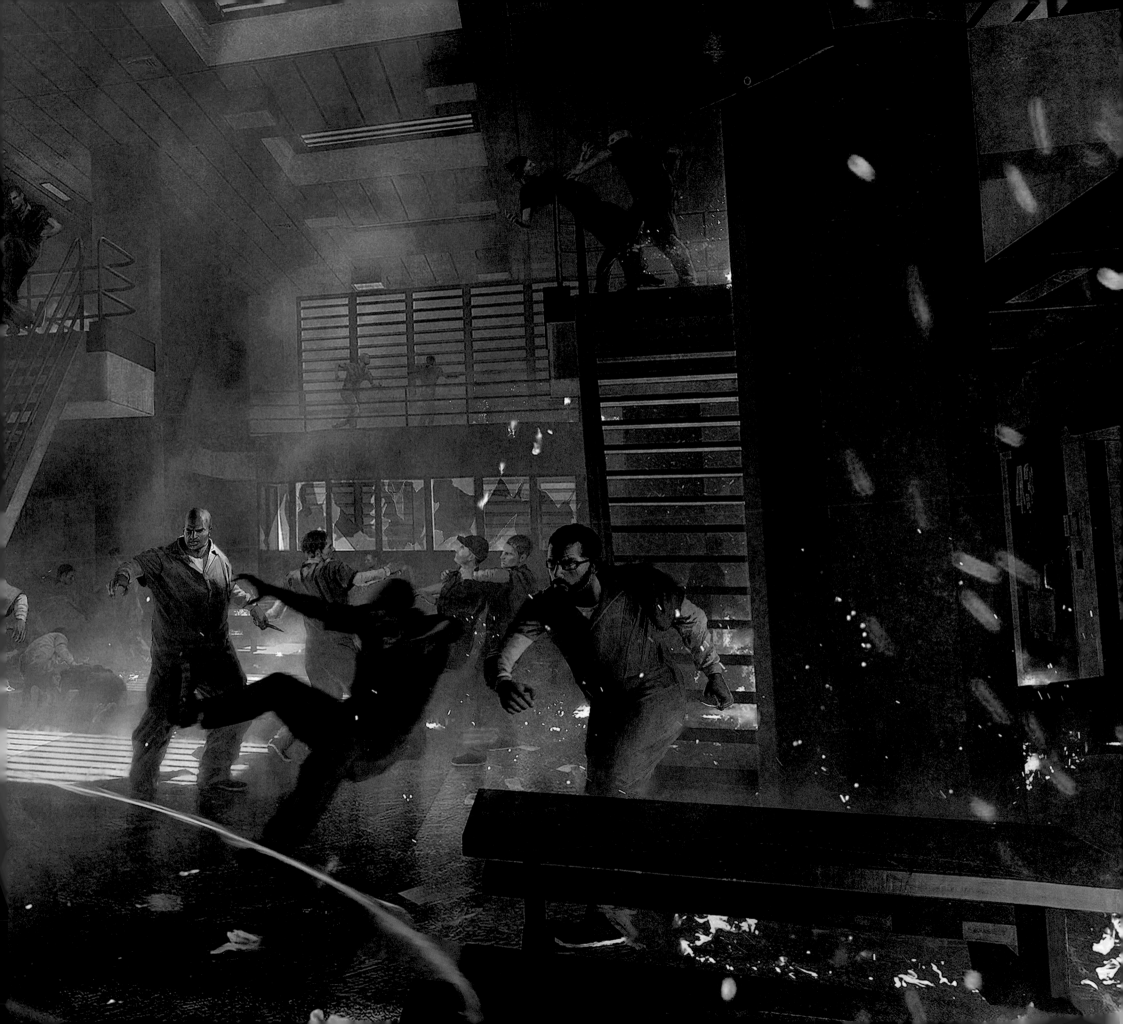

ELECTRO

"WE LOVED THE TEAM'S TAKE on Electro's design," says Marvel Games' Tim Tsang. "It is fresh and new, and has a ton of attitude and style that speaks to who he is as a character. Even though this design does not have the lightning bolt design from the comics, the team retained a lot of the visual elements and colors that help convey that this is Electro. While using a more grounded approach through science and technology to visually tell the story of how his rigged-up jacket helps him channel and control his powers, the team was also able to cleverly integrate his star-shaped mask design through burn scars directly on his face."

"We wanted to take more liberties with Electro in order to make him fit our story," explains Gavin Goulden. "He was originally intended to be more of a brooding personality, though with a harness that increased his super-powers to a level Spidey has never seen. With this original take, we tried to show his hateful nature by covering his face with hair and a hood. Eventually we decided that this took away from what made Electro recognizable, so we brought back elements to tie him more closely to common Marvel imagery. For example, we altered his color scheme to better match the classic green and yellow outfit, as well as the star-shaped scar and baldness seen in later versions of the character."

OPPOSITE PAGE, TOP: A moody look with a hood to hide inside.

OPPOSITE PAGE, BOTTOM: Closing in on the final design, with distinctive star-shaped scar and defiant expression.

BELOW: Daryl Mandryk's punk iterations of Electro, in pursuit of a persona to gel with Insomniac's narrative spark.

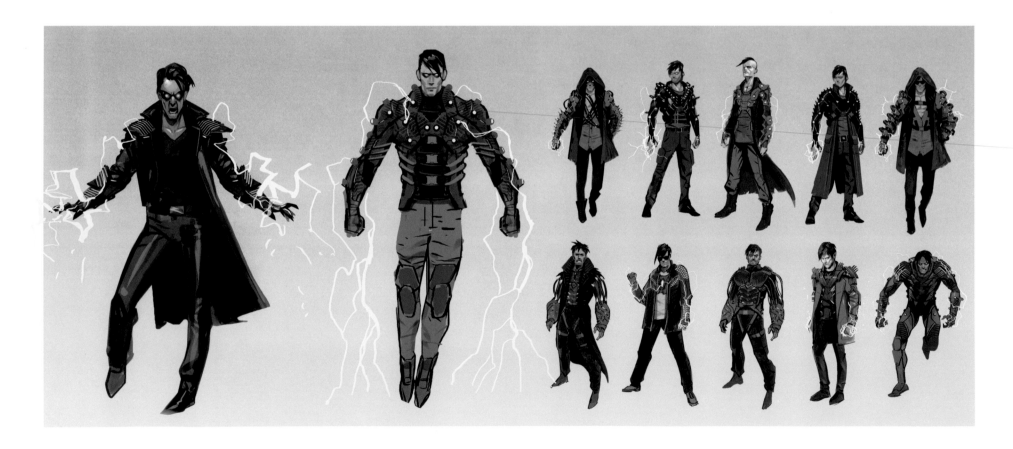

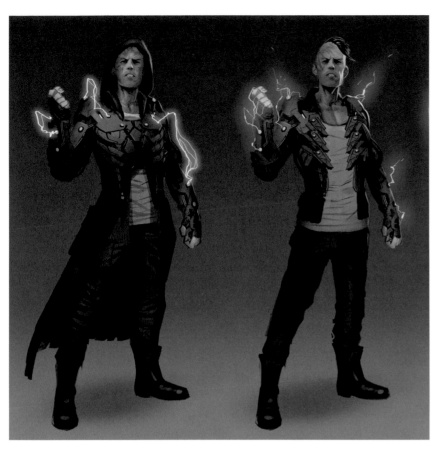

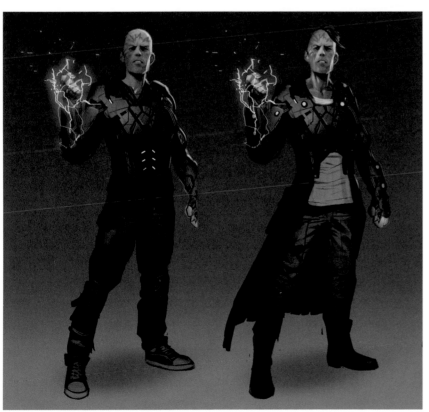

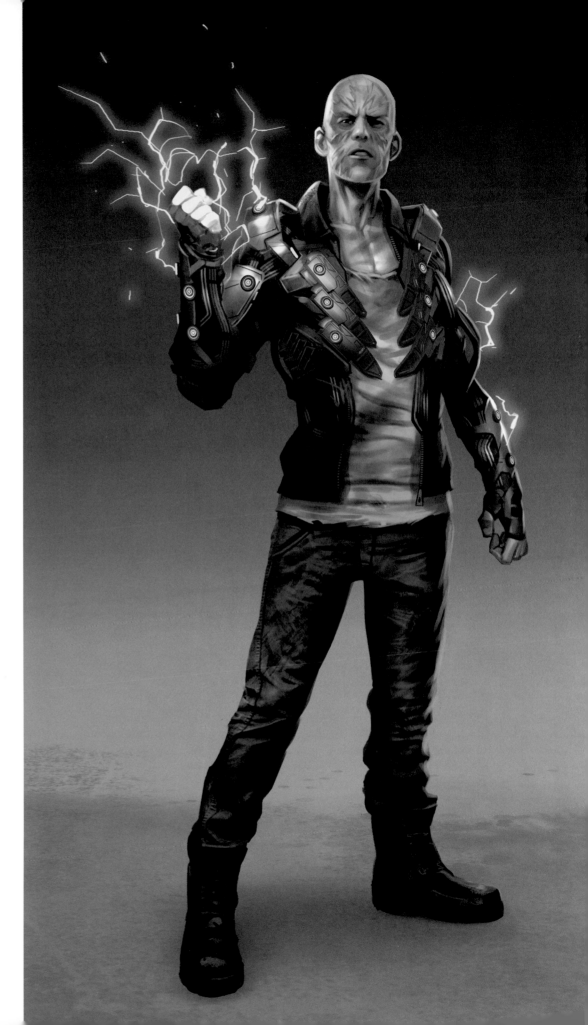

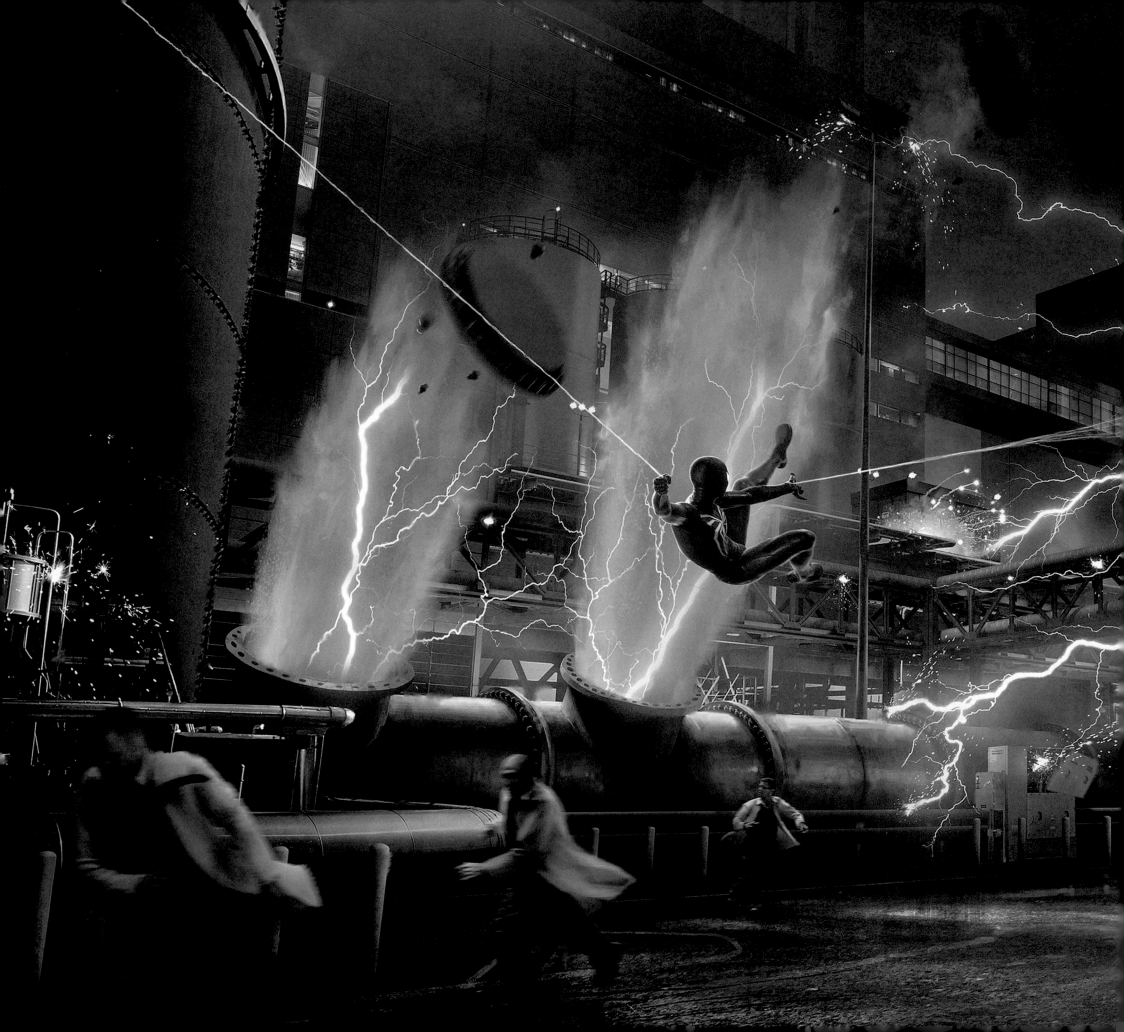

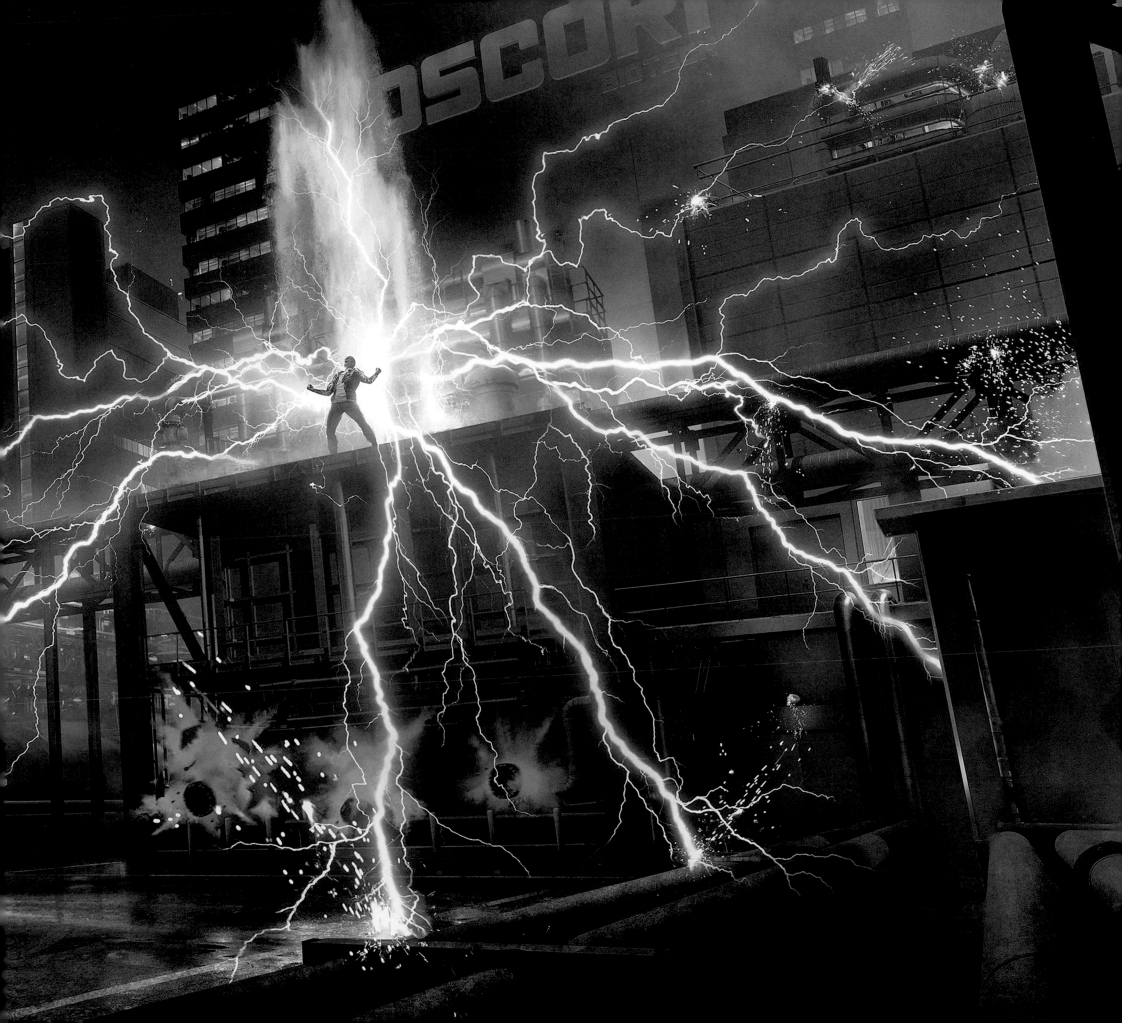

"Below is an Oscorp device that is used to boost the output of older power stations. Unfortunately, they make the perfect targets for the power-hungry Electro."

Jacinda Chew

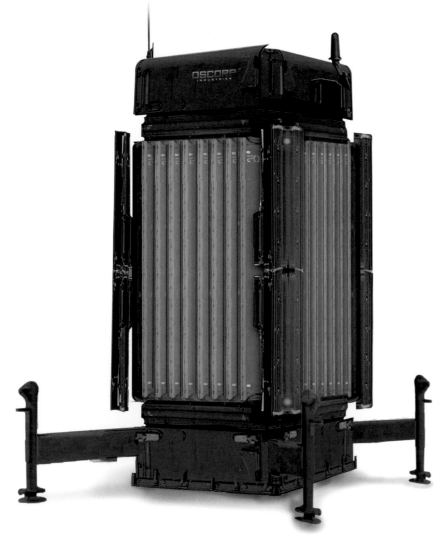

RIGHT: "Our power plant was inspired by an actual red brick power plant in Manhattan." Jacinda Chew

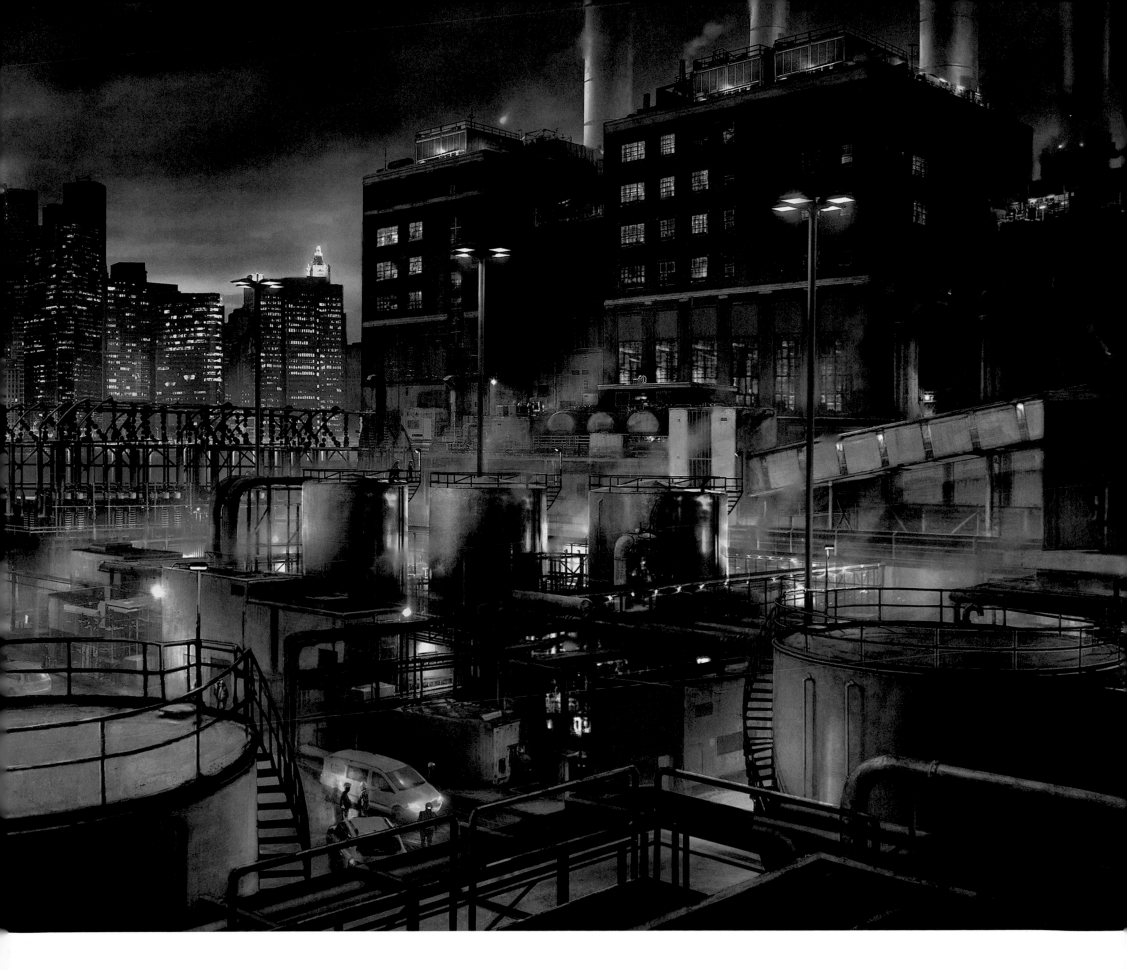

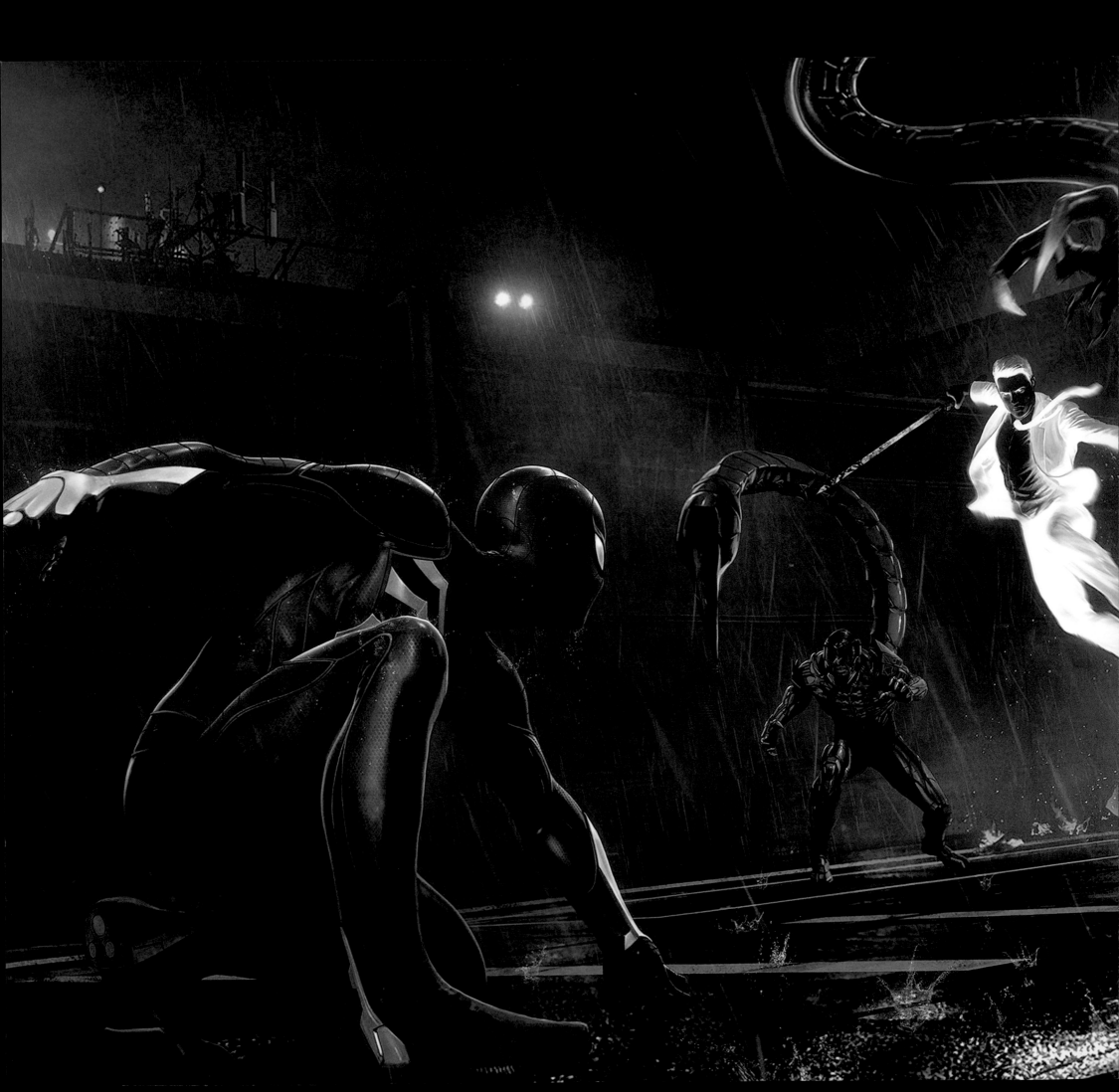

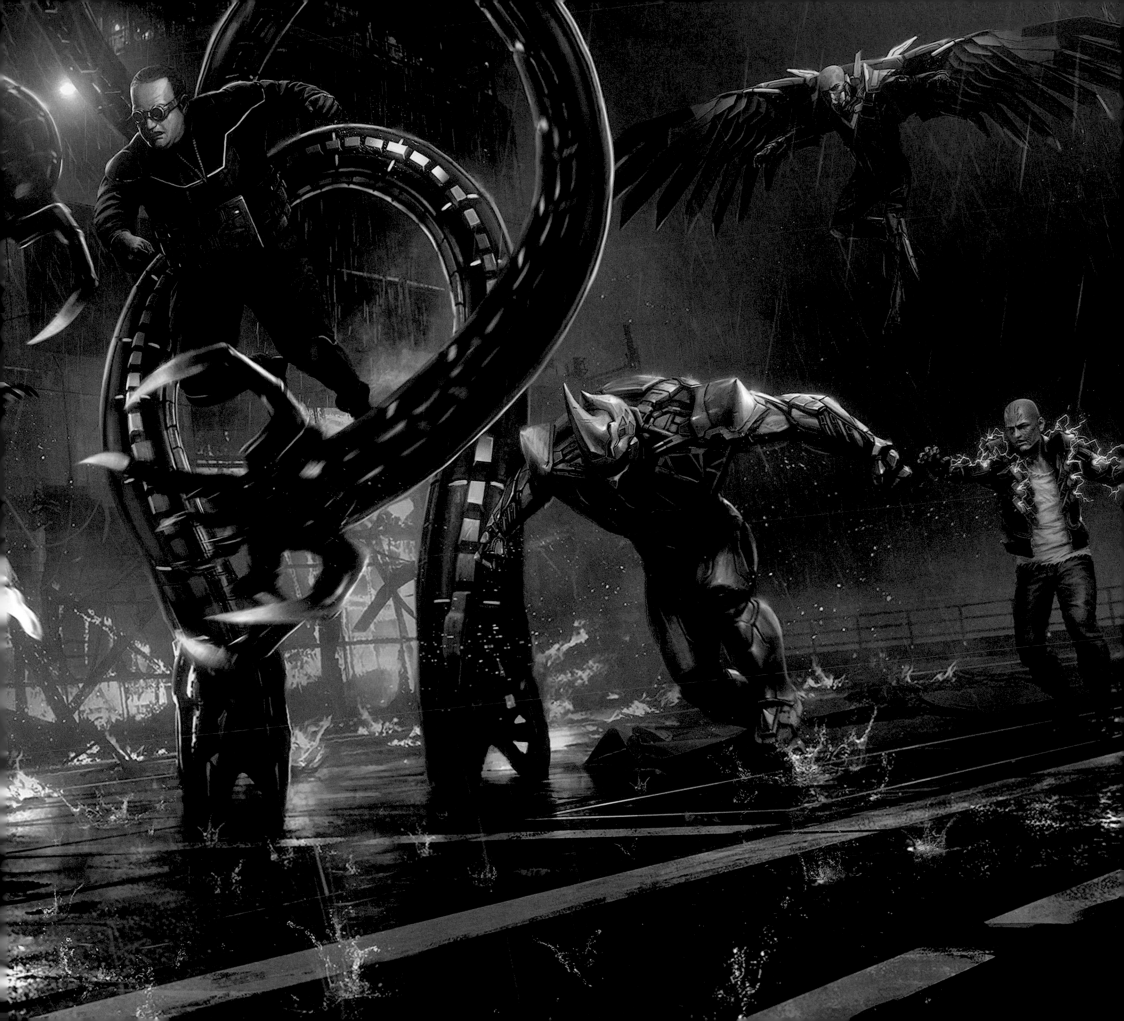

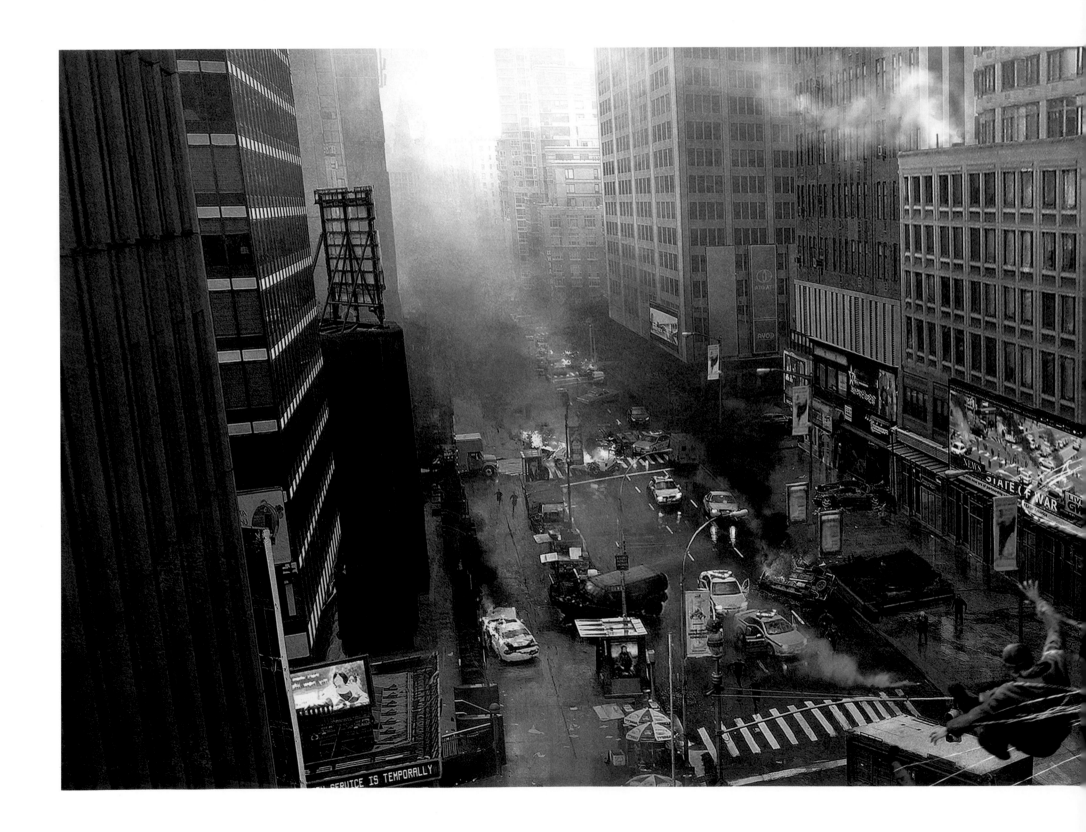

DOCTOR OCTOPUS

HE EVOLUTION OF DOCTOR OCTOPUS' design in *Marvel's Spider-Man* is a valuable study of the iteration process between Insomniac and Marvel. Although this is a partnership, one could also picture a relationship between three parties, the third being the all-important story.

"The process is immensely collaborative, and starts with Insomniac sharing their ideas for the concept along with a series of sketches to convey their intentions," Marvel Games' Tim Tsang explains. "From there, we provide our thoughts and feedback to the team, and discuss specific aspects of the design relating to anything from visual aesthetic and storytelling, to gameplay and functionality. We also constantly challenge ourselves to motivate the designs through the Marvel storytelling lens, and to ensure the designs have purpose and function. To consider what came before and analyze what worked, and what did not.

"How do we innovate and evolve existing designs, while questioning what's important? How do we bend and not break the original designs? Through that creative negotiation and iteration process we agreed on a version that we feel is best for the brand, the story, and the game."

Jacinda Chew explains: "We always have to look at what was done before, and

"Doctor Octopus went through a lot of iterations. Initially, Insomniac was going for a more organic/alien feel for his arms. Marvel eventually guided us toward a slicker, more mechanical approach."

Daryl Mandryk

OPPOSITE PAGE: "This was a near final version of Doctor Octopus. The arms had become slicker and more dangerous looking." Daryl Mandryk

BELOW: "These early Doctor Octopus sketches have a more military look." Daryl Mandryk

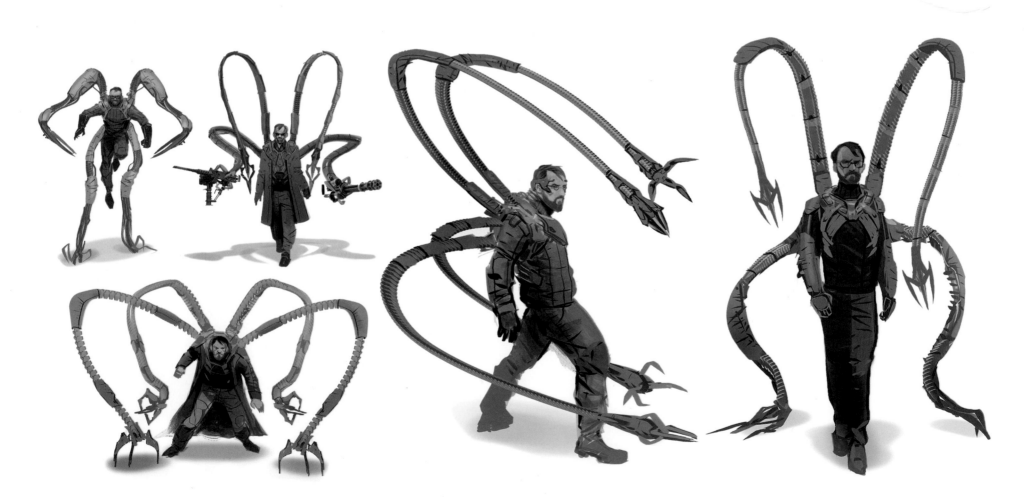

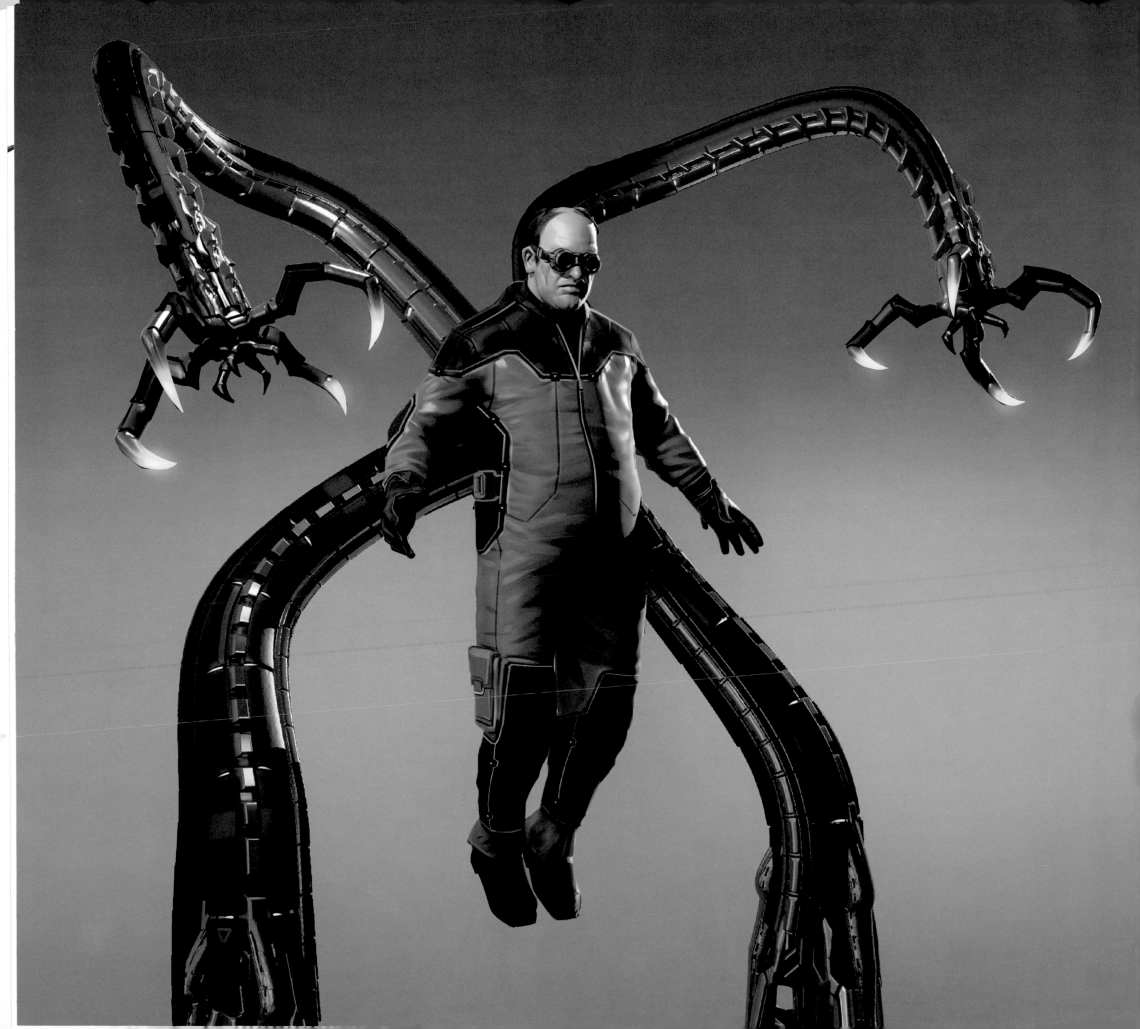

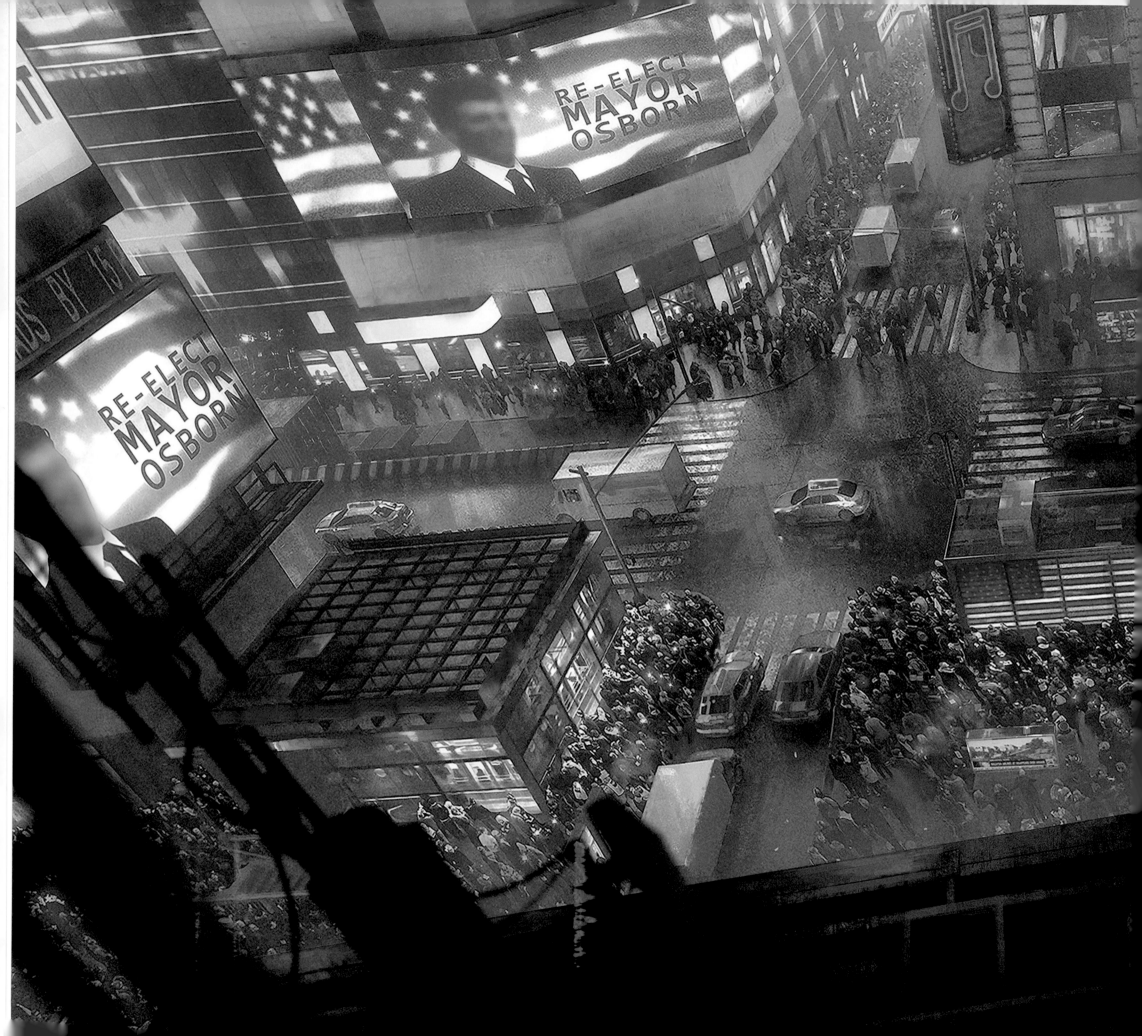

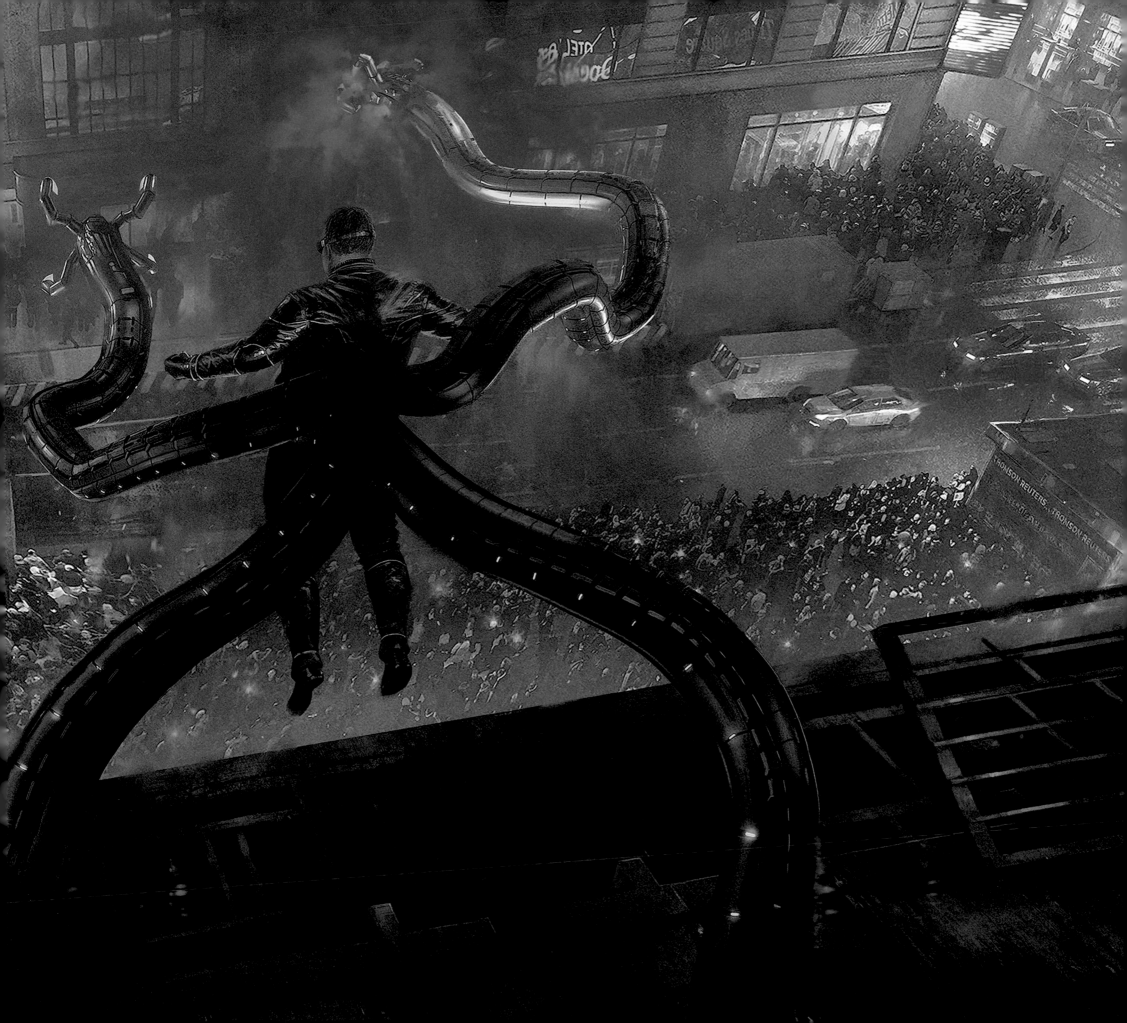

VULTURE

ADRIAN TOOMES' ALTER EGO POINTS to the extensive push and pull of ideas surrounding every repositioning of best-loved characters, friend or foe. The common trends for Insomniac's designs within *Marvel's Spider-Man* were 'convincingly real-world' and 'compelling design'. With Vulture, that combination became a tremendous success while retaining a classic look.

"For Vulture, we began by taking notes from flight suits, and near-future military technology, which helped inform what he could make his suit from, and what could realistically fit into our world," recounts Gavin Goulden. "Riffing on his classical design, we began to pull in these elements which transformed typical elements fans would expect into technological upgrades, such as the feather cowl becoming a flight harness, a retractable winged jetpack, and the bird-like visor, which plays into his character and gives him such an easily recognizable silhouette."

Marvel's response was hugely positive, congratulating Insomniac on its knack for invention. "The team's Vulture design is another one that we felt struck an excellent balance between capturing the essence of the original comic design through a more modern and believable interpretation," comments Tim Tsang. "The rebreather design that doubles as a beak was also very smart, and instantly own-able because of how it helps build the character in a new but authentic way."

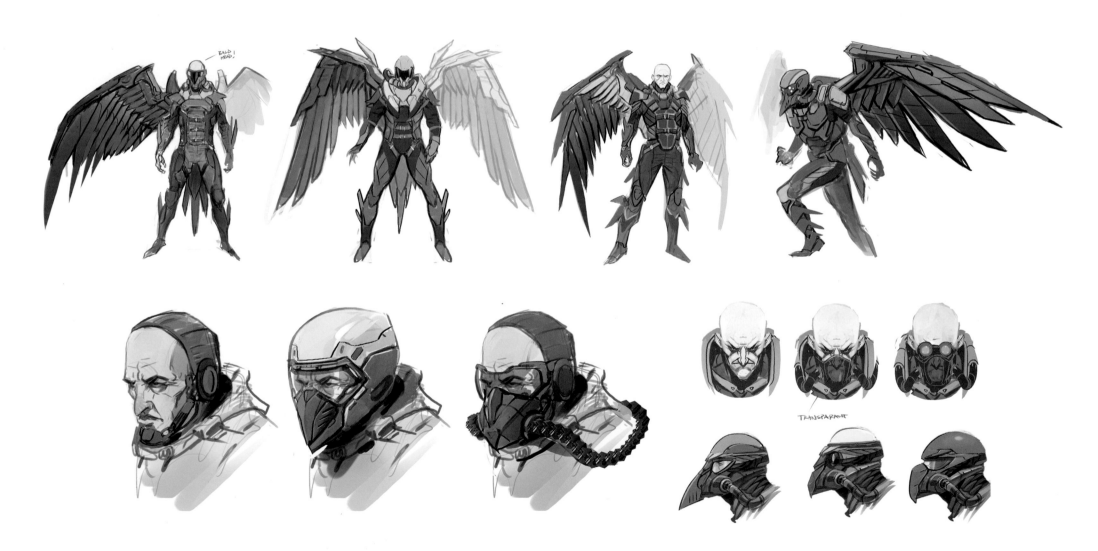

ABOVE: Exploring ideas related to aviation, and the necessity to breathe at altitude.

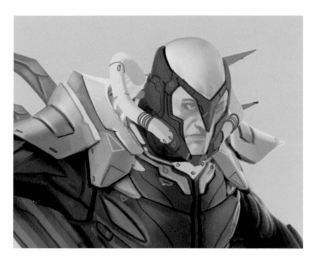
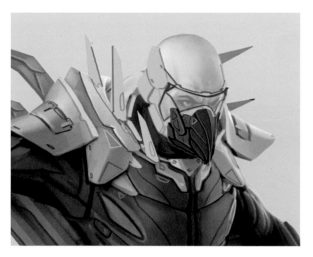
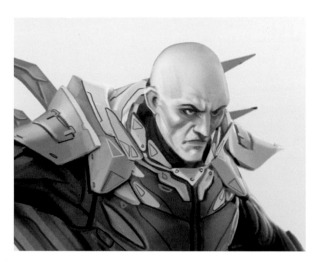

ABOVE: Concepts leading up to the final design, ultimately retaining classic elements but with a modern design twist.

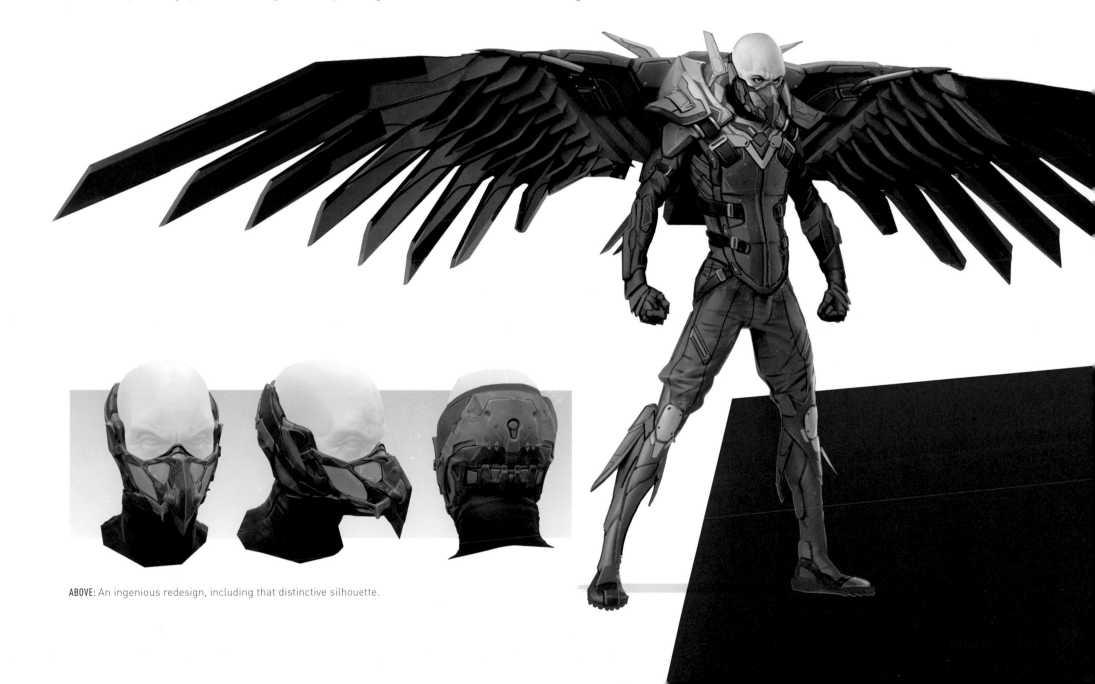

ABOVE: An ingenious redesign, including that distinctive silhouette.

STREET ART

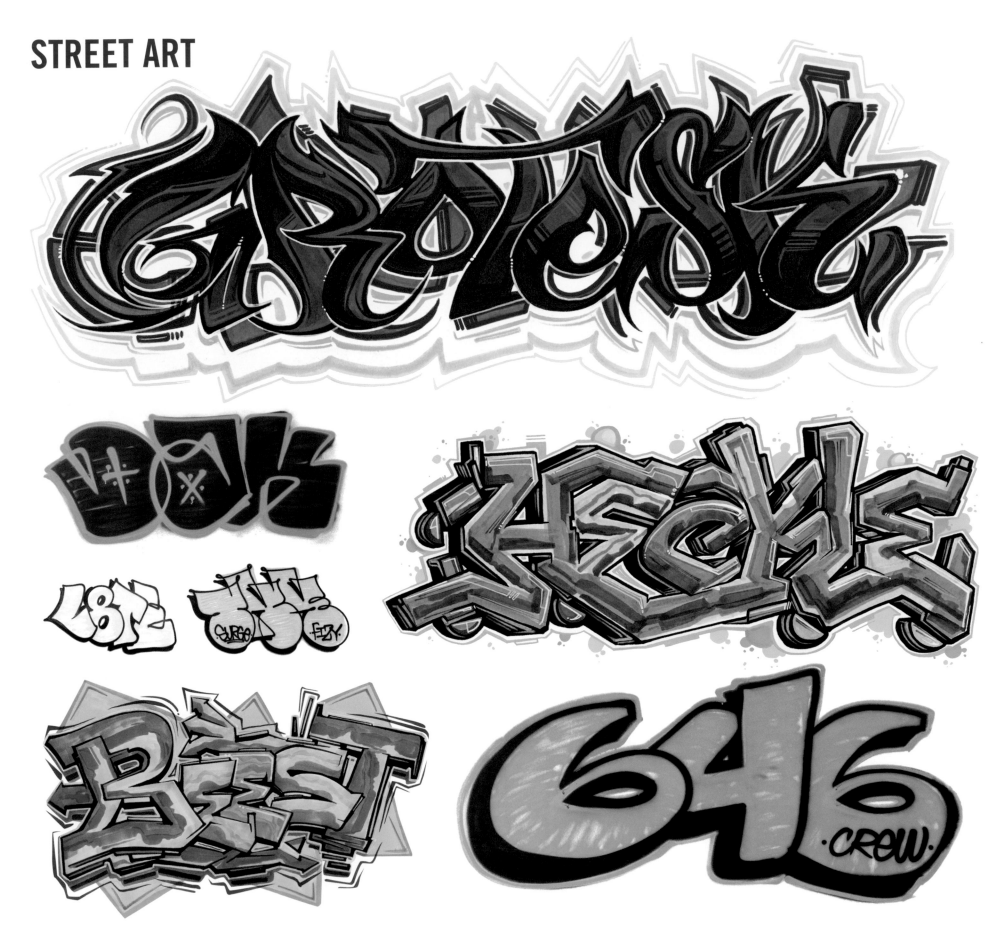

"Given that video game environments seek to be as realistic as possible, it was reassuring that Insomniac had the graffiti art recreated by a real graffiti writer, instead of using pictures and possibly not giving credit to the artist. Even worse, the art might have ended up looking wack and out of place if a non-graffiti artists had created it."

Plek One

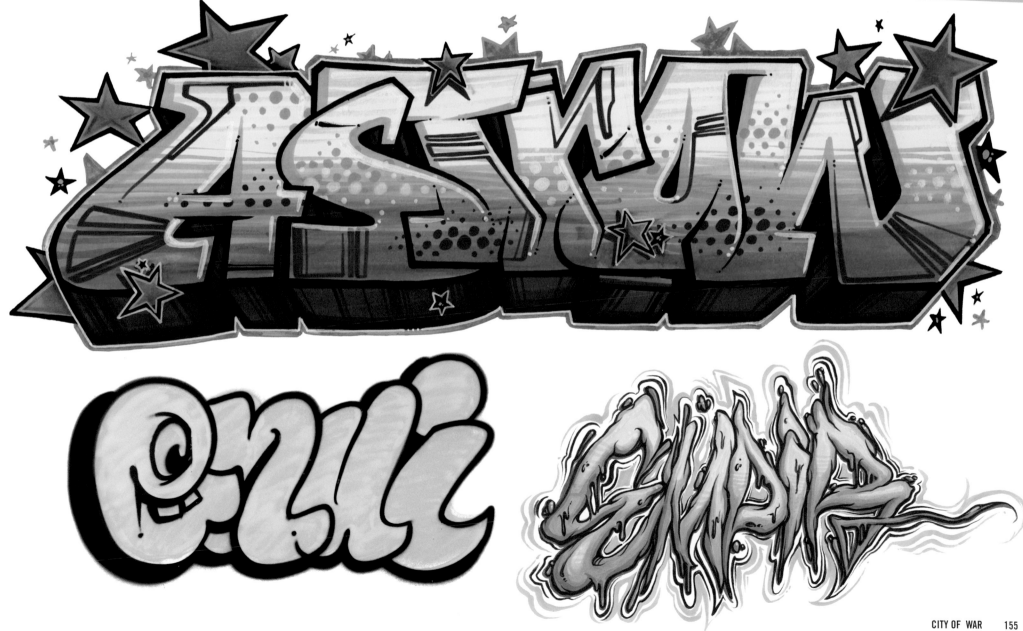

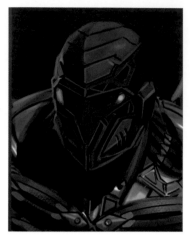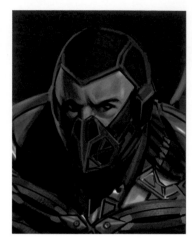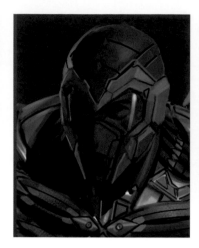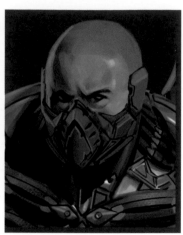

ABOVE: Various ways to obscure Mac's features, but crucially not his whole face.

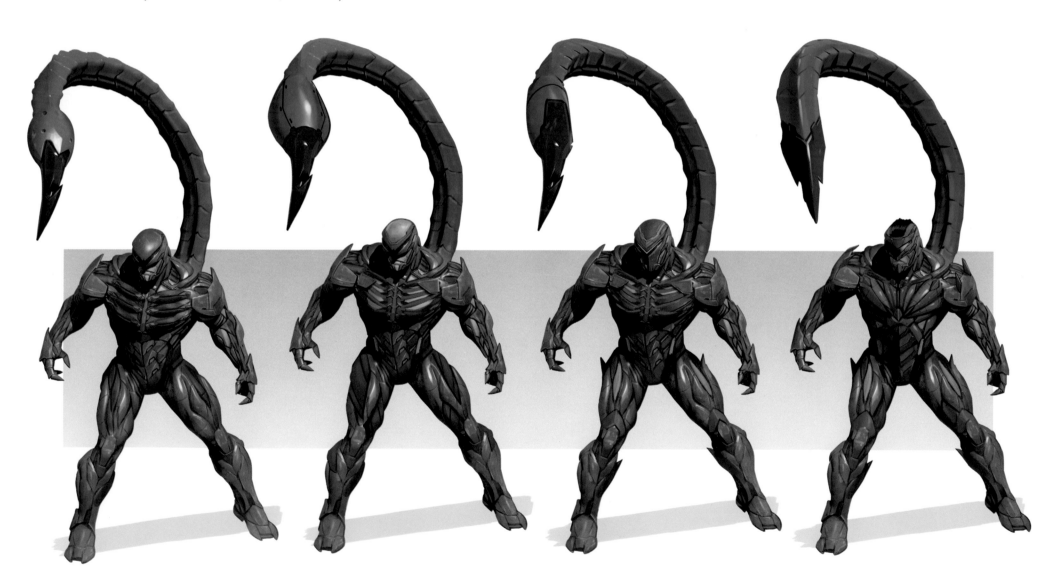

ABOVE: "These Scorpion sketches explore how much skin to expose, as well as variations of the helmet. The bulbous tail design was an early favorite and remained pretty much unchanged throughout the process." Daryl Mandryk

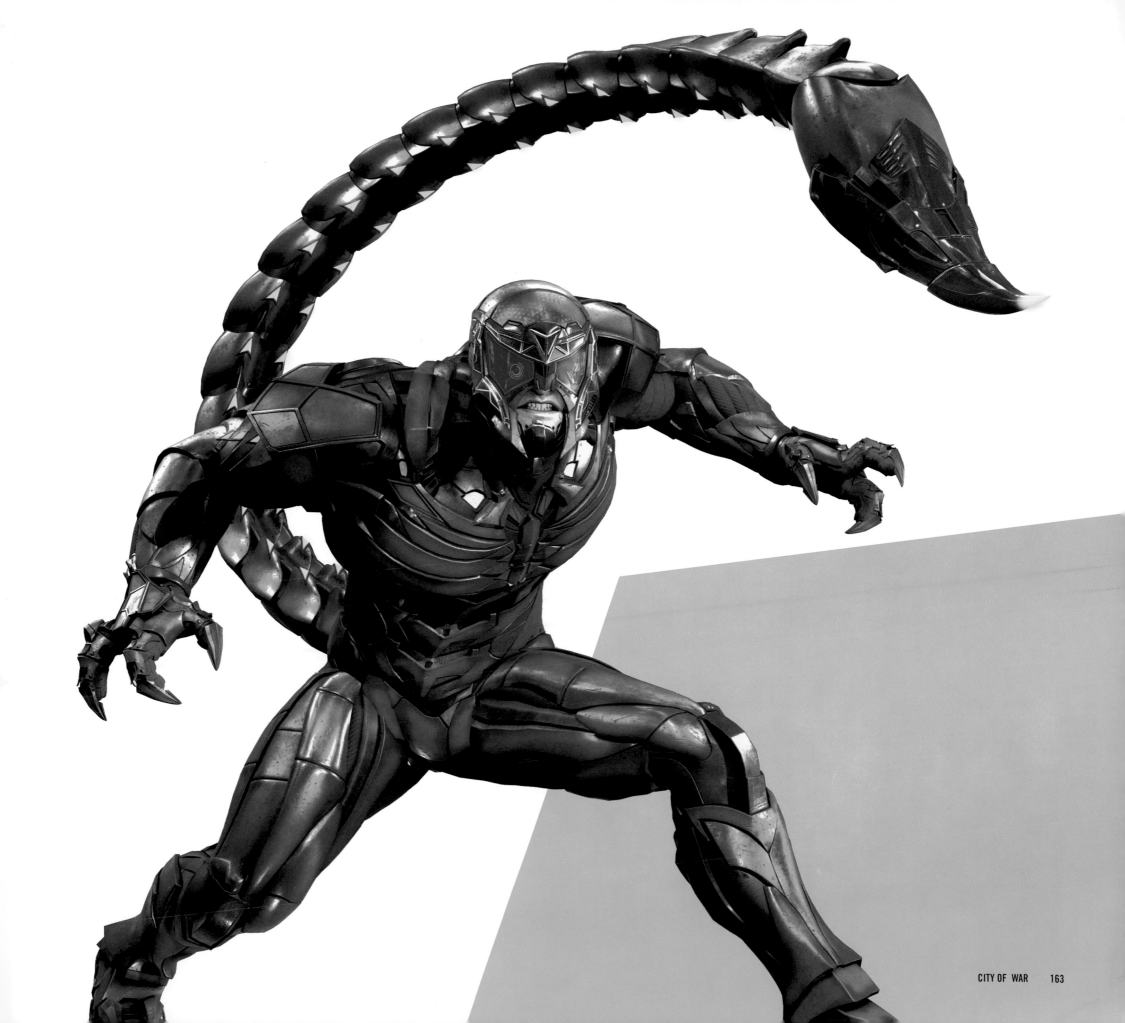

RHINO

SETTING THINGS STRAIGHT ON INSOMNIAC'S visualization of Spider-Man's largest physical foe in the game, Gavin Goulden shares that, "Rhino is typically a brute, and can be seen as just a villain who smashes things up. We wanted to go deeper with this character's design by digging into his purpose, and tell the story of a behemoth who is suffering. While his size was always part of his design, we toyed with the idea of having an organic suit—ones that he would wear, and ones that were fused to his body—before settling on heavy machinery.

"Not only does this give Rhino a place in our world by showing functionality and realism to his design, it serves the secondary purpose of being more of a burden to the character, and something no other character could handle—making it a pretty iconic design for a very well-known villain."

Dennis Chan was tasked with placing Rhino and Scorpion in the context of a battle against Spider-Man, and recalls the to-and-fro between himself and Insomniac. "Jacinda's descriptions gave a lot of space to interpret what I was reading. I would create sketches based on that—six different concepts for this scene alone."

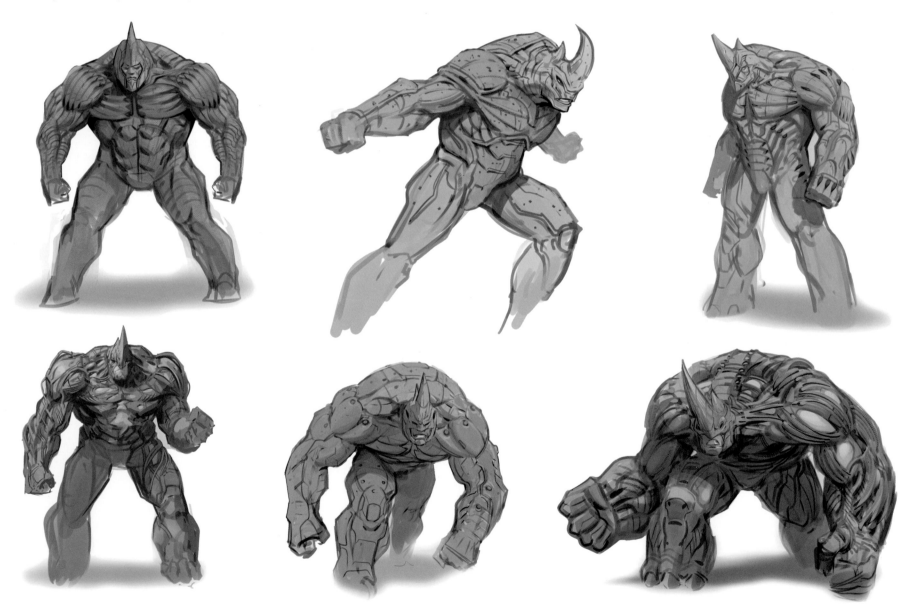

ABOVE: A more bestial Rhino is considered, before feedback reigned things in a little.

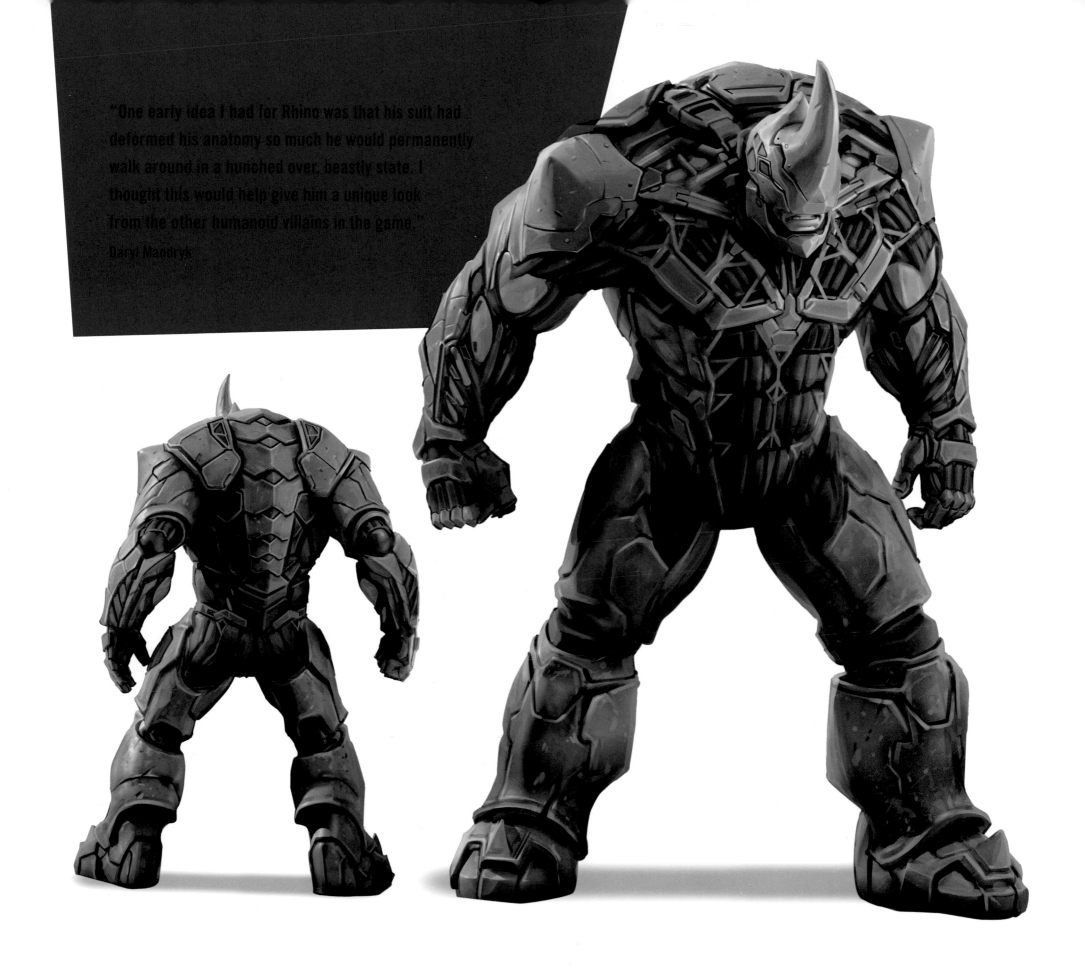

"One early idea I had for Rhino was that his suit had deformed his anatomy so much he would permanently walk around in a hunched over, beastly state. I thought this would help give him a unique look from the other humanoid villains in the game."

Daryl Mandryk

"Spider-Man was created over fifty years ago, so there's a lot of history to draw upon. There are some character designs that might be okay in a comic, but would look funny or dated in a realistic game. I wanted to keep the essence of each character intact, but the characters had to be modern and relatable."

Jacinda Chew

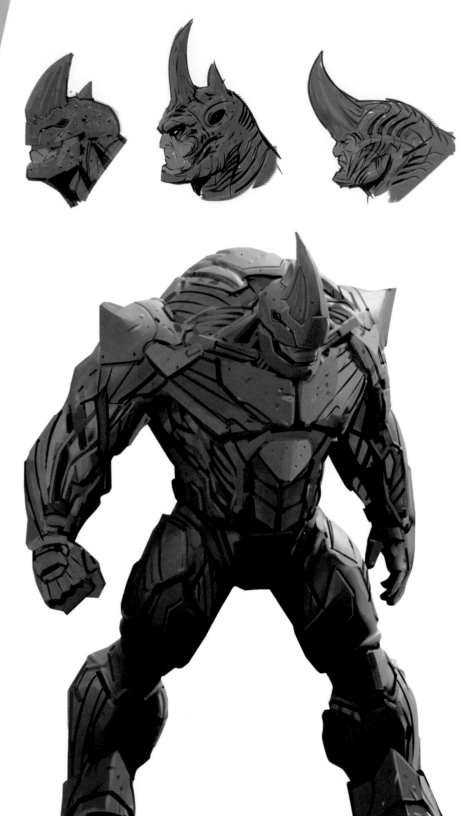

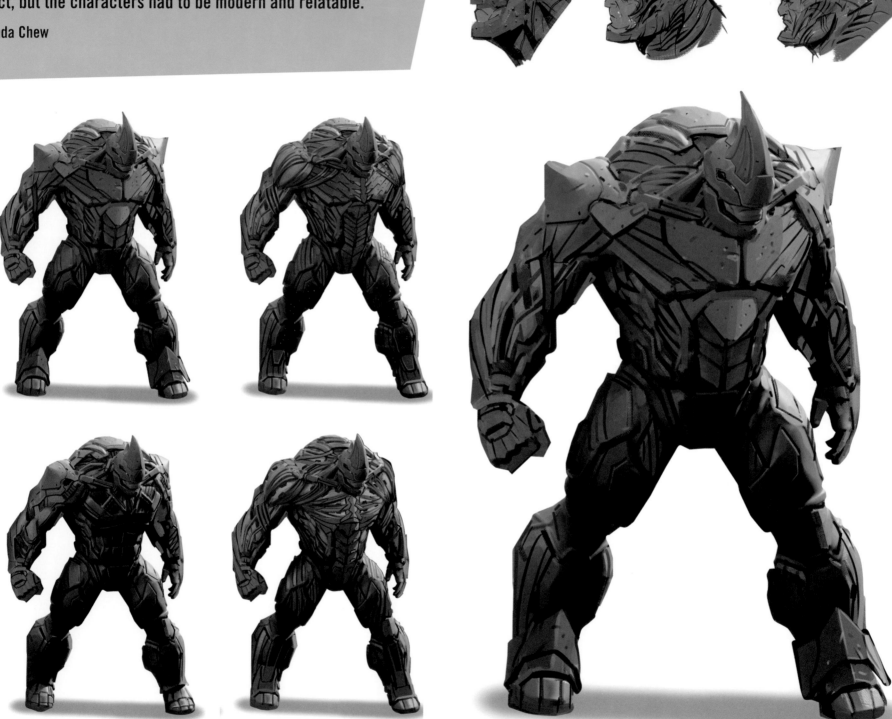

ABOVE: Various stages of fusion between man and suit, resembling a professional football player's worst nightmare.

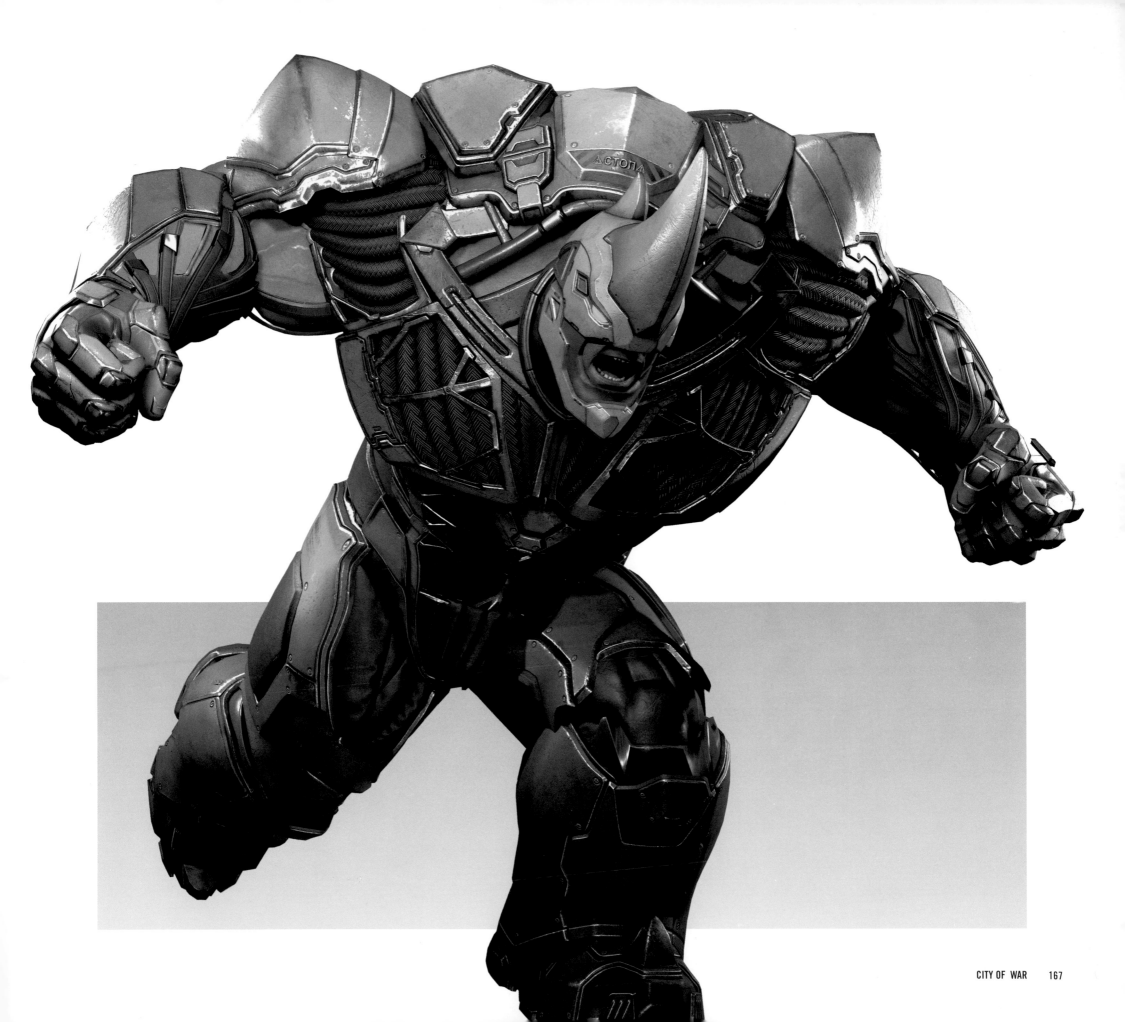

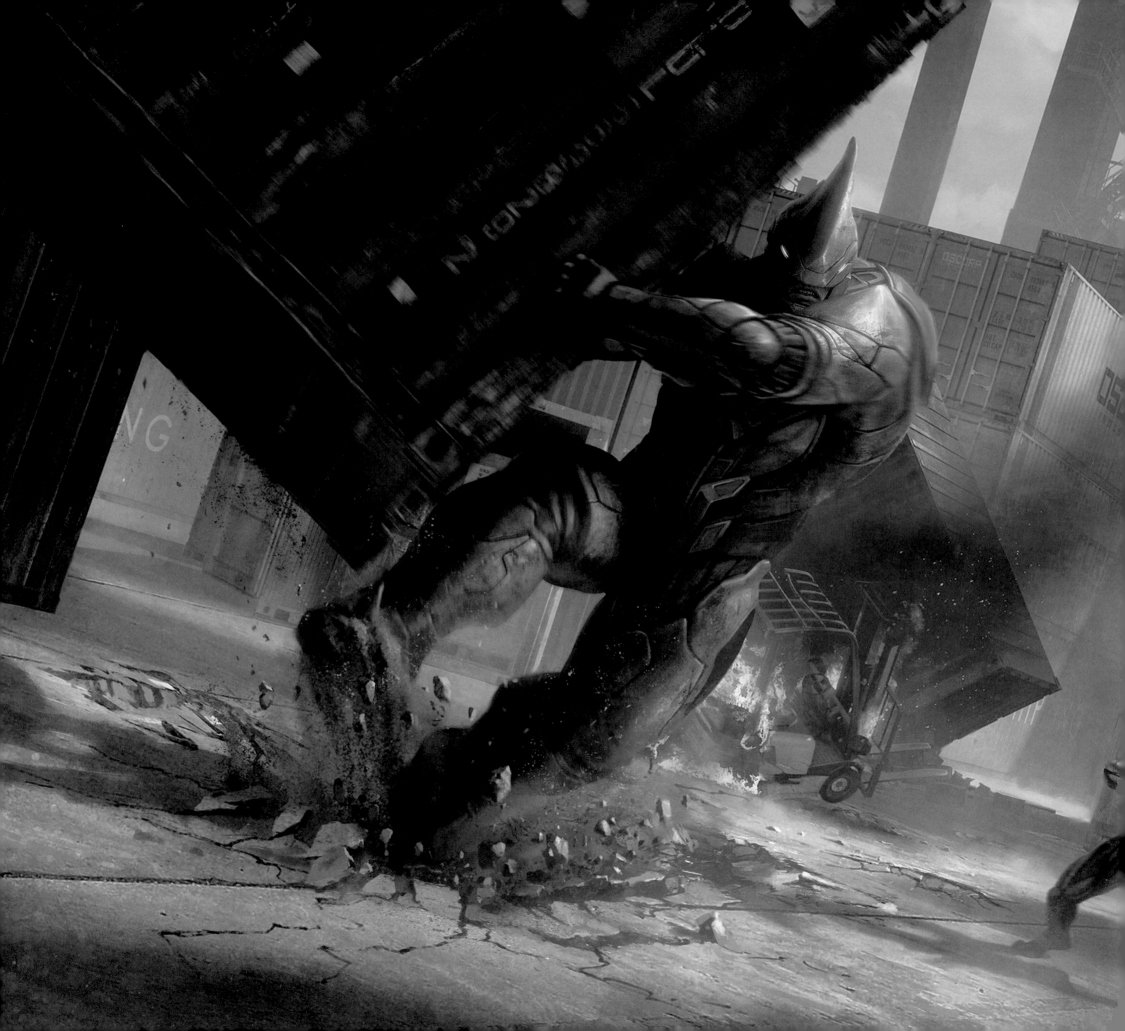

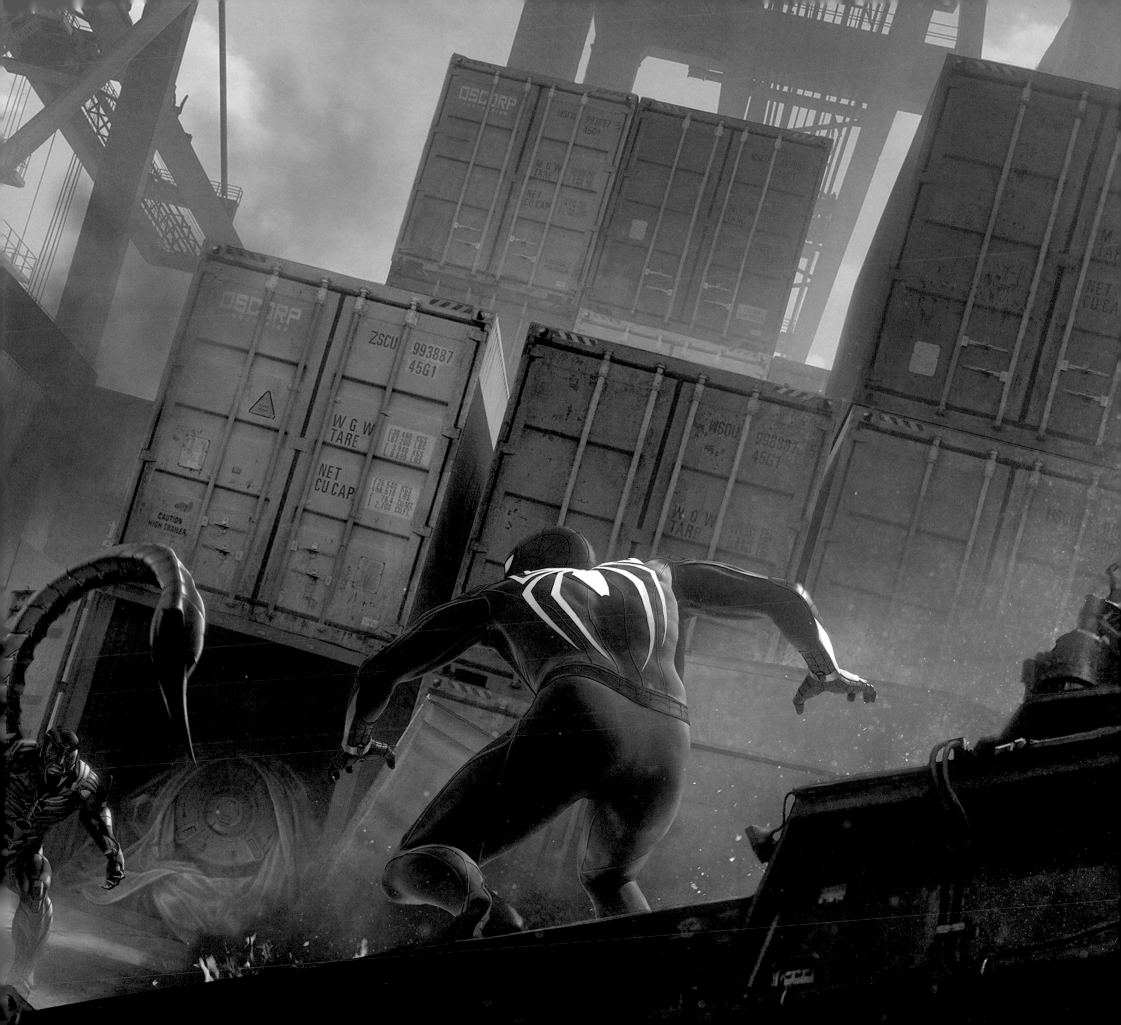

STATE OF EMERGENCY

DENNIS CHAN RECOUNTS THE MEETING with Insomniac that led to him being hired for *Marvel's Spider-Man*: "I had a piece in my portfolio that I had created around that time. It was story-driven but with characters, with a city and mood—a specific setting that they really liked. Almost dystopian. They said, 'We want this!' A state of emergency look and feel."

Reflecting on those early works, Chan says, "All the concepts that I did, including a lot of street views, are pretty dark and gritty. It's not bright, beautiful daylight. Even the daytime shots are intense. It's what I experience when I read about New York City. It has this kind of dramatic look to it that everyone is familiar with, and it's pretty much based on movies. New York should feel potentially unsafe, but it's not like doomsday—more a kind of late-night feel. There were images where I had to include Spidey and Mary Jane, and I had to figure out how they would look, based on loose ideas that they had."

RIGHT: "In the latter part of the game we wanted to show that New York has reached boiling point; everything shut down, subways closed, billboards no longer giving updates." Dennis Chan

BOTTOM RIGHT: "Midway through the game, we wanted to show the decline of the city. The melancholic gritty look and feel of NYC. The symptoms of lawlessness and unsafe streets." Dennis Chan

BELOW: "At the beginning of the game, we wanted to show a sunny day, civilians living their everyday lives, of vibrant activity that we can relate to." Dennis Chan

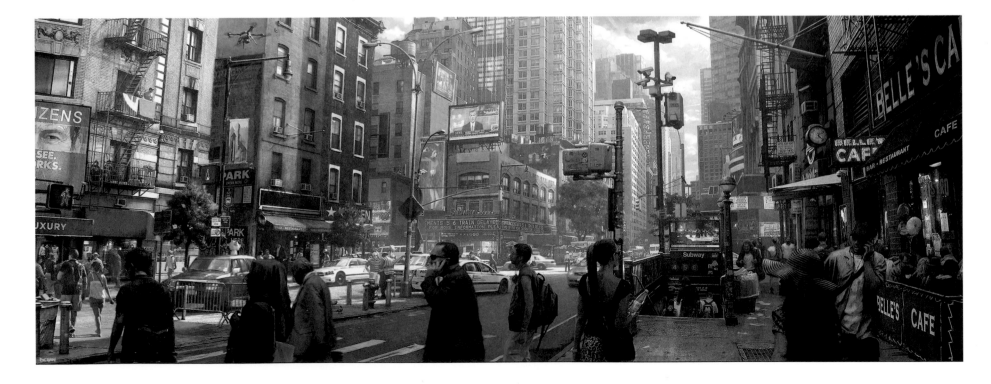

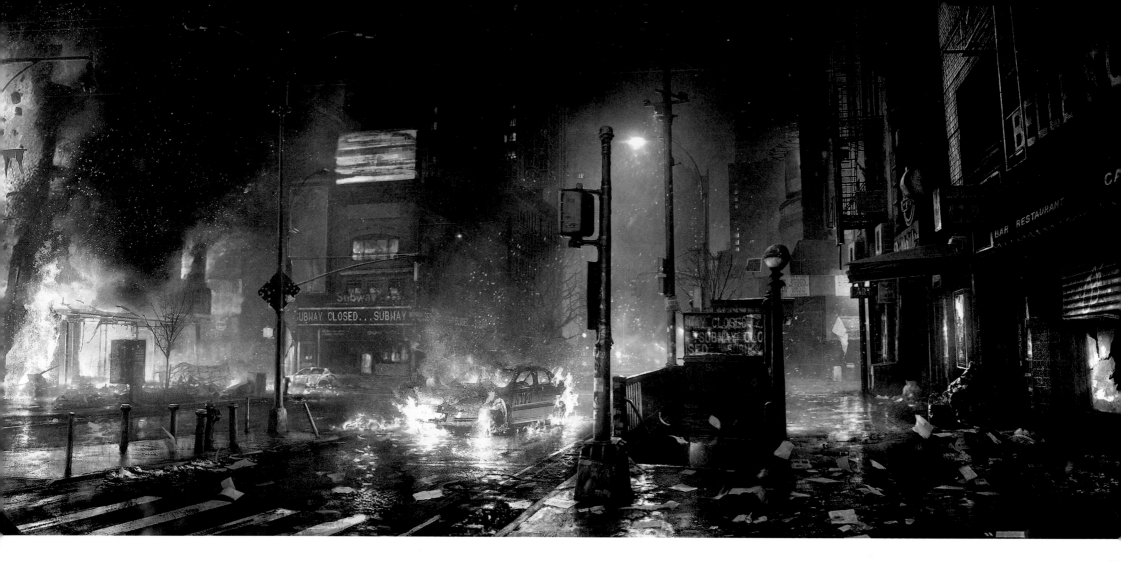

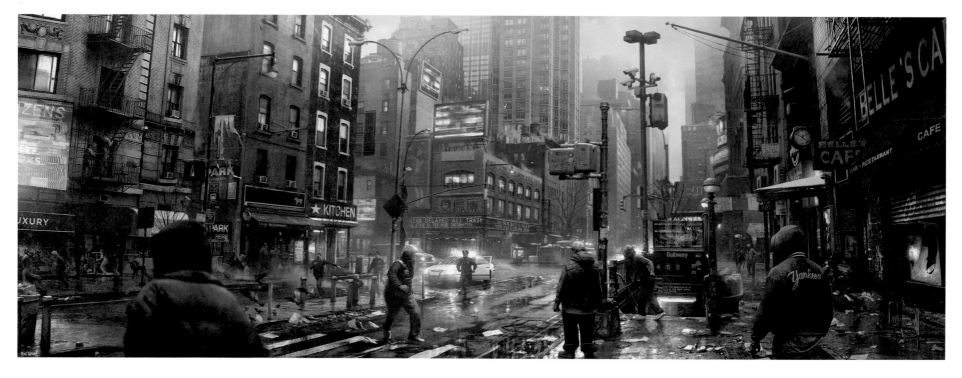

CRIMINALS AND STREET THUGS

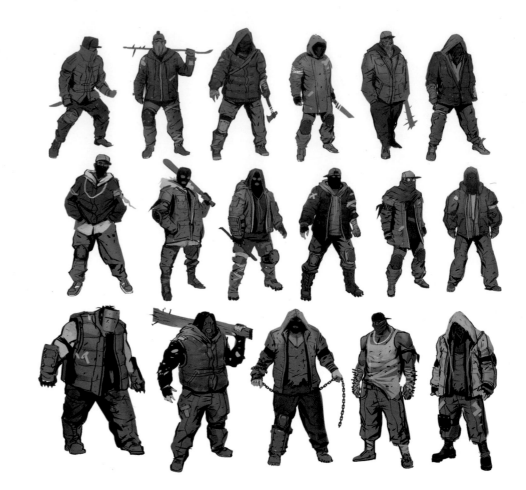

AMONG THE WORLD-CLASS CONCEPT ARTISTS hired to bolster the Insomniac team, industry veteran Daryl Mandryk "hit the ground running", according to Bryan Intihar. "He is very versatile. We could throw a lot of different challenges at him, and he could deliver on them. Daryl could really get down to the nuts and bolts, help the team with whatever they were working on." Initially this was to provide concept art for a few villains, but grew to include super villains in addition to low-level goons and prop designs.

"Designing thugs is always a fun challenge," declares Mandryk. "The player should be able to judge quickly what kind of threat they pose, so each 'class' needs their own visual cues. They also need enough consistency so that they all fit within the group."

From Bill Rosemann's point of view, it was important to convey this sense of a different Spider-Man via combat: "An older Peter, much more experienced and a master of improvisation, where he's mixing punches and kicks with webs and acrobatics and environment interaction that he can switch through on the fly."

We have Mandryk to thank, in a very significant way, for the awesome target practice.

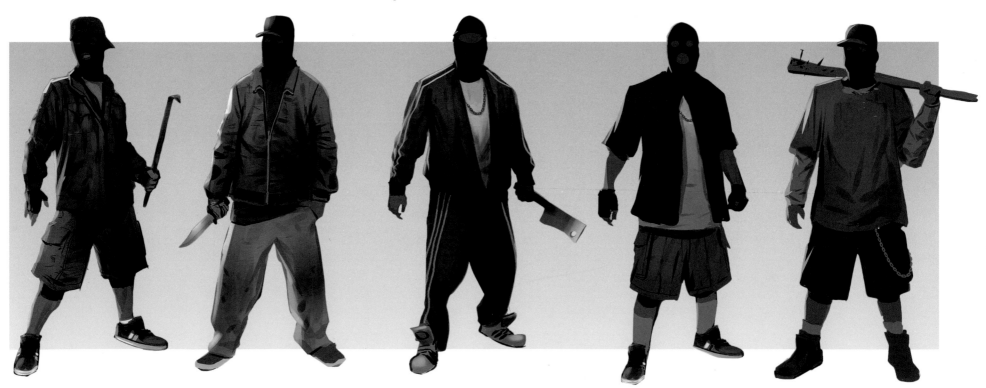

ABOVE: Masked men, not quite the same caliber as a certain web-flinging Super Hero.

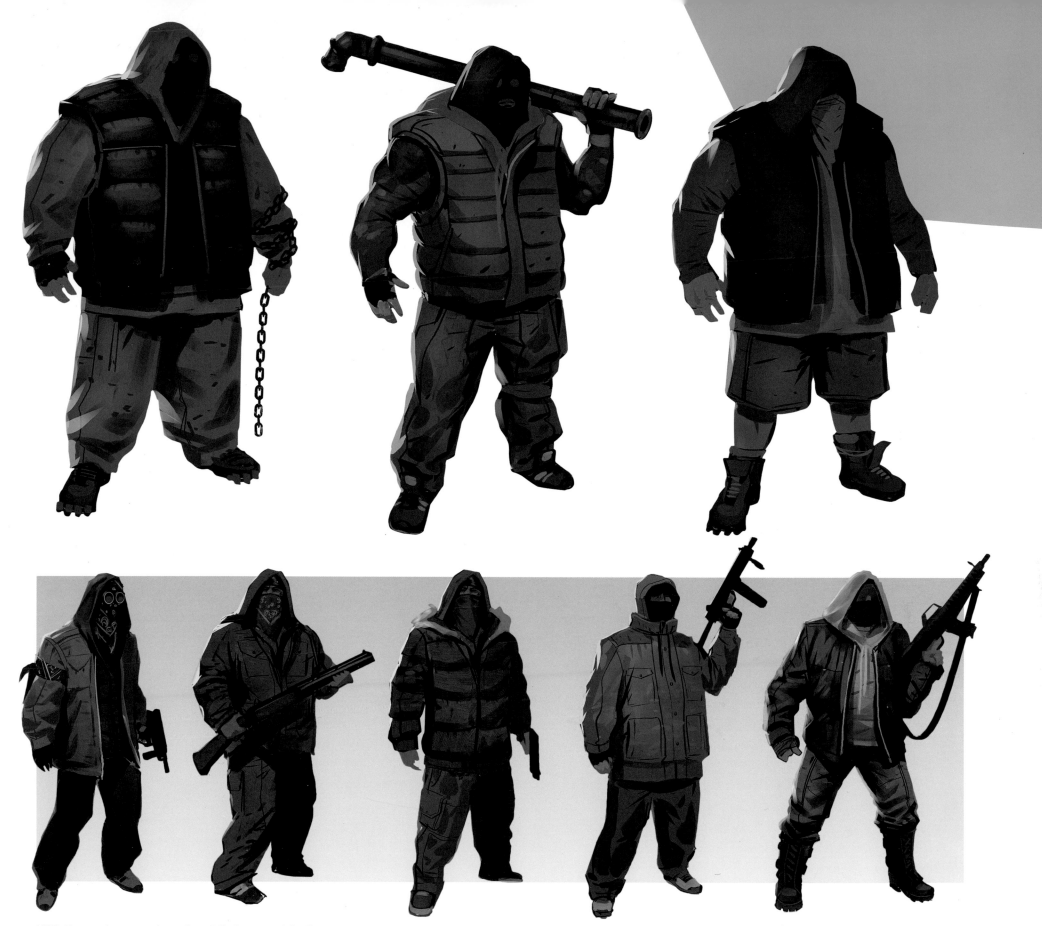

ABOVE: If meat cleavers and crowbars fail, thugs reach for firepower.

NORMAN OSBORN'S PENTHOUSE

MANY ARTISTS INVOLVED WITH *MARVEL'S* *Spider-Man* have experience in the movie industry, Dennis Chan among them. "The difference is that in a game like this you have to consider everything in the environment, from all angles," says Chan. "In movies you can choose what appears in each shot, and you don't have to show the rest.

"For Norman's penthouse it was important to design the room with enough space to fight in. To make this large room more interesting we added leveled floors and dividing walls to break the space, but still keep it open. Norman's penthouse should reflect his expensive taste, and personality: minimalistic, combining brutalism and rustic architecture, and materials that dominate the room, as well as carefully selected art and artifacts."

THIS SPREAD: "Norman's personal rooms were designed to invoke a sense of elegance and danger." Blake Rottinger

FIRST FLOOR PLAN

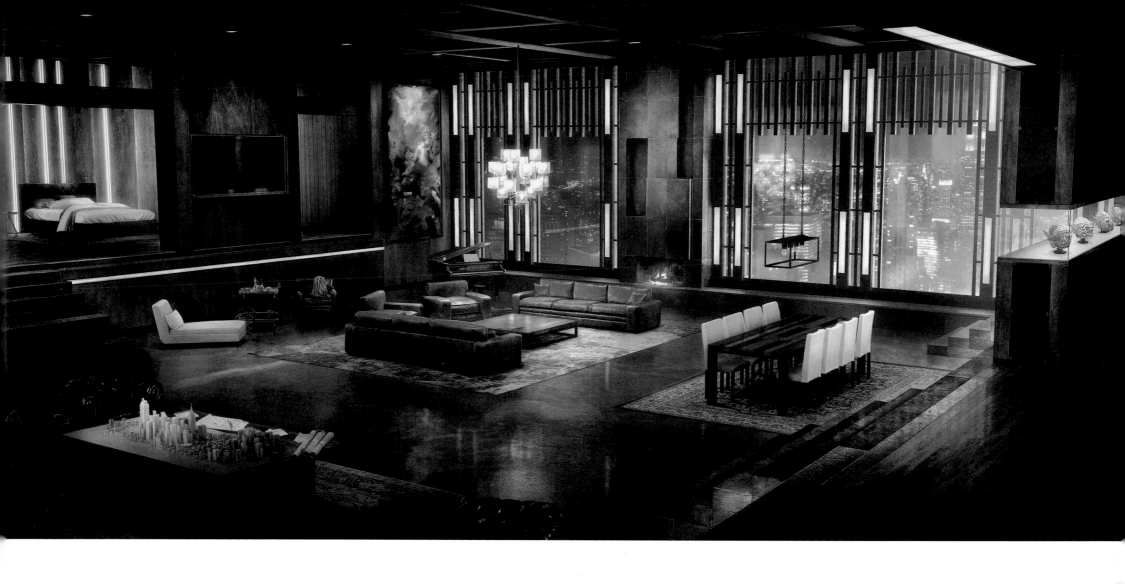

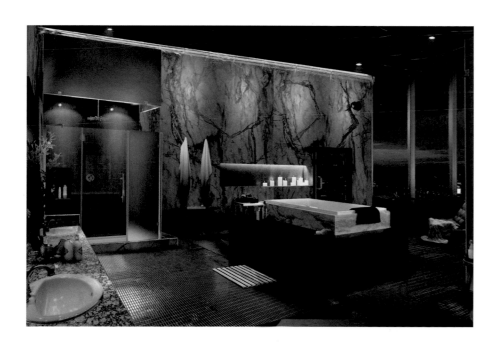

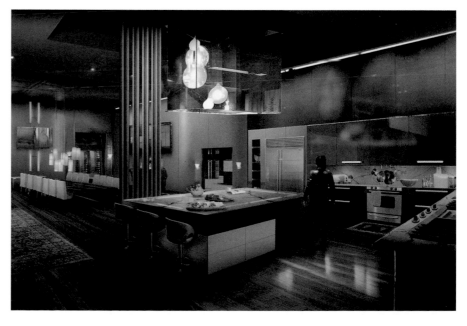

"In the hidden lab we wanted to show Norman's obsession with Spider-Man and his powers, and how Norman has been constructing his own spider-research facility."
Dennis Chan

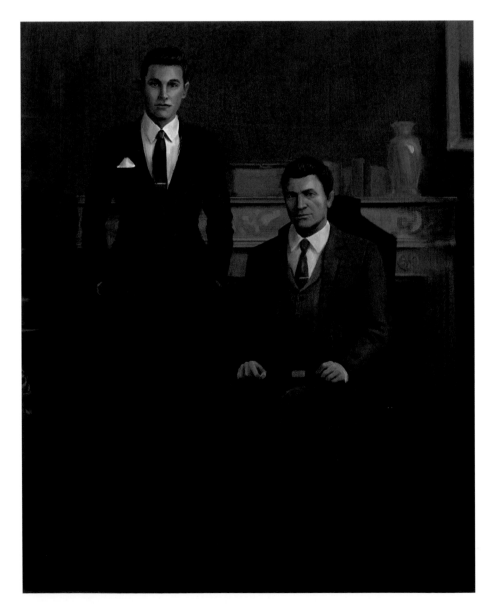

"INSOMNIAC WOULD HAVE A REFERENCE board, for example the type of architecture they are looking for, or the kinds of furniture based on their character description and what they'd be interested in—the small head statues, for example," Chan remembers. "The office space [page 177, top picture] was the second image I ever created for the project. They wanted to base it on those same attributes; it should feel like the same style. An exclusive look, and still robust somehow. The piano was in the description."

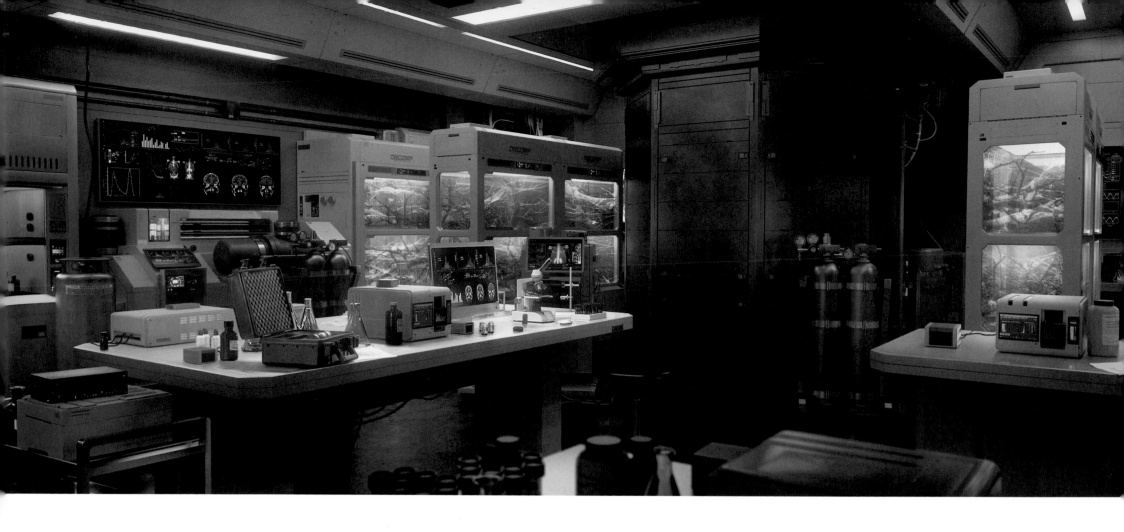

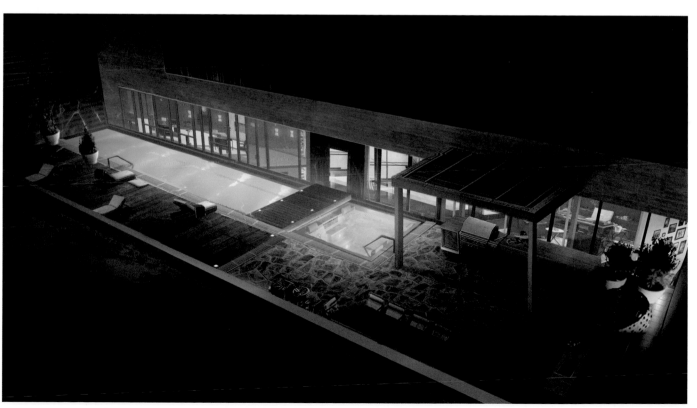

RIGHT: "I tried to achieve some interesting lighting for the outside area when the player is in the space, or looking at it from the inside." Blake Rottinger

OSCORP INDUSTRIES

JUST AS THE CHARACTER DESIGN in *Marvel's Spider-Man* diligently observes immortal elements from the comic books, Insomniac was careful to ensure that the architecture felt familiar. Equally, a modern audience has a broader frame of reference to shape opinion than fans would have way back in the 1960s. During that time, a movement known as Brutalism was on the rise—raw and purposeful, very much fitting the assiduous personality of Norman Osborn and his multinational, family-owned corporation.

"This was one of the first tasks I had for the project," recalls Dennis Chan. "I think they were trying to get an idea of what I should focus on. The references I got were pictures of Brutalist architecture, and tall glass towers. Insomniac wanted thick and hard shapes. I looked at the old comic books, and there are so many variations of the buildings in the Spider-Man universe. So lots of my work is based on old designs from the comics. I looked at everything I could find, to see what had already been made."

"In *Marvel's Spider-Man*, New York is the New York of your imagination and recollection," adds Jacinda Chew. "I've been to New York many times and I always remember things like the red brick buildings, and steam rising out of sidewalk vents. In reality, our imagination and recollection is hazy, and New York doesn't have nearly as many of these elements as you might think, but it *feels* right. We did look at satellite imagery of New York to make sure familiar landmarks and streets are in place, but everything has been interpreted through an idealized lens. A surprising number of New Yorkers tell me we 'nailed it,' so I think we got the feeling right."

RIGHT: Dennis Chan's Brutalist depiction of Norman Osborn's dominating skyscraper, looming over Insomniac's 'Marvel'-style rendition of New York City.

OPPOSITE PAGE, BOTTOM: "Norman's office went through a lot of exploration with different walls, statues, props and lighting. We eventually settled on more medical-inspired inventions than military ones." Blake Rottinger

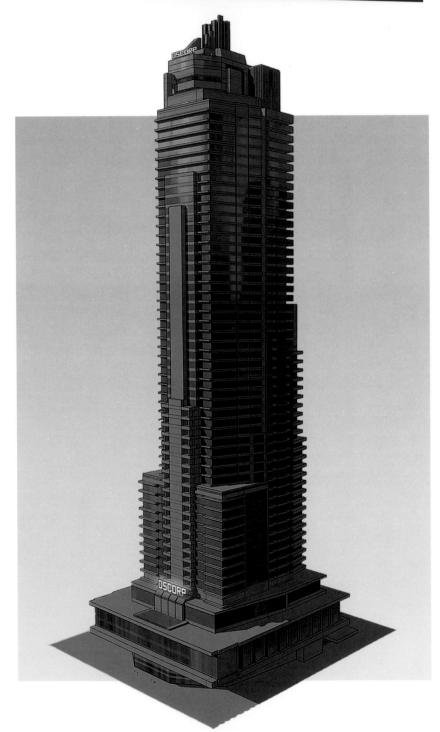

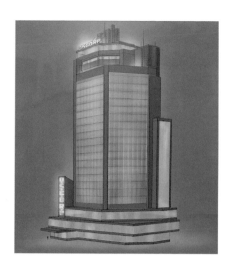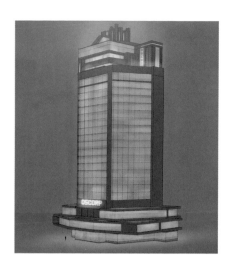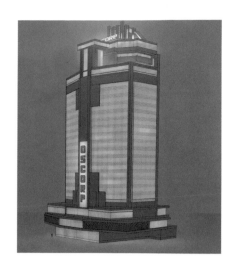

ABOVE: "Rough sketches for the tower. At this point they looked too short. They needed to look taller and more imposing, and I did many versions." Dennis Chan

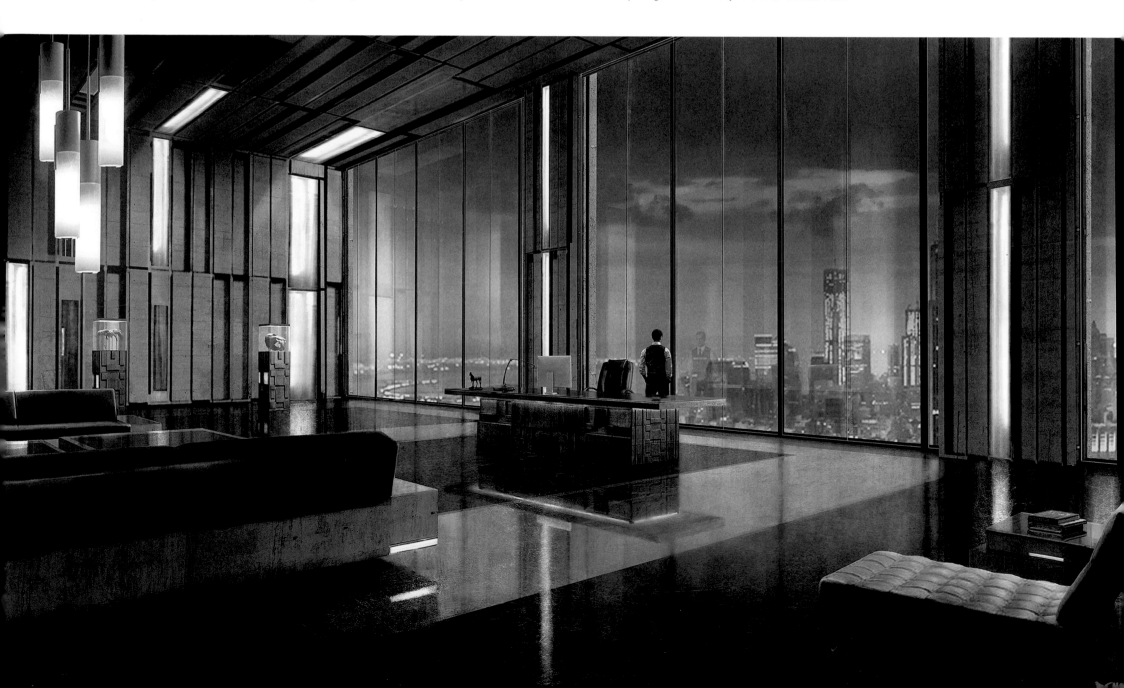

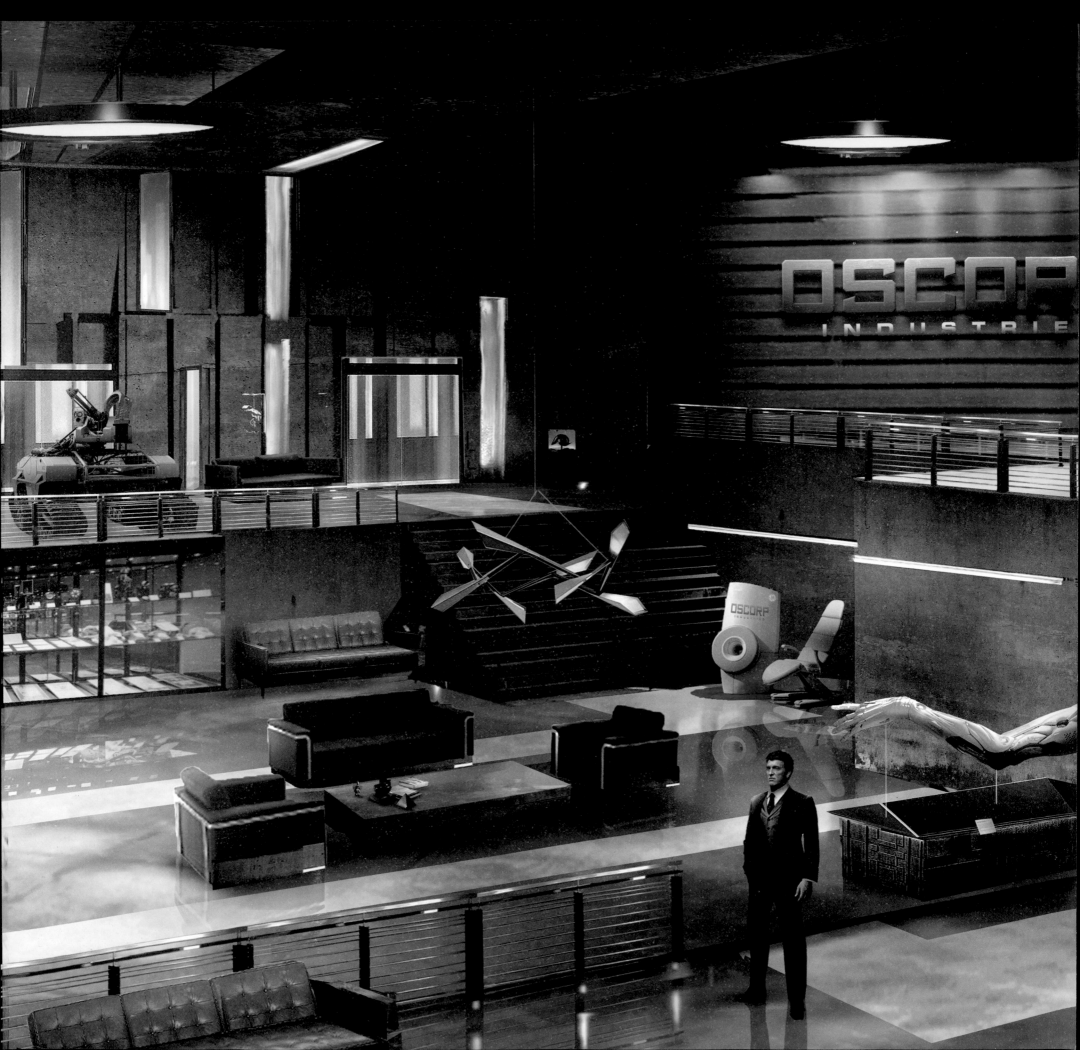

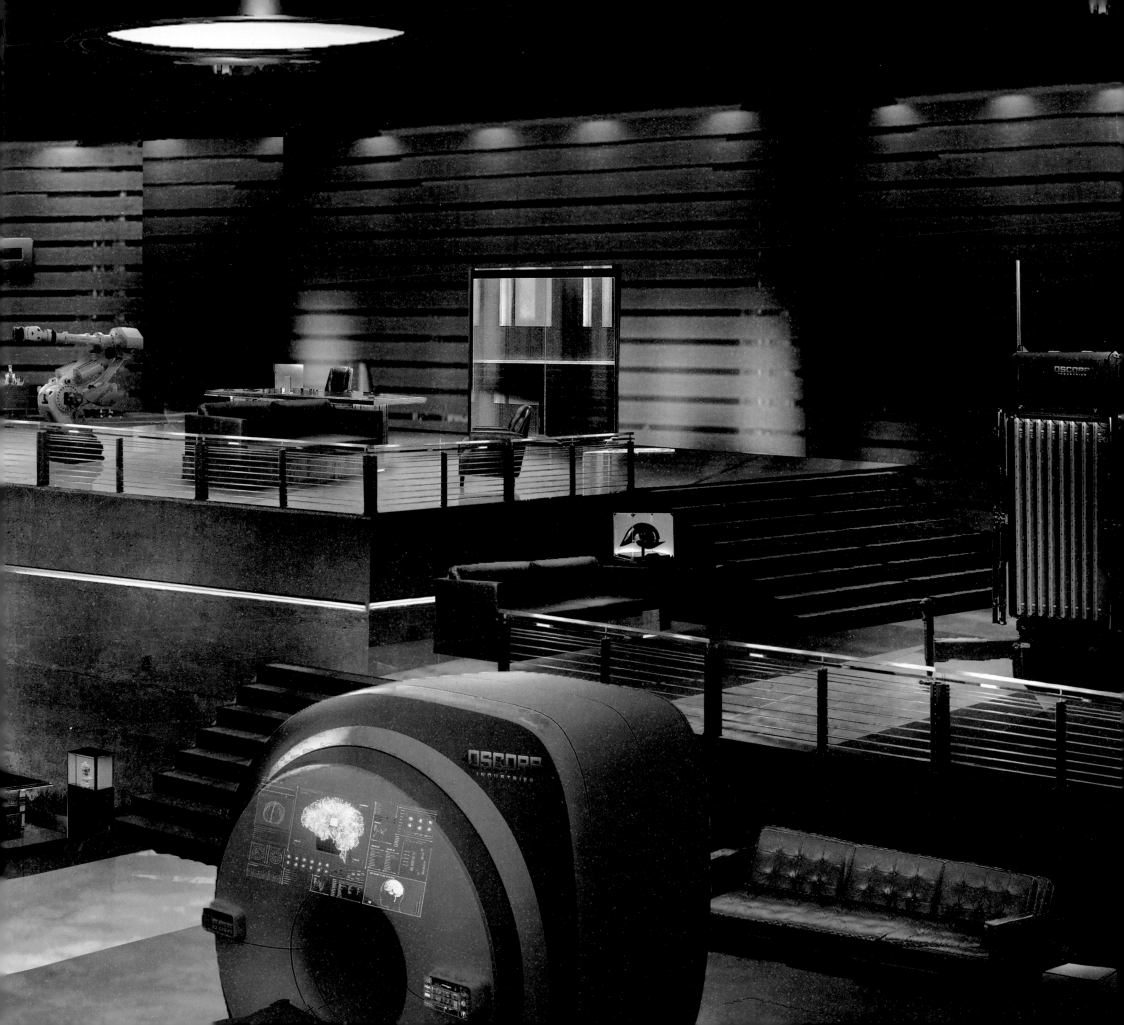

OSCORP
INDUSTRIES

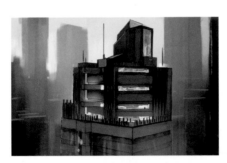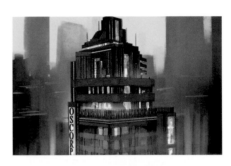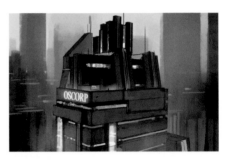

"Like his apartment, Norman's Oscorp office should reflect his expensive taste and personality. The big windows and their panoramic view of the city reveal the grandeur of Osborn's intentions for the city."

Dennis Chan

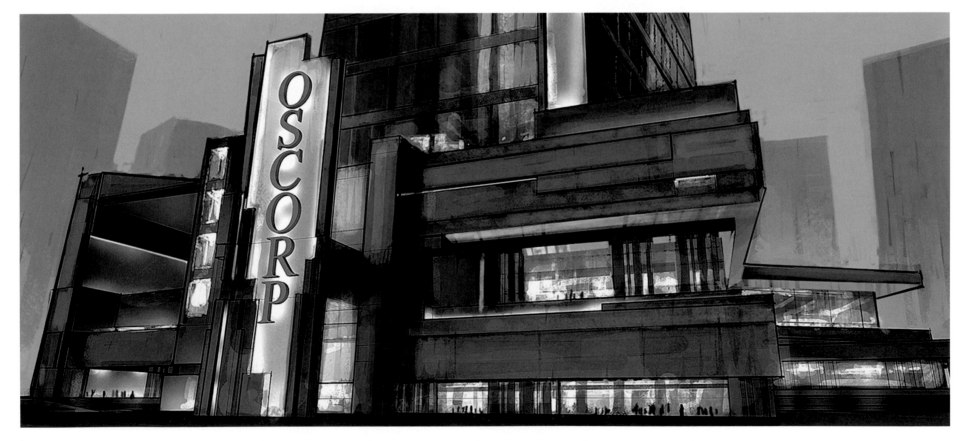

ABOVE: "Early sketches exploring the design for the Oscorp tower, which were becoming much closer to the goal Insomniac had in mind." Dennis Chan

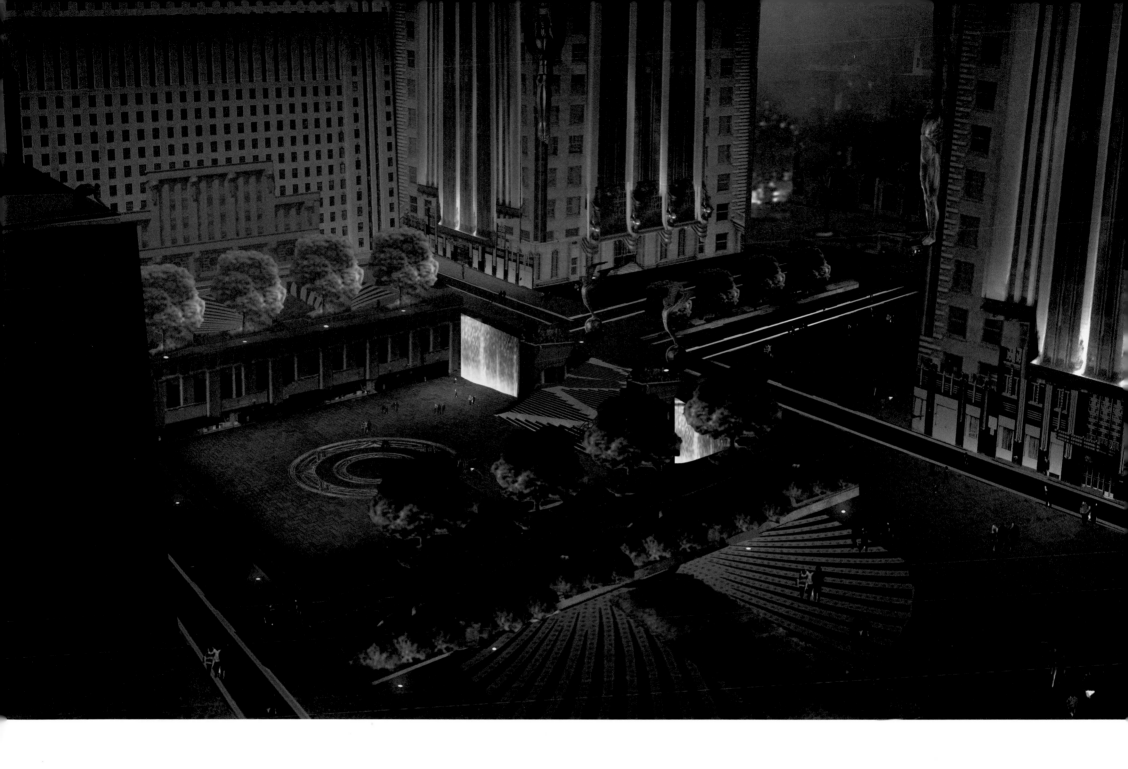

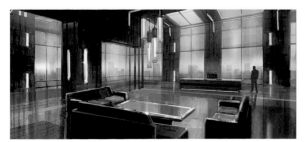

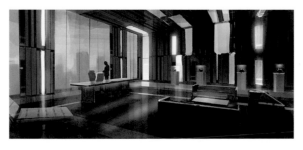

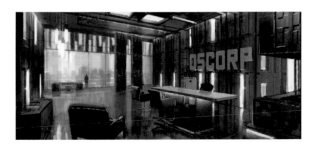

ABOVE: "Quick concepts for the building's ground level. I looked at a lot of art deco architecture for inspiration." Blake Rottinger

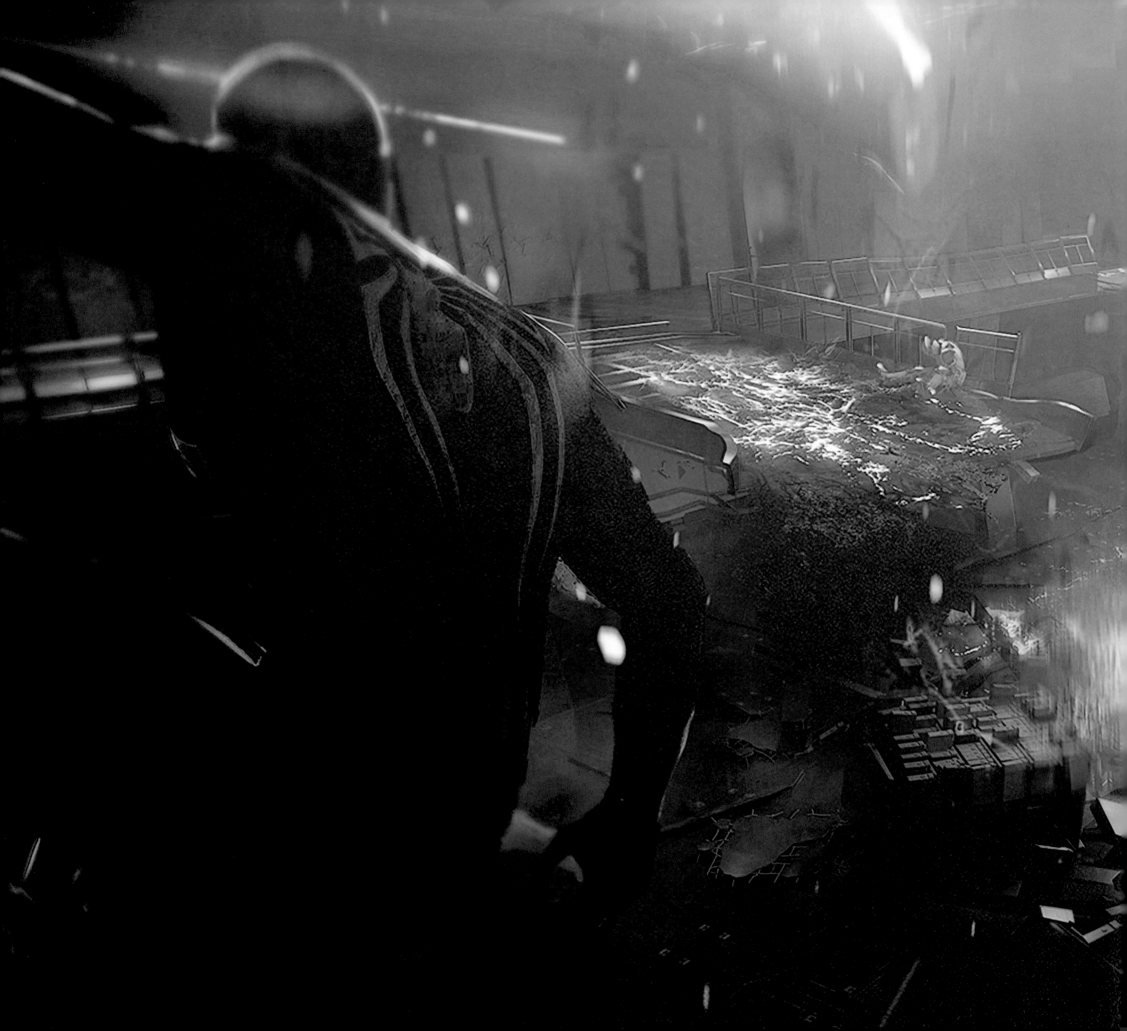

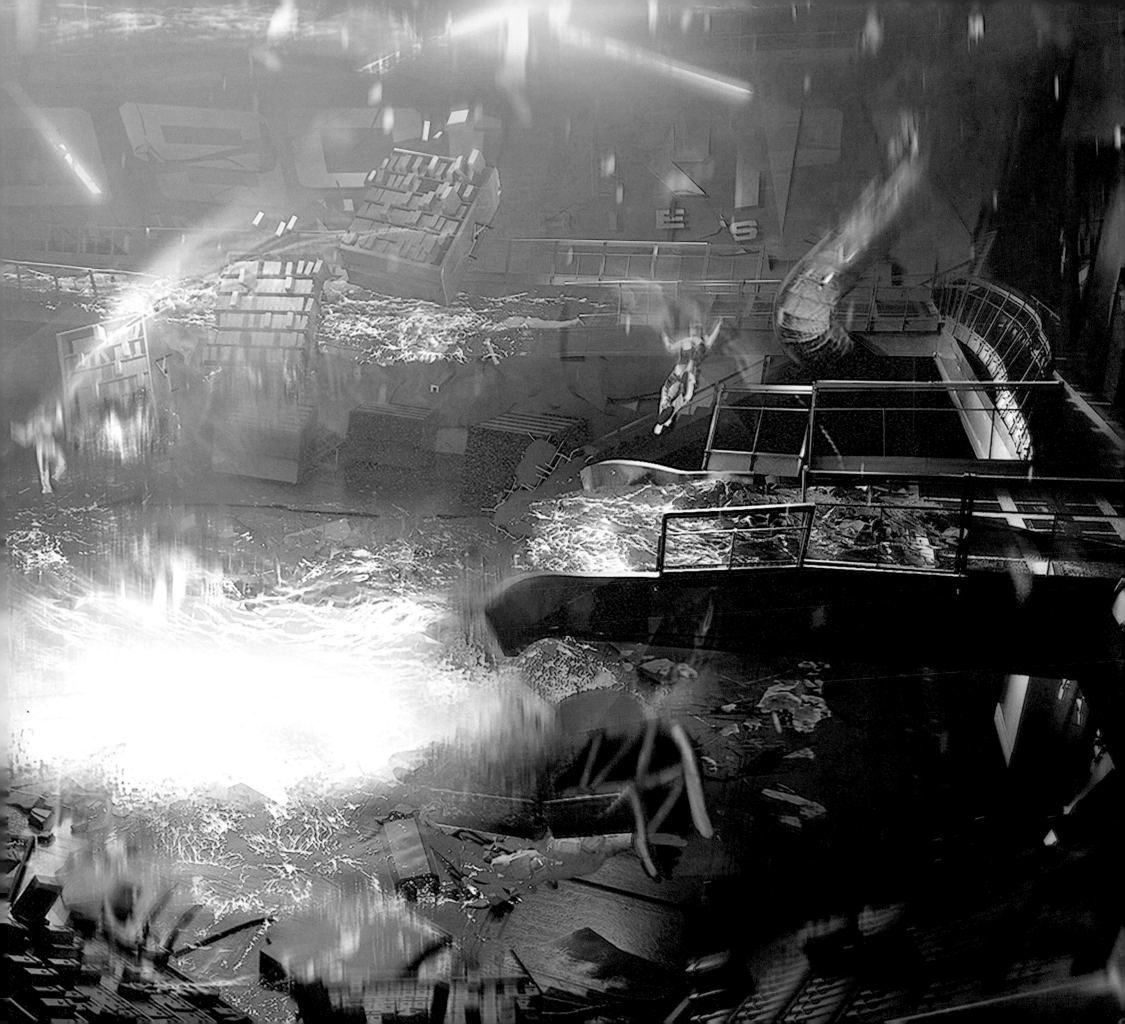

IT WAS HANDY THAT KEY artists on the project were also experienced gamers, considering the practicalities of area traversal, while ensuring the environments appear believable.

Dennis Chan points out that with the Oscorp secret lab arena, "The challenge was to make good use of its large space. It was important to keep the walls relatively flat to allow Spider-Man to perform wall-runs. The wall area was large enough that we could break up the flatness with a second-level open walkway, making it more interesting visually, and for the gameplay. It was important to show the characteristics of the building materials, to get reflections from the subdued green light. This allows us to retain the crisp, clean and shiny look we were going for."

"I normally play games that I like rather than games I should be researching," says Chew. "The games I played during *Marvel's Spider-Man*'s production included *Uncharted 4* and *Final Fantasy XV*. I made it a point not to play previous Spider-Man games. If I look at a reference that too closely resembles what I am working on, it tends to seep into my work too much. I would rather be influenced by things I like that aren't closely related to anything I'm working on. It was for this reason in art school that we studied the Old Masters rather than our contemporaries. I thought about how I could make the player feel like Spider-Man and Peter Parker, rather than how I could improve upon what has already been done."

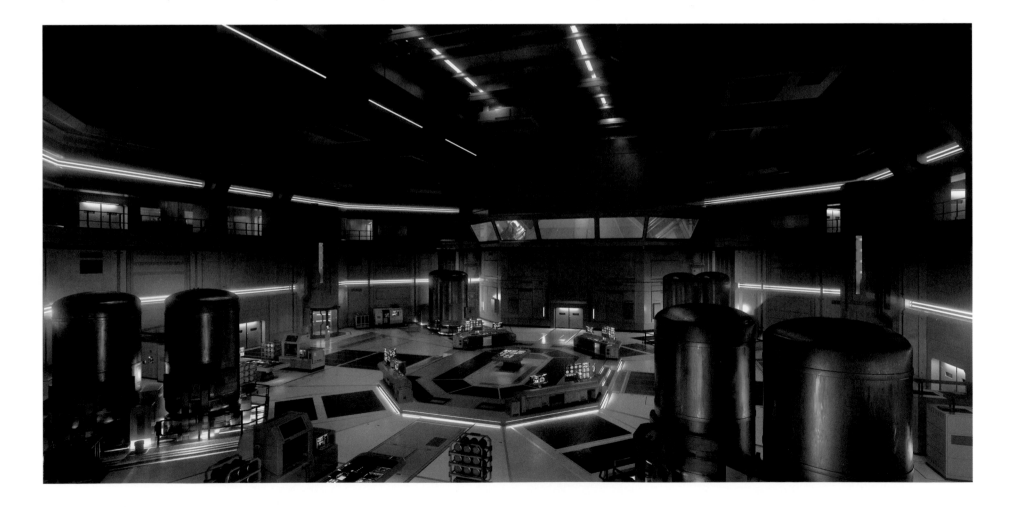

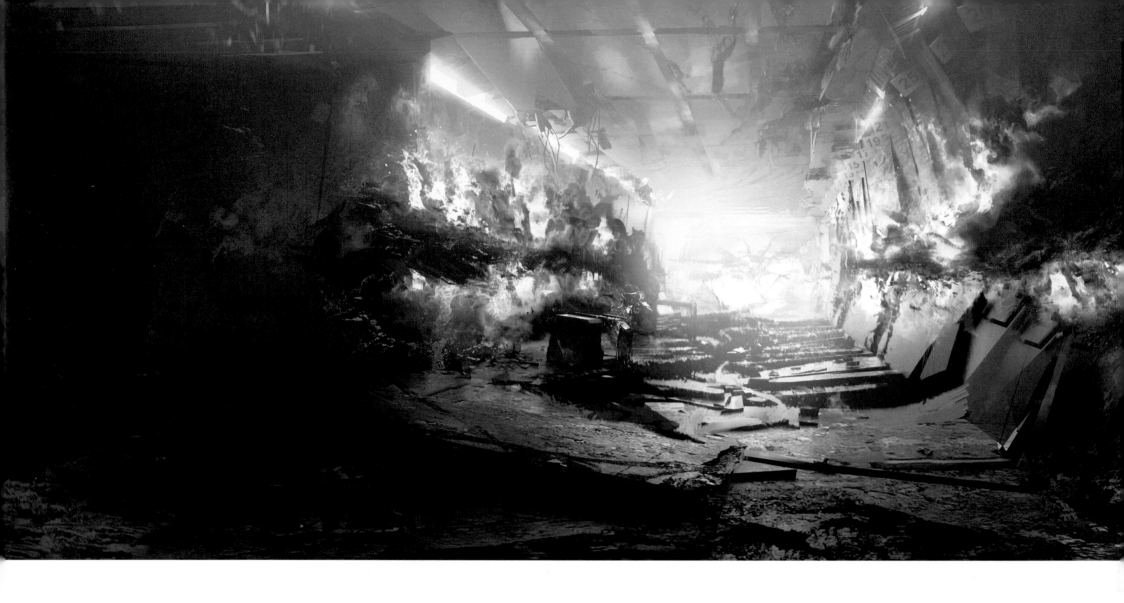

RIGHT: "For the observation deck overlooking the arena it was important that it look like a genetic experiment lab, with sci-fi elements to make it look more advanced, and with a human touch to make it more believable and grounded." Dennis Chan

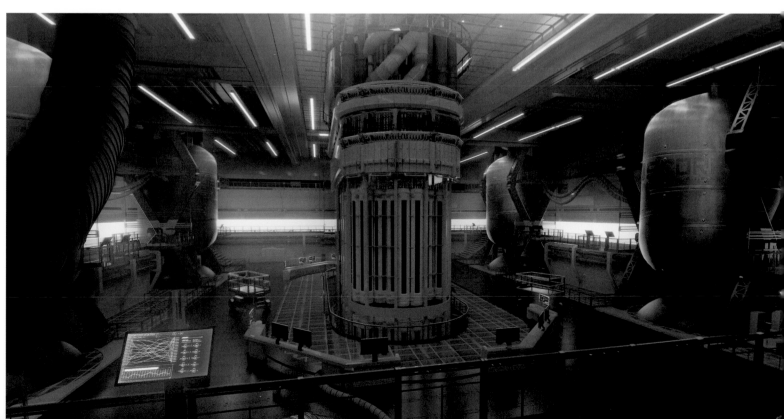

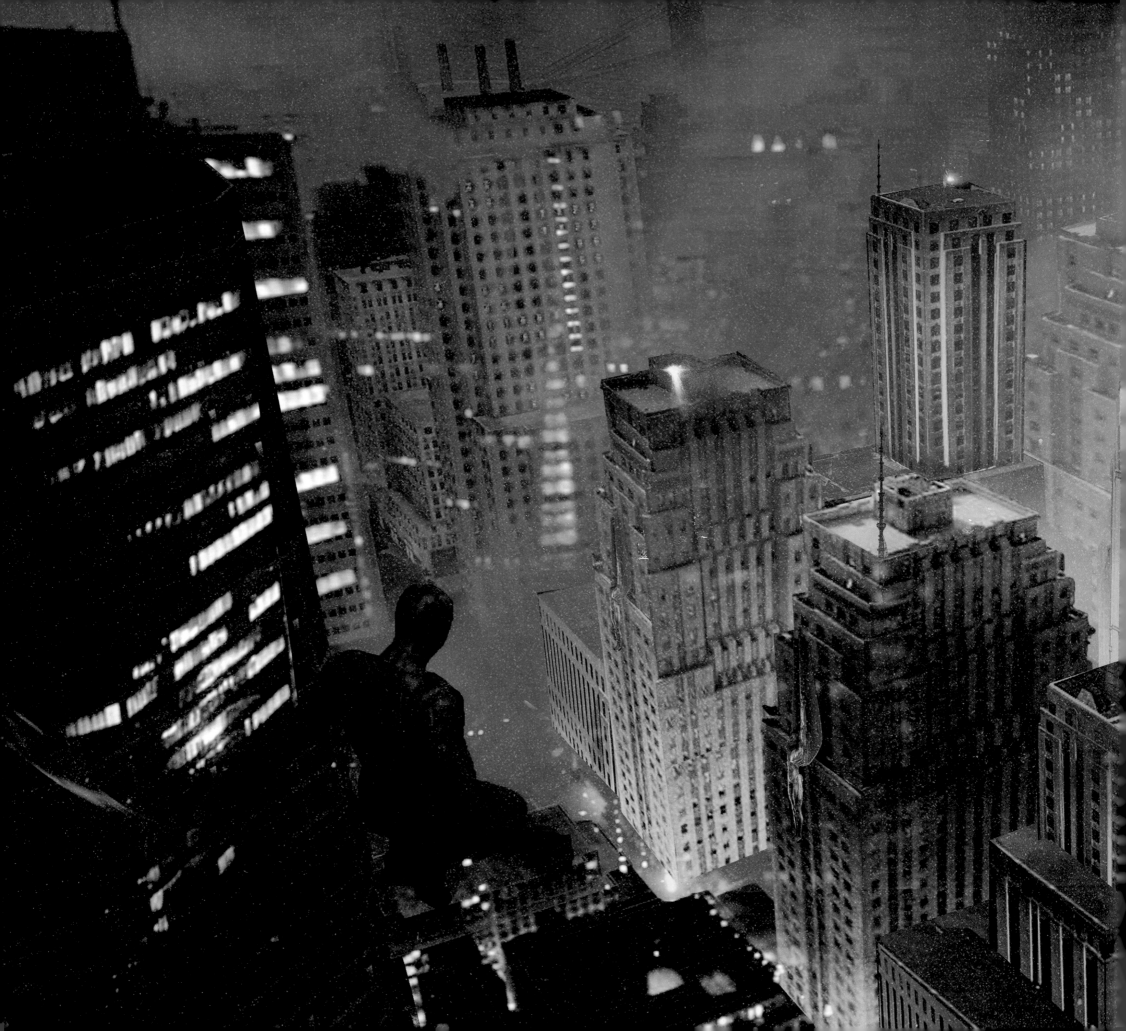

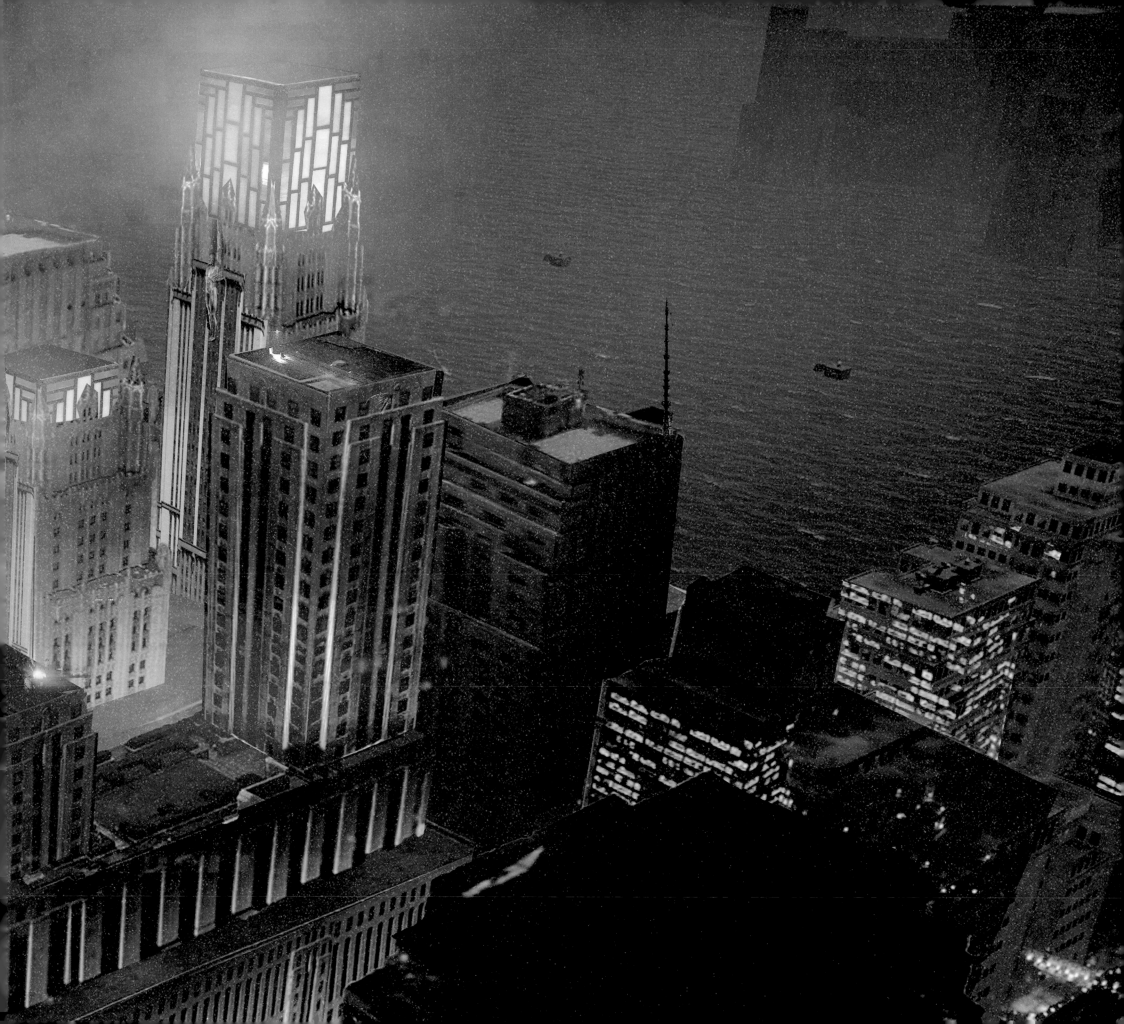

THE FINAL SHOWDOWN

WE CLOSE *MARVEL'S SPIDER-MAN: THE Art of the Game* with one final tribute to the work of the concept artists, and the passion driving the tasks set before them. The fact is that the first iterations are only ever the starting points for discussion, despite the standard of work in those early pieces being phenomenal. Case in point: the battle shown opposite between Doctor Octopus and Spider-Man, created by Dennis Chan at the very beginning of his involvement in the project.

Says Chan, "Though I had very little information about Doctor Octopus—nothing about his story or background specific to *Marvel's Spider-Man*—we all know the general story. I had a reference from a comic strip in which Spider-Man was falling down the building, and Insomniac wanted that same kind of effect. I had only loose ideas of how Doctor Octopus would look. There was a note that this should be an iconic building."

Here is the art brief, handed to Chan from Insomniac:

"Doc Ock and Spider-Man fight. They can punch each other through the floors so you can even do something with smashed-out windows. It's basically a Super Hero vs Super Villain fight so they're able to do some massive damage as they slug their way around."

Over time, Chan received guidance that is wonderfully demonstrative of the direction that Insomniac was going: "In terms of the poses…we can strengthen the sense of danger and action/athleticism more;" "Cool scenario, but we could activate Spidey's pose more. He looks surprised, but we could insert a sweet dodge pose instead. He will look more heroic;" "Doc Ock's pose is strong, but Spidey looks a bit too relaxed. I think he needs more tension or extension in his pose so he looks like he's out of control or struggling;" "The vertical composition is working much better, but I think we need more exaggerated perspective and tension on the characters…"

This is all in a concerted effort to capture and then convey the essence of Spider-Man, to deliver this into the hands of the players. And why? Because through Insomniac, Marvel believes that it has something vital to share, almost a gift from likeminded fans to others.

Bill Rosemann: "In Spider-Man I saw myself—or who I wanted to be—and often asked myself: 'What would Peter Parker do?' It's this relatable and tangible impact that Marvel characters can have in our everyday lives, and it's this firm belief in their transformative power that has driven me to make a career out of sharing their stories. As for our game, while I first hope that it first and foremost delivers hours of fun, I also hope that it provides a few touchstone moments for players facing difficult moments in the real world. Life is hard, and we are continuously tested by challenges and setbacks. But if Spider-Man, after being knocked down, can get up and be greater…then maybe we all can."

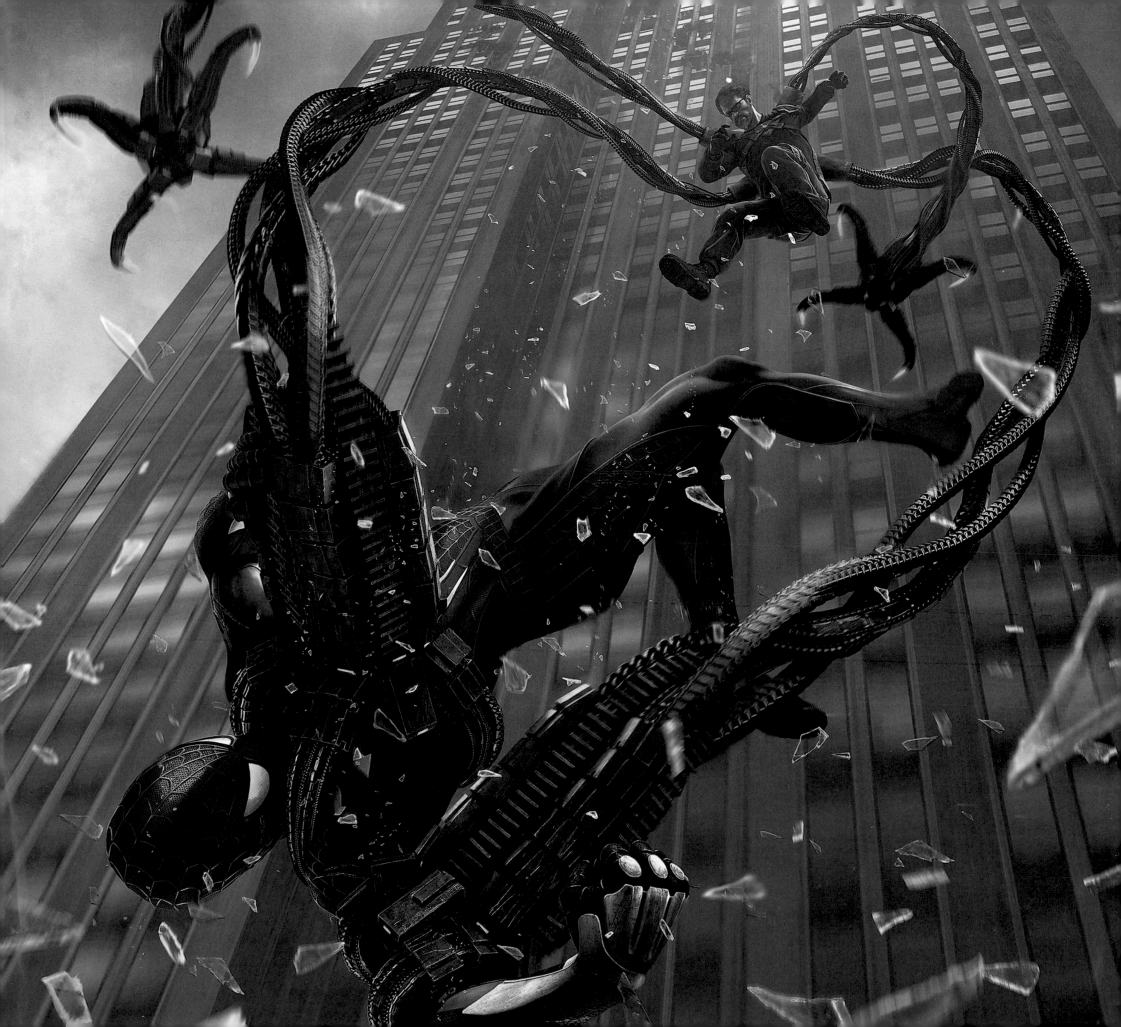

ACKNOWLEDGMENTS

We'd like to thank the Insomniac Games development team and our team of remote artists scattered throughout the world: Dennis Chan, Matt Ciaglia, Ian Galvin, Sing Ji, Peter Kim, Felix Mack, Daryl Mandryk, Rob McKinnon, Dan Milligan, Bao Nguyen, Justin Page, David Paget, Plek One, Julien Renoult, Blake Rottinger, Nicholas Schumaker, Jack Sun, Eve Ventrue, and Samma van Klaarbergen.